How to Select & Use
MINOLTA

SLR CAMERAS

by Carl Shipman

Published by HPBooks
A Division of HPBooks, Inc.
P.O. Box 5367, Tucson, AZ 85703 (602) 888-2150
ISBN: 0-89586-430-4 Library of Congress Catalog No.86-82234
©1986 HPBooks, Inc. Printed in U.S.A.
2nd Printing

CONTENTS

EQUIPMENT DISCUSSED IN THIS BOOK

Cameras	Standard MAXXUM 5000 Advanced MAXXUM 7000 Professional MAXXUM 9000 Interchangeable focusing screens Eyepiece accessories	**Close-Up and Macro**	Macro lens Macro-Zoom lenses Close-up lens attachments
Lenses	All current MAXXUM lenses	**Data Backs and Program Backs**	DATA BACK 70 PROGRAM BACK 70 PROGRAM BACK 90
Flash Units	MAXXUM 1800 AF MAXXUM 2800 AF MAXXUM 4000 AF Bounce Reflector Set CG-1000 Control Grip CG-1000 Set Multiple flash Off-camera flash accessories		PROGRAM BACK SUPER 70 PROGRAM BACK SUPER 90
		Motor Drive	MD 90
		Remote Control	WIRELESS CONTROLLER IR-1N Set

Publisher: Rick Bailey
Executive Editor: Randy Summerlin
Senior Editor: Vernon Gorter
Art Director: Don Burton
Book Design: Paul Fitzgerald
Production Coordinator: Cindy Coatsworth
Typography: Michelle Carter and Beverly Fine
Director of Manufacturing: Anthony B. Narducci
Cover Photograph: Bill Keller

Introduction

This book is about Minolta MAXXUM cameras, lenses, electronic flash and other accessories—how they work and how to use them. It begins with fundamentals of photography and cameras. Building on fundamentals, this book helps you understand and use all features of the most advanced cameras.

The cameras and accessory items discussed are listed in the table on page 2. They are manufactured by the Minolta Camera Co.

NEW CAMERA SERIES

The name MAXXUM identifies a new series of cameras, announced by Minolta in 1985. These cameras take advantage of recent developments in electronics, optics and automatic focusing methods.

MAXXUM cameras are electronic, with automatic or manual exposure control, automatic focus using a motor in the camera body or manual focus, and many other automatic features. They have advanced capabilities, but are easy to use and operate.

New Lens Series—There is a new series of MAXXUM lenses, designed to be focused automatically by the camera. Many are advanced zoom lenses, offering the capabilities of several fixed-focal-length lenses plus a macro range that allows you to make large images of small objects.

MAXXUM lenses communicate electronically with MAXXUM cameras to provide new and helpful operating features that were not possible a few years ago.

MAXXUM AF Flash Series—MAXXUM flash units are available to work with MAXXUM cameras. They provide all features of modern electronic flash units, including full automation. In addition, they have

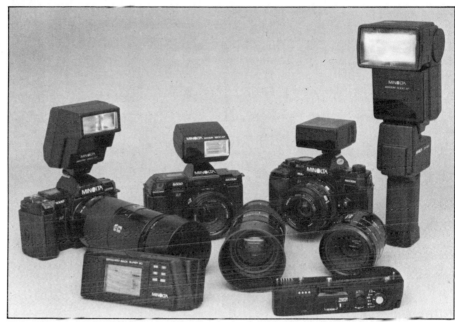

This book discusses MAXXUM cameras, lenses, flash units and accessories such as data backs and motor drive attachments.

built-in infrared illuminators that allow MAXXUM cameras to focus automatically in dim light or even in total darkness.

Several flash units can be connected to a MAXXUM camera for studio-type lighting with automatic exposure control by the camera.

Data and Program Backs—Interchangeable camera backs are available with a range of capabilities. They imprint data on the film, such as the date and time the picture was made. They can control the camera for unattended shooting at preset time intervals, with flash if desired. They can provide advanced methods of exposure metering and exposure control.

A Camera System—This book is about the MAXXUM *system*. A camera system includes camera, interchangeable lenses, data backs, flash units and a wide range of accessories. The system approach allows you to use your equipment for virtually any kind of photography.

ORGANIZATION OF THIS BOOK

Some chapters in this book are of a general nature, offering basic information applicable also to MAXXUM cameras and accessories. The chapter on exposure metering is an example.

Some chapters are specific—they discuss individual items of equipment, such as lenses and flash, with specifications of the items discussed. Chapter 10, for example, provides descriptions of MAXXUM cameras and major accessories, with specifications.

How an SLR Works

MAXXUM SLR cameras allow you to view the scene through the same lens that is used to take the picture. A *single lens* is used for both purposes. You see exactly what will appear on the film. When viewing the scene, you see an image that is reflected by a mirror. The word *reflex* is a variable of the word reflection. An SLR is a *Single-Lens Reflex* camera.

SLR cameras can use interchangeable lenses. Whatever type of lens is mounted on the camera, you view the scene through it and then photograph the scene through it.

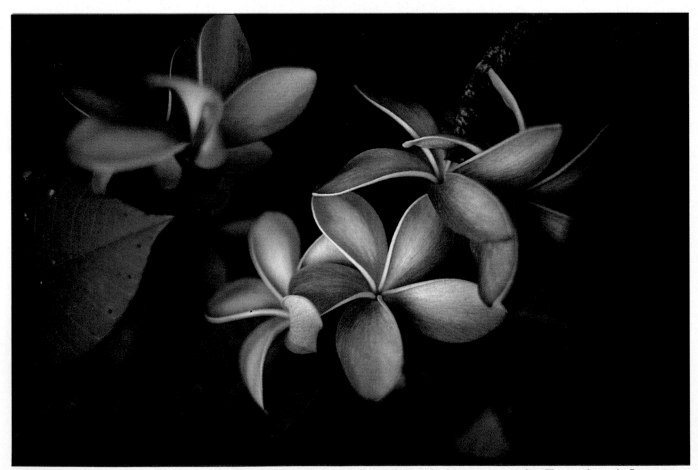

MAXXUM cameras and lenses give you both technical and esthetic control over the images you make. These plumeria flowers were photographed close-up to get the largest possible image and to eliminate distracting background.

VIEWING THE SCENE

As shown in the accompanying drawing, light from the scene enters the camera through the lens. The image from the lens is reflected upward by a movable mirror. The space in the camera body that contains the mirror is called the *mirror box.*

To view the scene, the mirror is in the "down" position. The reflected image passes upward through a *focusing screen,* is redirected by a *pentaprism,* and emerges at the viewfinder eyepiece. The purpose of the pentaprism is to provide a correctly oriented view, with the top of the scene at the top of the image and with left and right not reversed.

With your eye at the viewing eyepiece, you see an image of the scene. The image is formed at the focusing screen, which has a frosted or matte surface, like ground glass.

The image is used to compose the scene and to set or check focus. You may improve the focus by turning the focusing control on the lens—or a MAXXUM camera can focus the lens automatically, usually faster than you can do it manually.

ON-OFF CONTROLS

MAXXUM cameras have a Main Switch. With this switch off, the camera cannot be operated. Moving the switch to the ON setting prepares the camera for use but, to save battery power, does not turn on all of the electronic systems.

Moving the Main Switch past ON, to a sound-wave symbol, also turns on a built-in beeper that is used for warnings and other purposes.

Operating Button—The button that you press to make an exposure is commonly called a shutter button. Minolta refers to it as the Operating Button. This book will use the terms interchangeably. The button has three stages of operation.

The top of the button is sensitive to the touch of a finger, so the first stage is merely touching it. That turns on all of

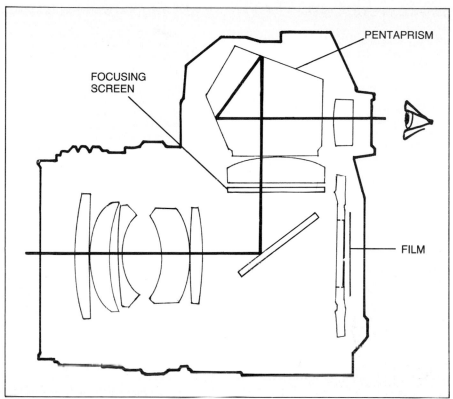

Light from the scene enters the lens and reflects upward from a movable mirror. An image of the scene is formed on the focusing screen. By looking into the viewfinder eyepiece, you can see the image to check composition and focus.

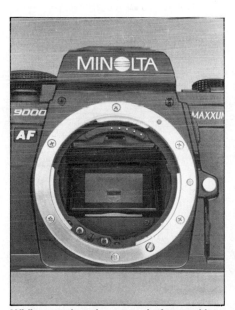

While you view the scene before making an exposure, the mirror is in the down position, as shown here. It intercepts the image from the lens and reflects it upward into the viewfinder.

When you press the Operating Button to make an exposure, the mirror moves up and out of the way. Light from the lens travels straight to the film, to expose it.

5

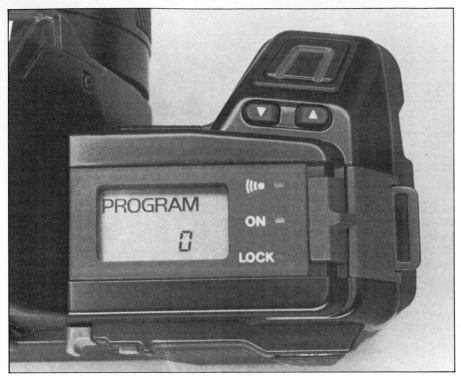

This is the Main Switch of a MAXXUM 5000. Moving the switch to ON turns on the camera. Moving it past ON to the sound-wave symbol also turns on a built-in beeper. The beeper provides audible signals, such as an indication that the image is in good focus. The 0 in the display means there is no film in the camera.

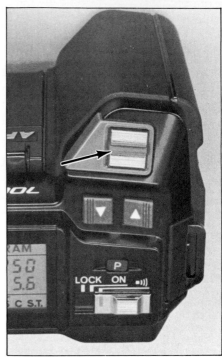

MAXXUM cameras use a special Operating Button design with two segments that respond to the touch of a finger. On the MAXXUM 7000, the two segments are rectangular, as shown.

the camera electronic systems. This method saves battery power because most of the camera electronics are turned on only when you need them. If you remove your finger from the Operating Button, the electronic systems automatically turn off in 10 seconds.

The second stage of operation is to depress the button slightly. What happens at the second stage depends on the camera model and is discussed later. The third stage is to depress the button fully. That causes the camera to make an exposure.

If you are wearing gloves or your finger is unusually dry, the Operating Button may not respond to the first stage of touching it. If so, depress it slightly. That combines stages 1 and 2.

FILM TRANSPORT

MAXXUM SLRs use 35mm film. When purchased, the film is on a spool inside a light-tight cartridge. One end of the film sticks out of the cartridge through a light-tight slot. The other end is attached to the spool inside the cartridge with adhesive tape.

The film cartridge is loaded into the camera as shown on pages 8 and 9. As

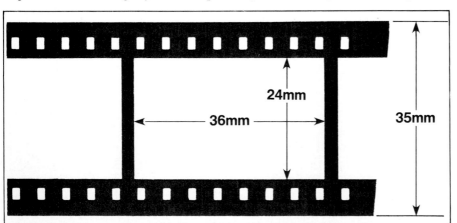

A 35mm SLR camera uses film that is 35mm wide. Sprocket holes along the edges are used to advance the film. The film frame—where the image is formed—is approximately 24mm tall and 36mm wide.

METRIC AND ENGLISH UNITS	
1 meter	= 39.37 inches
	= about 1.1 yard
1 centimeter	= 1/100 of a meter
	= about 3/8 inch
1 millimeter	= 1/1000 of a meter
	= about 1/25 inch

CM

1 2 3 4 5

INCHES

1 2

exposures are made, the film is wound onto the take-up spool. This is called *advancing* the film. Film advance is done by a roller in the camera which has sprockets that fit into sprocket holes along the edges of the film.

When all exposures have been made, most of the film has been wound onto the take-up spool. If you were to open the camera back at that time, light would strike the unprotected film on the take-up spool and the entire roll would be ruined.

Before opening the camera back, it is necessary to *rewind* the film back into the original cartridge. Then, open the camera back and remove the cartridge of exposed film, to have it developed.

TAKING THE PICTURE

While you are viewing the scene, the film is protected from light by a shutter directly in front of the film. When you press the Operating Button to take the picture, the mirror swings upward and out of the way. It moves up against the bottom of the focusing screen. This closes the light path through the viewfinder so you can no longer view the scene.

After the mirror has moved up, the shutter opens and the image from the lens falls on the sensitive front surface of the film—the photographic emulsion.

For correct exposure, there is a certain amount of time that the light must fall on the film. The exposure time depends on the brightness of the scene and other factors.

At the end of the exposure interval, the shutter closes and the mirror moves down again so you can view and compose the image for the next frame. The film is advanced so an unexposed frame is in place behind the lens. The number of frames that have been exposed is displayed by a *frame counter* on top of the camera.

FOCAL-PLANE SHUTTER

The shutter is called a *focal-plane* shutter because it is very close to the

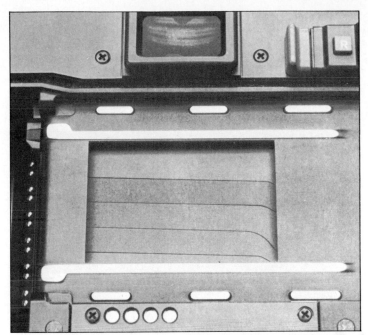

With the back cover open and no film in the camera, you can see the rectangular opening between film and lens that is normally closed by the focal-plane shutter. When the shutter opens, it exposes the film to light. This shutter uses metal leaves that "fan out" vertically to open and close.

film and the plane where the image is brought into sharp focus by the lens. A focal-plane shutter has two shutter curtains, shown in the drawings on page 10.

When you press the shutter button, the first curtain moves across the opening, from top to bottom, progressively opening the frame to light from the lens. To end the exposure, the second curtain moves across the opening to close the shutter—also from top to bottom. When film is advanced, the shutter mechanism is reset so it can expose the next frame.

VIEWFINDER

The viewing system includes the mirror that reflects the image upward into the viewfinder, the focusing screen, the pentaprism, and the viewfinder eyepiece. The eyepiece lens helps your eye focus on the image at the focusing screen.

VIEWFINDER IMAGE COVERAGE

Camera	Percent of Frame Area	Magnification*
5000	94%	0.85
7000	94%	0.85
9000	94%	0.81

*With 50mm lens focused at infinity

You see 94% of the total image area. That's equivalent to about 97% of the total image height or width. Magnification compares the apparent height of what you see in the viewfinder to what you see looking directly at the scene. It applies to subjects at medium to far distances.

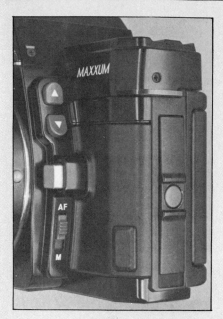

MAXXUM 5000 AND 7000
FILM LOADING AND REWINDING

TO LOAD FILM:

1. Turn the camera on. If the frame counter display on the camera top shows 0, you can open the camera. If it shows any other number, film is loaded. Don't open the camera.

2. If the frame counter shows 0, open the back cover. Press the button in the center of the Back-Cover Release (see photo at left) and slide the release downward. The back cover will spring open.

3. Place a film cartridge in the chamber as shown below. Tip the cartridge and insert it top first, so the metal fork in the camera enters the hole in the top of the film cartridge.

4. Draw the film leader across the back of the camera. The film must lie flat and the tip of the leader should extend slightly past the rectangular red dot shown by an arrow in the photo below.

5. Use your finger to place a sprocket hole in the film over a sprocket tooth in the camera.

6. Hold the film in that position as long as you can while closing the back cover.

7. The camera will automatically advance film to the first frame and a 1 will appear in the frame counter. If film does not advance, check to see if the camera is turned on and has good batteries installed. If the motor operates, but the number 1 does not appear in the frame counter, the film was not loaded correctly. Open the back and start again.

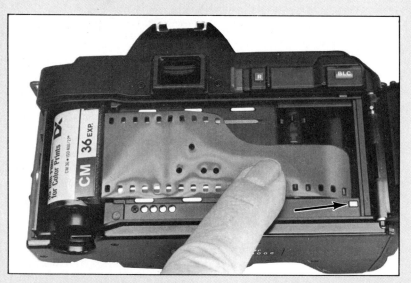

TO REWIND FILM:

1. After the last frame has been exposed, the frame number blinks and you can no longer make exposures by pressing the Operating Button. Other indications for each camera model are discussed in Chapter 10.

2. While pressing the Rewind-Release button labeled R, move the adjacent Rewind Switch to the left as shown in the accompanying photo. It will lock in that position.

3. The camera will automatically rewind the film into the film cartridge.

4. The display on top of the camera will show when the film is completely rewound. The indication varies among camera models and is shown for each model in Chapter 10.

5. Check the display to be sure the film is fully rewound. If so, open the camera back and remove the cartridge. If not, the camera batteries may have failed during rewind. Don't open the camera. Turn the camera off. Install fresh batteries. Turn the camera on again. Rewind should resume and run to completion.

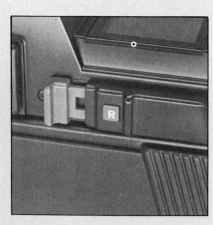

MAXXUM 9000 FILM LOADING AND REWINDING

TO LOAD FILM:

The manual loading and rewinding procedure, without Motor Drive MD-90, is discussed here. The procedure is different with the MD-90 attached, as discussed in Chapter 10.

1. Turn the camera on. If the frame counter on top of the camera shows S, it is safe to open the camera. If it shows a number, film is loaded. Rewind the film before opening the camera, as shown below.

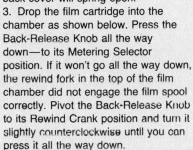

If there is no film in the camera, or if it has been rewound, you can open the back cover. The Back-Release Knob serves three purposes. When pulled straight up, it opens the back cover. When pulled up and pivoted, as shown in the photo at right, it serves as a Rewind Crank. When pressed down against the top of the camera, it serves as a Metering Selector switch.

2. To open the camera back, pull the Back-Release Knob upward until it meets resistance. Continuing to pull upward, use one finger to move the Lock Release button (arrow) to the right. The Back-Release Knob will move farther upward and the camera back cover will spring open.

3. Drop the film cartridge into the chamber as shown below. Press the Back-Release Knob all the way down—to its Metering Selector position. If it won't go all the way down, the rewind fork in the top of the film chamber did not engage the film spool correctly. Pivot the Back-Release Knob to its Rewind Crank position and turn it slightly counterclockwise until you can press it all the way down.

4. Pull the film leader across and insert the tip into the take-up spool as shown at right. Be sure that a tooth on the take-up spool fits into a sprocket hole in the leader. The film will wind onto the spool with the emulsion out, as shown here.

5. Use your right thumb to advance film by rotating the Film-Advance Lever. Press the Operating Button if necessary, so film can be advanced. Advance film until sprocket teeth are engaged at both top and bottom.

6. With the film taut and flat across the back of the camera, close the back cover.

7. A small knob with a white dot is in the center of the Back-Release Knob. The small knob turns when film is being pulled out of the cartridge. Use the Film-Advance Lever to advance film to frame 1. Press the Operating Button when necessary, so film can be advanced. Watch the small knob, to check that film is actually advancing. If the small knob does not rotate, film is not being advanced even though the frame counter will advance to the number 1. If this happens, open the back cover and start again.

TO REWIND FILM:

When the last frame has been exposed, the Film-Advance Lever will become difficult to rotate. Don't force it. The frame counter should show the number of frames contained in the cartridge, such as 36 or 24.

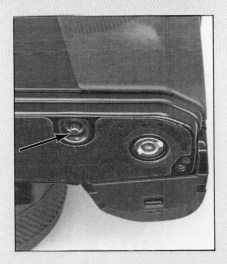

1. Press in the Rewind-Release Button on the bottom of the camera, shown by the arrow in the photo. It will lock.

2. Lift the Back-Release Knob partway, until it meets resistance. Pivot it to its Rewind Knob position. Turn it clockwise to rewind the film. When the Rewind Knob turns freely, the film end has been pulled free from the take-up spool and the film has been rewound.

3. Open the back cover and remove the film cartridge. Opening the back cover resets the frame counter to the S (Start) position.

HOW A FOCAL-PLANE SHUTTER WORKS

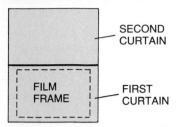

Ready to make an exposure, the first shutter curtain covers the film-frame opening.

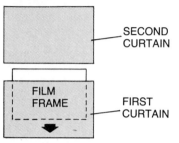

When you press the Operating Button, the mirror moves up. Then, the first curtain travels down across the frame, progressively opening the film area to light.

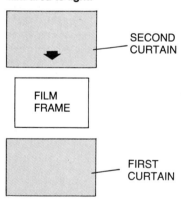

Travel of the first curtain is completed. The film frame is fully open to light.

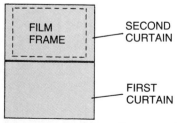

To end the exposure, the second curtain moves downward across the frame, closing it to light.

AT FAST SHUTTER SPEEDS

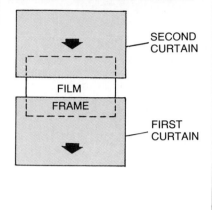

For short exposure times, such as 1/500 second, the second curtain must start closing the frame before the first curtain has fully opened it. The film is exposed by a moving slit of light between the two curtains.

Viewfinder Image Area—In most SLR cameras, the image in the viewfinder is cropped a little tighter than the image that appears on film.

Slides are placed in cardboard or plastic mounts that cover a small part of the image at each edge of the frame. The image area you see in the viewfinder is approximately equal to what you'll see when you project a slide. It will be a little less than you see on a print made from the full frame.

Information Displays—In the viewfinder, information displays are in the area outside the image frame. The information includes camera control settings and a display to show if the image is in good focus. Information displays are turned on when you touch the Operating Button.

Focusing Aids—MAXXUM focusing screens have a small rectangle at the center of the image to show you which part of the scene the autofocus system is focusing on. You can judge or set focus visually by looking at the image on the screen.

EXPOSURE CONTROLS

When you have composed and focused the image, the next step is to set exposure so the image will be correctly exposed on the film. This is usually done automatically by the camera. MAXXUM cameras also allow manual control of exposure.

Exposure is determined by three things: the sensitivity of the film, the brightness of the light reaching the film, and the length of time the light is allowed to fall on the film.

FILM SENSITIVITY

Some types of film require more exposure than others. It depends on the film's sensitivity to light, or the *film speed*. Film speed is expressed by a number called the ISO film-speed rating. ISO stands for International Standards Organization.

Fast films, with a *high* ISO speed number such as 400 or 1000, form an image with relatively little exposure. *Slow* films, having an ISO speed number such as 25 or 32, require more exposure.

The film-speed number is a *message* from the film manufacturer to the exposure-control system in your camera. It tells the camera how much exposure that type of film requires.

For the camera to receive that message, the film-speed number must be set on a camera control. This can be done manually or, with certain film cartridges, it can be done automatically by the camera.

Setting Film Speed Manually— When loading film, be sure the correct film-speed number is set. The manual procedure is shown on page 12.

Automatic Film-Speed Setting— Film that is DX-coded has a "checkerboard" code pattern that conveys the film-speed to the camera. MAXXUM cameras automatically read the code

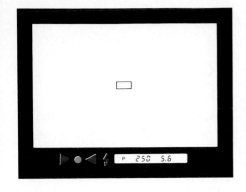

The viewfinder has two information displays below the image area. Focus information is shown at lower left. The green dot glows when the image is in focus. If out of focus, one of the red arrows will glow. Exposure information is shown at lower right. The rectangle at the center of the image area shows which part of the scene is being focused by the camera autofocus system.

and set the film-speed. The setting is displayed so you can see what it is.

If you prefer to use a different film-speed number, you can change the automatic setting by using the manual procedure.

LENS APERTURE

Lenses have an adjustable opening called *aperture* to control the amount of light that passes through to the film.

Aperture Size—The size of the lens opening is represented by a number, such as 2 or 8, called the *f-number*. *Smaller f-numbers* represent *larger* aperture openings.

The Aperture Scale—In the table of standard f-numbers on page 12, each larger number on the scale is approximately 1.4 times the preceding value. On this scale, the largest aperture is f-1. The smallest shown is f-22. The next smaller aperture size would be f-32.

The aperture scale is arranged so that each standard aperture setting transmits twice as much light as the next smaller. A setting of f-4 transmits twice as much light as f-5.6 but half as much a f-2.8.

The f-number settings of a lens are usually called *f-stops*. The interval between standard f-numbers is one *stop*, or one *exposure step*. Changing aperture from f-4 to f-5.6 is one step; changing from f-4 to f-11 is three steps.

The term *largest aperture* means the setting that transmits the most light, such as f-1.4. The *smallest aperture*, such as f-22, transmits the least light.

Setting Aperture—Aperture size is an exposure control. Aperture size may be set manually by a control on MAX-XUM cameras or it may be set automatically by the camera. The setting is shown by an *f-number* in the viewfinder display.

Intermediate Settings—Aperture size can be changed in half steps, as shown in a table on page 12.

SHUTTER SPEED

Shutter speed is an exposure control. The shutter-speed setting determines how long the focal-plane shutter remains open for light from the scene to strike the film. Shutter speed may be set manually by a control on MAX-XUM cameras or automatically by the camera.

Shutter-Speed Scale—The numbers on the standard shutter-speed scale are time intervals, measured in seconds. Each longer standard time interval is double the next shorter time.

Display—The shutter-speed setting is shown in the viewfinder display. The numerators of fractions are omitted. The value 1/500 is shown as 500. Speeds of 1 second or longer are indicated by a "seconds" symbol.

Setting Shutter Speed—When setting shutter speed manually, using the control on the camera, only standard speeds—such as 1/250 and 1/500 second—may be set.

When the camera is setting shutter speed automatically, any value may be used, such as 1/323 second. Because the camera doesn't use standard steps or half steps, this is called *stepless*

shutter operation. Even though operation is stepless, the nearest half-step will be displayed in the viewfinder.

The Bulb Setting—Shutter-speed controls also have a setting labeled bulb. At that setting, the shutter remains open as long as the Operating Button is depressed. This is used to make time exposures longer than the slowest available shutter-speed.

EXPOSURE STEPS

The standard steps of exposure are multiples of two. Each larger step is double the exposure of the preceding step. There are two reasons for that.

Doubling exposure makes a perceptible difference in the appearance of a photograph but not a large difference. If exposure is doubled repeatedly, to make a series of exposure steps, the eye perceives the steps to be approximately equal in visual effect.

The formula for exposure is:

$$\text{Exposure} = \text{Intensity} \times \text{Time}$$

Intensity is the brightness of the light striking the film. *Time* is how long the shutter is open.

Because *Exposure* is the product of *Intensity* and *Time*, doubling either will double the exposure—or increase exposure by one step. Dividing either factor by two will cut the exposure in half—one step less.

That's the reason for the values on the aperture and shutter-speed scales: Changing aperture to the next larger or smaller standard value on the scale doubles or halves the amount of light

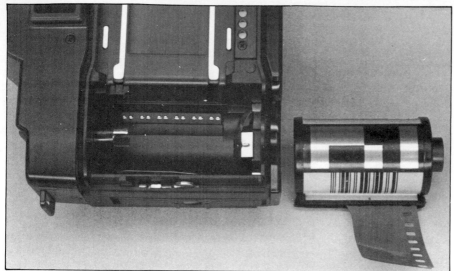

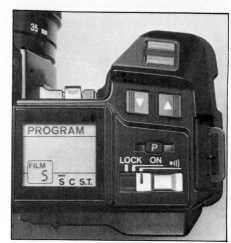

DX-coded film cartridges have a black-and-silver checkerboard pattern that encodes film speed. The silver area is electrically conductive. The MAXXUM film chamber has a row of electrical contacts that touch the checkerboard area of the cartridge, read the encoded film speed, and automatically set that value in the camera.

The frame counter on the MAXXUM 7000 is on the LCD Display Panel on the camera. It's the box labeled FILM. Here, the next exposure will be frame 5. The counter on the MAXXUM 5000 is similar. The MAXXUM 9000 uses a mechanical counter, viewed through a window.

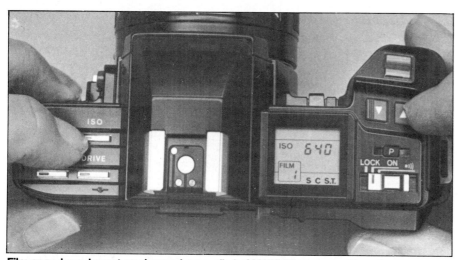

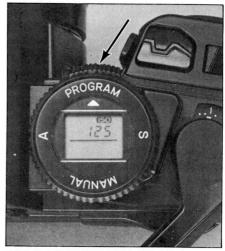

Film speed can be set or changed manually in MAXXUM cameras. Turn the camera on, to show the film-speed setting. To change the film-speed setting of a MAXXUM 7000, press the ISO button while also pressing one of the arrow keys near the Operating Button. The down arrow selects lower speeds, the up arrow higher speeds. The procedure with other MAXXUM cameras is similar.

With the MAXXUM 9000, film speed is set by pressing the ISO button (not shown) while moving a lever (arrow) to the left or right. This camera is set to ISO 125.

```
 1    1.4    2    2.8    4    5.6    8    11    16    22 etc.
```

It's easy to remember the series of standard f-numbers. Start with the numbers 1 and 1.4. Double them alternately as shown by the arrows.

Standard f-numbers	1.4	2		2.8	4		5.6	8		11		16	22
Half steps			1.7	2.4		3.5	4.5		6.7	9.5	13		19

Standard aperture sizes, in full steps, are shown at the top. Intermediate half steps are below. Depending on the operating mode, MAXXUM cameras display aperture-size values in full steps or in full and half steps.

and thereby changes exposure by one step. Changing shutter speed to the next larger or smaller standard value also changes exposure by one step. Changing either factor by one-half step changes exposure by one-half step.

These two controls can be used to counterbalance each other. Changing aperture to the next *larger* size and shutter speed to the next *faster* setting will maintain the same amount of exposure, but with different values of shutter speed and aperture.

Steps and Stops—Most photographic literature uses the word *stop* instead of *step* to describe the standard incremental changes in aperture size, shutter speed and exposure. This book uses *step*.

The aperture of this lens is wide open. The symbol 1:1.7 engraved on the front of the lens means that its maximum aperture is *f*-1.7.

This is the same lens at minimum aperture. The symbol (22) means that the minimum aperture is *f*-22. This lens has a range of aperture settings from *f*-1.7 to *f*-22.

OTHER EFFECTS OF EXPOSURE CONTROLS

In addition to setting exposure, exposure controls have other effects on a photo.

Depth of Field—Everything need not necessarily be in sharp focus in a photograph. The background behind the subject may be blurred, or the foreground may be blurred, or both. The zone of good focus is called *depth of field*. Depth of field is controlled by aperture size and other factors. A small aperture provides relatively greater depth of field.

With an SLR, you can control depth of field by using an aperture that gives the desired visual effect and then setting shutter speed to give correct exposure. More information on depth of field is in Chapter 3.

Subjects in Motion—You may want to stop a subject's motion on film—and *freeze* the action. Or, you may wish to allow the image to blur, to give the impression of movement.

Using a slow shutter speed, such as 1/8 second, allows a moving subject to travel a greater distance while the shutter is open and thereby make a blurred image on film.

Using a fast shutter speed reduces the amount of subject movement that occurs while the shutter is open and the image is less blurred. With a shutter speed of 1/1000 second, you can freeze movement that is fairly fast.

VIEWING WITH OPEN APERTURE

Most exposures are not made with the lens aperture wide open. The smaller aperture size used to make the exposure is the *shooting* aperture.

While you are viewing the scene, a MAXXUM camera holds the aperture wide open so you see the brightest image. When you press the Operating Button to make the shot, the lens is closed down to the shooting aperture size. Changing the lens aperture from its maximum size to a smaller size is called *stopping down* the lens.

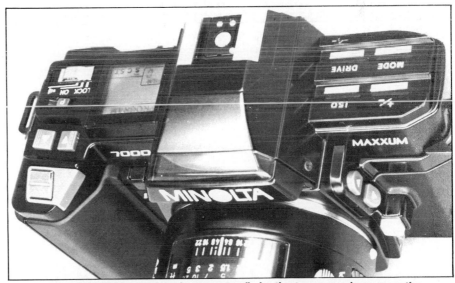

On this MAXXUM 7000, aperture is set manually by the two arrow keys near the lens—just below the word MAXXUM. Shutter speed is set manually by the two arrow keys near the Operating Button. Other MAXXUM cameras are similar although the MAXXUM 9000 uses a sliding switch rather than arrow keys.

Depth of field is the zone of good focus, measured from its near limit to its far limit. It is increased by using a smaller aperture.

THE EXPOSURE SEQUENCE

Doing the things described in this chapter involves a series of complicated events. When you press the Operating Button to make an exposure, this is what happens:
• The mirror moves up so light from the lens can reach the film.
• The lens closes to the shooting aperture size.

• The first curtain of the focal-plane shutter opens the frame.
• An electronic timer in the camera holds the shutter open for the desired exposure time.
• The second curtain of the focal-plane shutter closes the frame.
• The lens opens up to maximum aperture again, to give the brightest image.
• The mirror moves down so you can view through the lens again.

At fast shutter speeds, all of this hap-

pens in a fraction of a second.

Before making the next exposure, the film is advanced to place an unexposed frame in position behind the lens. This may be done manually or by an electric motor, depending on the camera model and accessories. Advancing the film resets the focal-plane shutter so it can operate again.

MAXXUM Lenses

A major advantage of SLR cameras is lens interchangeability. You can select from a variety of lenses with different characteristics and capabilities.

LENS MOUNT

A lens attaches to a camera body as shown in the accompanying photos. The lens is held in place by three lugs on the lens that fit behind three lugs on the camera body. This is a *bayonet mount*. The MAXXUM lens mount is called the Minolta A (Autofocus) mount. It's a little larger in diameter than the mount on earlier Minolta cameras.

In this book, the part of the mount that's on the camera is called the *lens mount* and the part that's on the lens is called simply the *back of the lens*.

Couplings—In addition to holding the lens securely, the mount also provides mechanical and electrical *couplings* between camera and lens.

Aperture Control—The aperture size of MAXXUM lenses is controlled by the camera's electronic system through a mechanical coupling using two levers.

As the lens is rotated during the mounting procedure, the aperture is opened to its maximum size so you can view at maximum aperture.

When you press the Operating Button to make an exposure, aperture size is set by the camera to provide correct exposure. After the exposure, the camera opens the aperture to its maximum size again.

Automatic Focus—MAXXUM AF lenses use the letters AF (Auto Focus) in their nomenclature because they can be focused automatically. This is done by a small motor in the camera body.

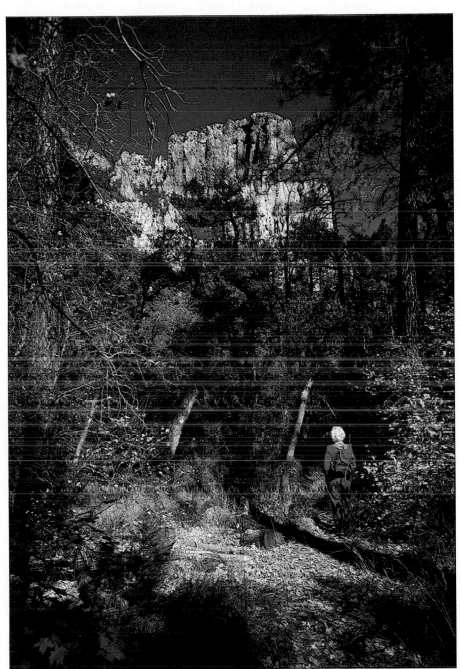

MAXXUM cameras accept interchangeable MAXXUM AF lenses. This shot was made with a wide-angle lens to capture a wide view. Even with a wide-angle lens, it was necessary to turn the camera so the long axis of the frame was vertical, to include the tall rock cliffs in the background.

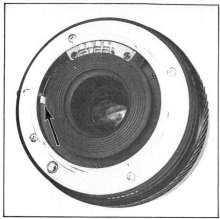

In addition to the mechanical mount, there are three couplings between MAXXUM lenses and cameras. The lens informs the camera of its aperture range. The camera controls lens aperture by moving an Aperture Lever (arrow) on the lens. The camera also focuses the lens by rotating a shaft in the lens.

On the camera, the coupling is a small blade that extends through a hole in the surface of the lens mount. The blade is rotated by the focus motor in the camera.

The blade fits into a slot at the end of a shaft on the back of the lens, which focuses the lens.

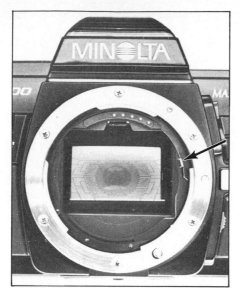

The bayonet-type lens mount on the camera has three lugs that grip three matching lugs on the lens. Five metal contact pins in the lens mount touch the contacts on the lens. Inside the lens mount is an Aperture-Control Lever (arrow) that works with the Aperture Lever on the lens.

Manual Focus—All MAXXUM cameras and lenses offer the option of manual focus. Each lens has a narrow

Manual Focusing Ring. On most MAXXUM lenses, the focusing ring is near the front.

The camera has a Focus-Mode Switch with two settings: AF for auto-focus and M for manual focus. The M setting withdraws the blade in the lens mount so it cannot engage the slotted shaft at the back of the lens.

Warnings—The Manual Focusing Ring on the lens turns when the lens is being focused by the camera. Don't touch the ring or impede its rotation.

Before focusing manually, be sure to move the camera Focus-Mode Switch to M. Otherwise, the Manual Focusing Ring is mechanically coupled to the focus motor in the camera. The focusing ring will be difficult to turn. If you force it, damage to camera and lens may result.

Electrical Contacts—Each MAXXUM lens has a row of electrical contacts on the back that are used to send information about the lens to the control systems in the camera body. When the lens is mounted, the electrical contacts on the back of the lens touch a row

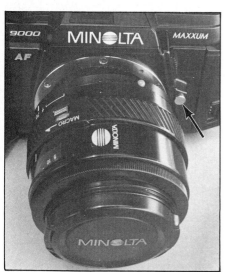

To mount a lens, align the raised red dot on the lens with the red dot on the lens mount (just below the letter A in the word MINOLTA). Rotate the lens clockwise until it clicks into place. To remove the lens, depress the chromed Lens-Release Button (arrow) while turning the lens counterclockwise.

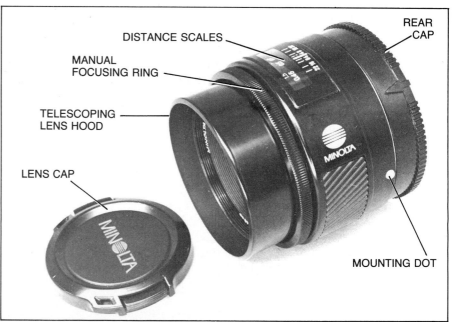

DISTANCE SCALES

REAR CAP

MANUAL FOCUSING RING

TELESCOPING LENS HOOD

LENS CAP

MOUNTING DOT

When not on a camera, protect the lens by attaching front and rear caps. When mounted on a camera but not being used, attach the front lens cap. To do that, slide the telescoping hood on this lens back into the body of the lens. Squeeze the "ears" on the cap and place it on the front of the lens. Some lenses have detachable hoods instead of the type shown here.

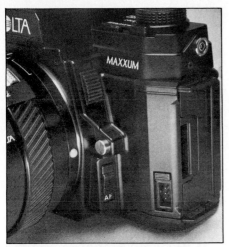

MAXXUM cameras have a Focus-Mode Switch at lower left on the lens mount, just below the Lens-Release Button. This MAXXUM 9000 is set to AF, so it will focus the lens automatically.

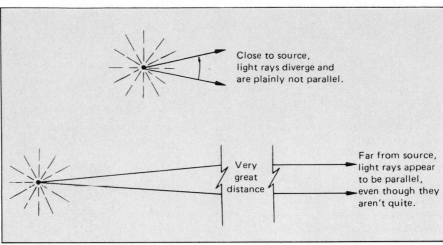

Figure 2-1/Light rays from a point diverge. If viewed from a location that is close to the source, they are plainly not parallel. At a great distance from the source, light rays still diverge, but the divergence is so small that they appear to be parallel.

of contacts inside the lens mount on the camera, near the top.

Each MAXXUM lens contains a computer chip—a ROM (Read-Only Memory) chip that stores data about the lens. The data is used by the camera to provide autofocus and automatic exposure.

The electronic control systems in MAXXUM cameras use small computers. A computer in the camera reads the information stored in the ROM inside the lens and other information, such as the focused distance of the lens. This information is updated 33 times per second, or more frequently, as needed.

HOW A LENS FORMS AN IMAGE

Light normally travels in straight lines called rays. The rays do not change direction unless they are acted on by something with optical properties, such as a lens or mirror.

Light rays that originate at a distant location, such as the sun, appear to be parallel, as shown in Figure 2-1.

CONVERGING LENS

Camera lenses are *converging* lenses. They cause light rays from a subject to converge to form an image on film in the camera.

Light rays from a single point on a distant scene are *effectively* parallel when they enter the lens. All light rays from a single point are brought to focus at a single point on the film, as shown in Figure 2-2. In this drawing, all light rays entering the lens are from the same point of the scene. Light rays from a different point on the scene will be brought to focus at a different location on the film. Thus, all points of the scene are imaged at the correct locations on the film.

Focal length is the distance behind the lens at which parallel light rays are brought to focus.

Infinity—The greatest imaginable distance is called *infinity* (∞). As I've already indicated, light rays traveling from infinity are parallel.

Rays arriving from shorter distances, such as 300 feet, are still *effectively* parallel. Photographically, any distant scenic subject can be regarded as being at infinity.

Nearby Subjects—As shown in Figure 2-3, light rays from a point that is not distant will not be parallel when they enter the lens. They will diverge.

The lens can still bring them to

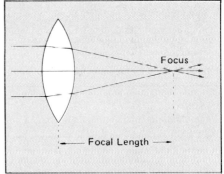

Figure 2-2/Light rays from a distant point appear to be parallel and are treated by the lens as though they are parallel. A converging lens focuses such rays at a distance behind the lens that is equal to its focal length.

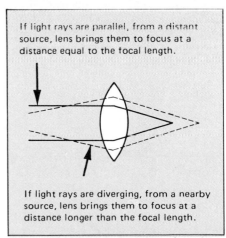

Figure 2-3/Light rays entering a lens from a nearby point diverge noticeably. More distance is needed behind the lens to bring diverging rays to focus.

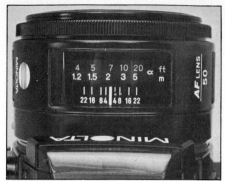

This is the MAXXUM AF 50mm *f*-1.7 lens. The two upper scales show focused distance in feet and meters, read against the distance index mark. This lens is focused at 7 feet. The lower scale shows depth of field, discussed later.

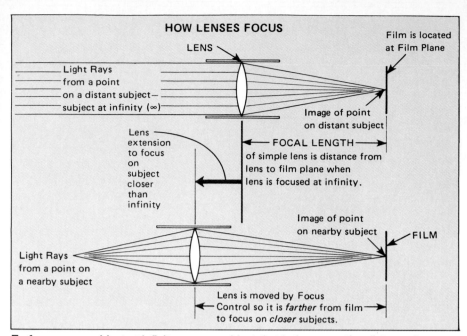

To focus on a subject at infinity, or any subject that is far away, the distance from lens to film is equal to the focal length of the lens. To focus on a nearer subject, the lens must be moved farther from the film.

focus. Because they were diverging rather than parallel when they came into the lens, it takes a greater distance behind the lens to bring them to focus.

To focus the image of a nearby subject on film, the lens must be moved *farther* from the film than the focal length of the lens.

Instead of the single element shown in these drawings, photographic lenses have more than one glass element. However, the lenses work in basically the same way.

Remember the rule: To focus a lens at infinity, it is placed at a distance from the film that is equal to its focal length. To focus on a nearer subject, the lens must be moved farther from the film.

FOCUSING

Some lenses have a telescoping barrel that becomes longer or shorter as the lens is focused.

Internal Focusing—Some lenses are designed so the lens body does not change length as it is focused. The lens elements inside the lens move.

Rear Focusing—Rear focusing is similar to internal focusing, except that the rear elements move. If you look at the back of a rear-focusing lens while turning the focusing ring, you can see it happen.

Floating Elements—To improve image quality with close subjects, focusing some lenses at short distances causes some of the lens elements to move while others remain static. Those that move are called *floating* elements.

FOCUSED-DISTANCE SCALE
MAXXUM lenses have a scale that shows the focused distance of the lens

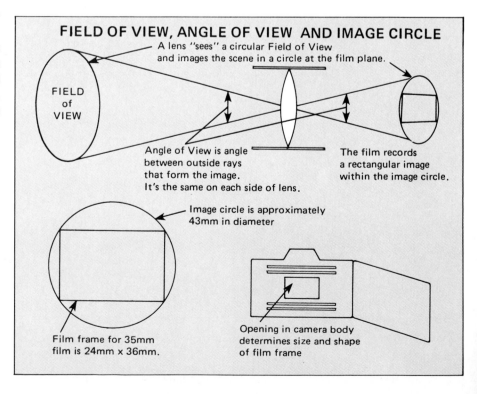

in feet and meters. The distance scale rotates as the lens is focused.

The body of the lens, including the part with the distance scale, is enclosed in a housing that does not rotate so you can grasp that part of the lens if you wish. The focused-distance scale is viewed through a window in the housing.

FIELD AND ANGLE OF VIEW

The circular part of a scene that is "seen" by a lens is called the *field of view*. The lens projects a circular image to the back of the camera. A rectangular portion of that circular image is actually recorded on the film.

If a lens has a wide field of view, then it also has a wide *angle of view*—the angle between the outside rays that form the image. The angle of view is the same on both sides of the lens—for rays coming in at the front and going out at the back.

EFFECT OF FOCAL LENGTH

In the lower drawing on the preceding page, the angle of view is shown by an arrow drawn between the outside rays that form the image circle. When you use a lens with a different focal length, the diameter of the image circle in the camera doesn't change appreciably. It must always be slightly larger than the rectangular shutter opening that defines the film frame.

When focused at infinity, a long-focal-length lens requires greater distance between lens and film than a short-focal-length lens.

If the lens-to-film distance becomes greater because a longer focal length is used, the angle between the outside rays that form the image circle *must* become smaller. For that reason, long-focal-length lenses have narrow angles of view.

A short-focal-length lens is closer to the film, so the rays *must* diverge faster to fill the image circle. Short focal lengths give wide angles of view. The angles of view of MAXXUM lenses

DIFFERENT FOCAL LENGTHS AT SAME CAMERA LOCATION

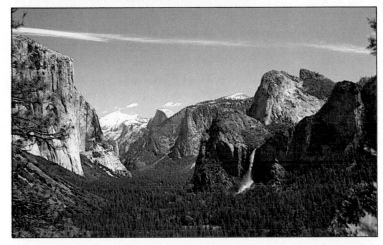

50mm

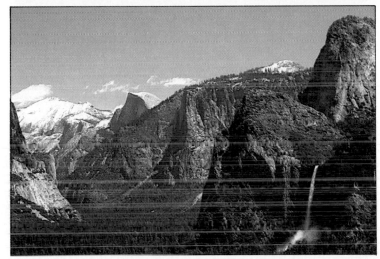

100mm

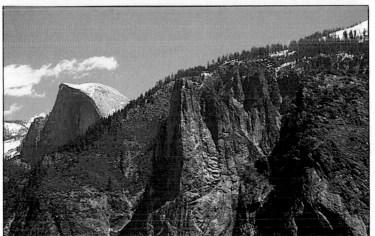

200mm

These are views of Yosemite Valley from a fixed camera location. The only thing that changed was focal length of the lens—from a 50mm standard lens to a 200mm telephoto.

19

WHEN CAMERA LOCATION CHANGES, PERSPECTIVE CHANGES

24mm **50mm** **200mm**

This series of photos was made with lenses of different focal lengths. The model remained in the same place but the camera position was changed so the model appears to be about the same height in each photo. As focal length and camera distance increase, the apparent distance between model and background decreases—the background seems to move closer. This is typical of long-focal-length lenses—they make distant objects appear closer than they actually are.

are included in the lens table near the end of this chapter.

APERTURE

Physically, a lens aperture is an approximately circular opening formed by metal blades. The blades pivot to change the diameter of the opening. Optically, aperture is specified by an *f*-number:

$$f\text{-number} = \frac{\text{Focal Length}}{\text{Aperture Diameter}}$$

If focal length becomes larger, but the *f*-number doesn't change, then the aperture diameter must also become larger. That's why long-focal-length lenses usually have larger diameters than standard lenses.

The *f*-number is also called the *relative aperture*. It's an indication of the amount of light that will reach the film. If one lens set at *f*-4 gives correct exposure, then another lens set at *f*-4 will also give correct exposure, even if the second lens has a different focal length.

In print, *f*-numbers are written in a variety of ways, such as f/4, F4, and *f*-4. This book uses *f*-4.

Maximum Aperture—When aperture is stated as lens identification, it's the maximum aperture, or largest aperture.

LENS ABERRATIONS

Aberration	Effect	User Correction
Spherical Aberration	Image not sharp with any film or subject.	Use smaller than maximum aperture.
Chromatic Aberration	Image not sharp with any film. Color fringes visible with color film.	Same as above.
Astigmatism	All parts of image cannot be brought to focus at same time.	Same as above.
Coma	Off-axis points have tails like comets when viewed under high magnification. To unaided eye, edges of photo are fuzzy.	Same as above.
Curvature of Field	Image of flat object can be focused at center or edges, but not both at same time.	Same as above.
Distortion	Straight lines appear curved.	None.

LENS ABERRATIONS

Optical defects in a lens are called *aberrations*. Aberrations exist to some extent in every lens, but are minimal in lenses from reputable manufacturers. In the design and manufacture of

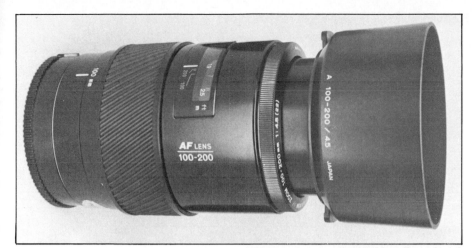

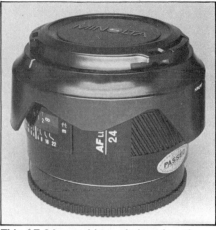

lenses, special techniques are used to keep aberrations to a minimum.

A couple of aberrations are mentioned here. The accompanying table lists more and tells what you can do about them.

Spherical Aberration—The effect is to produce an unsharp image, especially at larger apertures. Conventional lens surfaces are segments of a sphere. That kind of design leads to spherical aberration. It can be avoided by the lens manufacturer's use of *aspheric* lens elements—elements that are not spherical.

Chromatic Aberration—This defect causes color fringes around bright lights or at points where different colors meet. It's caused by a lens' inability to bring different colors to a focus at the same plane.

A lens designed to minimize this aberration is called *apochromatic*, abbreviated *apo*. A special optical glass used to reduce chromatic aberration is called *Anomalous-Dispersion* or *AD* glass.

Effect of Aperture—The effect of many aberrations is reduced by shooting at a small lens aperture.

OTHER FACTORS AFFECTING IMAGE QUALITY

The factors discussed below are not lens aberrations but, nonetheless, they do affect image quality.

This lens uses a detachable, clip-on hood that attaches to an external groove around the front of the lens. To attach or remove, squeeze the "ears" at the back of the hood. To store the lens, reverse the hood, then attach the lens cap.

This AF 24mm wide-angle lens has the hood reversed for storage. The hood is cut away at the corners of the frame so it doesn't vignette the image. When mounted, the hood cannot rotate. Therefore the cut-outs for the corners remain in the right place.

HOW TO CLEAN A LENS

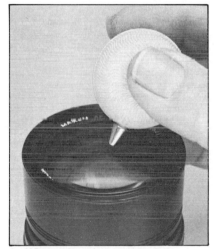

2. If dust particles still cling to the lens surface, use a soft lens brush to gently *lift* them off. Don't scour them into the lens. Don't use the same brush for cleaning camera bodies.

1. When a lens has visible dust particles on the surface, blow them off using a squeeze bulb, photographers' "canned air" or, as a last resort, a puff of air from your mouth.

3. If smears or particles on the lens surface won't blow or brush off, apply a drop of lens-cleaning fluid to a lens-cleaning tissue. Wipe the lens surface with the tissue, starting at the center and spiraling outward. If cleaning fluid residue remains, use dry tissue to gently remove it.

A 50mm lens is probably the shortest focal length that you should use for portraits. With a shorter lens, you would have to get too close to a subject, causing unflattering image distortion.

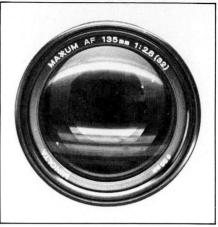

Lens identification is engraved on the front of each lens. This is a MAXXUM AF (Auto Focus) lens with a focal length of 135mm. Maximum aperture is *f*-2.8, indicated by 1:2.8. Minimum aperture, shown in parentheses, is *f*-32. The diameter of the filter-mounting threads on the front of the lens is 55mm. The lens is manufactured by MINOLTA.

DIFFRACTION

When light rays pass very close to the edge of an opaque object, their direction is changed. This is called *diffraction*. Light rays that are diffracted by the edges of the lens aperture don't land on the film at the right places. This can contribute to an overall lack of sharpness in the image, especially at small apertures, when a larger proportion of the light is diffracted.

The effect of diffraction can be reduced by avoiding the smallest lens apertures when they are not necessary. Using a large aperture reduces the effect of diffraction because more light rays can pass through the center of the opening.

OPTIMUM APERTURE

Many aberrations are reduced by using a small lens aperture. However, diffraction increases as aperture is reduced. In most normal shooting conditions, lenses make the sharpest image when set about midway between the largest and smallest aperture.

FLARE AND GHOST IMAGES

These are caused by stray light entering the lens—usually from the side—and reflecting off internal glass and metal surfaces. Flare is an overall haze or a diffused spot of light. Sometimes one or more *ghost* images of the aperture are formed, especially if you shoot into the sun.

The best prevention is to use a lens hood or otherwise shade the lens so off-axis light sources don't enter the lens.

LENS HOODS

Most MAXXUM lenses are supplied with a hood. One type telescopes into the lens body for storage. The other type fits on lugs on the front of the lens. They can be installed backwards on the lens for storage.

A hood should closely match the lens angle of view, so it blocks light from just beyond the angle of view. Zoom lenses with a very wide range of focal lengths are not supplied with a hood because it would vignette the image at the shorter focal lengths. The MAXXUM 28—135mm zoom lens is an example.

LENS COATINGS

Flare and ghost images can be greatly reduced by a procedure called *lens coating,* applied during the manufacture of the lens.

A very thin, transparent coating on the front surface of a lens reduces reflection from that surface and admits more light into the lens. Coating the interior glass surfaces reduces internal reflections and thereby reduces flare and ghost images.

A single-layer coating reduces reflections at one color of light. Multiple layers of different thicknesses reduce reflections across the spectrum, which is better. Minolta refers to multiple-layer coating as *achromatic.*

Virtually all modern lenses are coated. Your assurance of good quality is the integrity of the lens maker and, to some degree, the price of the lens.

FLATNESS OF FIELD

When photographing a flat surface, such as a newspaper or a postage stamp, it's particularly important that all parts of the subject are in focus on the film. If they are not, the lens being used has poor flatness of field. You can improve it by using a smaller aperture.

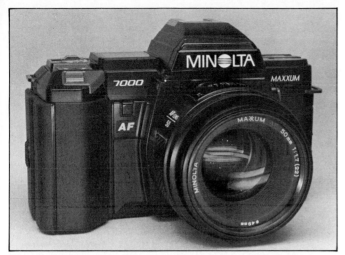

The standard lens for 35mm cameras has a focal length of about 50mm. Its angle of view suits a lot of photographic situations. We tend to accept photos made with a 50mm lens as having "natural-looking" perspective.

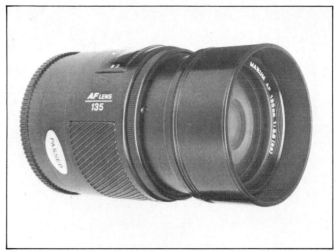

A medium telephoto, such as this AF 135mm, is sometimes necessary when you can't get close enough to the subject to get a large enough image.

LENS SPECIFICATIONS

The two main specifications of a lens are the focal length, in millimeters, and its maximum aperture size, stated as an f-number Manufacturers' lens tables include additional information, such as minimum aperture and angle of view. Specifications of MAXXUM AF lenses scheduled for introduction in 1986 are at the end of this chapter.

CATEGORIES AND USES OF LENSES

Not all of the lens types discussed here are at present available in the MAXXUM AF series. This is a new series that is still being developed. Lens types that are not available now may be offered later.

WIDE-ANGLE LENSES

These have focal lengths of 35mm and shorter. A 35mm lens has an angle of view of 63°. Angle of view increases as focal length decreases.

Wide-angle lenses are useful to photograph interiors, where you want to get a lot of room in a single photo. They are useful with any subject when you can't stand far enough back to use a longer lens.

These lenses also make pleasing outdoor and scenic shots when you want to include a vast expanse of landscape. Such photos are usually improved and given dimension by a prominent foreground, such as a person or a fence.

STANDARD LENSES

Standard lenses for MAXXUM cameras are the 50mm f-1.4 and 50mm f-1.7. They are good general-purpose lenses. Use a 50mm lens unless there is a photographic reason to use some other focal length.

The angle of view of 50mm lenses is 47°—about the same as your angle of vision with one eye closed.

MEDIUM TELEPHOTO

Lenses with focal lengths in the range of 70mm to 200mm are medium telephotos. These lenses are useful when you can't get close enough to the subject to fill the frame with a standard lens. The angle of view of a 135mm lens is 18°.

These focal lengths are particularly useful for sports, travel and nature photography. Because they have narrow angles of view, they can isolate an interesting part of a scene, leaving out less interesting parts.

The telephoto effect on perspective is evident in this photo—taken with a 200mm lens. The distant mountain ranges seem very close together.

LONG TELEPHOTO

These lenses, having focal lengths of 300mm and longer, are for the specialist. Long telephotos usually require a tripod or other steady mount to avoid image blur due to camera movement. The angle of view of a 300mm lens is

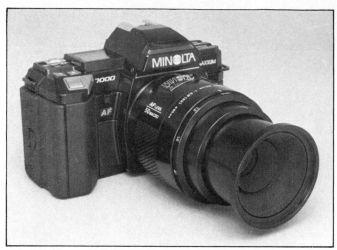

This AF 50mm *f*-2.8 Macro lens makes high quality images with magnifications up to 1 and also serves as an excellent general-purpose lens. When used at high magnification, a firm camera support is essential.

The MAXXUM AF 70—210mm macro-zoom has four marked focal lengths on the Zoom Ring. At the 210mm focal-length setting, also marked MACRO, the lens focuses close enough to provide an image that is 25% as tall as the subject—a magnification of 0.25.

8°. A 600mm lens has an angle of view of 4°.

These lenses will reach out a long way to fill the frame with a distant subject, such as a sailboat photographed from the beach. Image quality may be deteriorated by the long air path between lens and subject.

Zoom lenses have a Zoom Ring that changes focal length without changing focused distance. On this AF 35—70mm zoom, the focal-length scale is marked at 35mm, 50mm and 70mm, for reference. Usually, you zoom while composing the scene in the viewfinder. This lens has a special Macro setting of the Zoom Ring providing a magnification of 0.25.

Most photographers don't often need focal lengths longer than 300mm. However, when you do need a very long lens there's usually no other way to make the photo.

Filters for Long Telephotos—The MAXXUM 300mm *f*-2.8 and 600mm *f*-4 telephotos don't use front-mounted filters because the front diameters of these lenses are very large. Instead, the filter is screwed into a holder and the holder is inserted in a slot near the back of the lens.

Because the filter is inside the lens, the lens is designed with the assumption that glass will always be in the filter holder. The lens is delivered with a clear glass filter which should be used unless another filter is installed.

To protect the front element, clear glass attachments are available to fit on the front of these lenses. For this purpose, the 300mm lens has threads of 114mm diameter and the 600mm lens has 152mm threads.

MACRO LENS

The closest focusing distance of an ordinary 50mm lens is about 1.5 feet. At that distance, the lens produces an image on film that is about 15% as tall as the subject.

The MAXXUM AF 50mm *f*-2.8

Macro lens has a minimum focusing distance of 0.6 feet. At that distance, the image on film is the same size as the subject—referred to as *life-size*.

Macro lenses are used to fill the frame with small objects such as coins and postage stamps. They have good image quality when shooting at life-size. They have excellent flatness of field. Using a macro lens is discussed in Chapter 7.

ZOOM LENSES

Zoom lenses have a control that changes the focal length without changing focused distance. The subject grows larger or smaller in the frame as you zoom. On MAXXUM AF lenses, the zoom control is a ring that you rotate to change focal length.

Zoom lenses have become very popular, and deservedly so. With today's lens designs, there is usually no visible difference in image quality of zoom and non-zoom lenses. Among the first 15 MAXXUM AF lenses announced by Minolta, seven were zooms.

A single zoom lens can provide the focal lengths of several fixed-focal-length lenses plus all focal lengths in between. For example, The MAXXUM AF 70-210mm *f*-4 lens has all focal lengths from 70mm to 210mm.

A zoom is useful in composing a photo because it gives very precise control of what appears within the frame. This is especially useful in situations where it is not convenient to change the camera location. Zoom lenses are handy and sometimes essential when shooting action and sports, when you don't have time to change lenses to get a different focal length.

For travel or general photography, two zoom lenses can satisfy most requirements. The MAXXUM AF 35-70mm with the MAXXUM AF 70-210mm provide every focal length from 35mm to 210mm.

Maximum Aperture—Zoom lenses typically have smaller maximum apertures than conventional lenses in the same range of focal lengths. Fast films help solve the problem.

Aperture Change—Some zoom lenses change aperture size when zoomed. It is easier to manufacture zoom lenses with variable aperture and they are therefore less expensive. The AF 28-85mm *f*-3.5-4.5 changes aperture from *f*-3.5 to *f*-4.5 when zoomed from 28mm to 85mm.

With automatic exposure, the aperture change is compensated automatically. If you set exposure manually, zoom first, then set exposure.

An aperture change due to zooming occurs only at the maximum and minimum aperture settings—not at intermediate settings. Using the AF 28-85mm lens as an example, if the maximum aperture of *f*-3.5 is set with the lens at its shortest focal length, the aperture will become smaller as the lens is zoomed to longer focal lengths. But, if a smaller aperture—*f*-4.5 or smaller—is set, it will not change when the lens is zoomed from shortest to longest focal length.

Because the camera controls lens aperture size, it automatically maintains the set value when possible. If the set value is the maximum aperture, however, maintaining that size is not possible when zooming to a longer focal length.

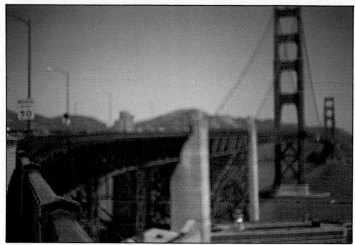
Depth of field is a zone of good focus that is determined by the setting of the lens focus control and the lens aperture. Here, there isn't much depth of field and it is all at the near end of the bridge.

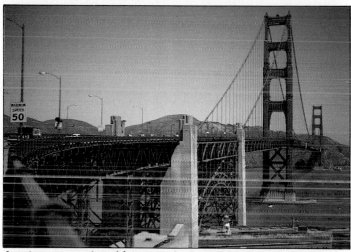
Aperture was reduced for more depth of field. Focus was placed nearer the center of the bridge. The near end is now out of the zone of good focus; most of the center is in focus.

Aperture was reduced to its minimum value to get maximum depth of field. Most of the bridge is in focus, including the nearby railing.

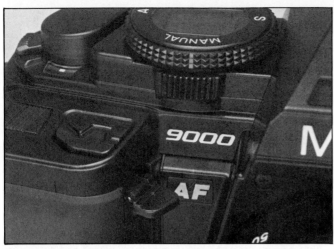

The MAXXUM 9000 has a Depth-of-Field Preview Switch that folds out of the camera grip when needed. To see depth of field, press the switch downward. The lens aperture will close to the size that has been selected for the next exposure.

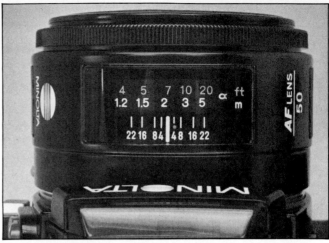

The lower scale is the depth-of-field scale. Here, it runs from 4 to 22—on each side of the distance index mark. These are *f*-numbers because depth of field is dependent on aperture size. Focus the lens on the scene or subject and determine aperture size. Then look at the depth-of-field scale on the lens and find that *f*-number at two places, one on each side of the distance index. In the example shown, at *f*-16 depth of field is about 5 to 13 feet (1.5 to 4 meters).

Similarly, if minimum aperture is set with the lens at its longest focal length, it will become larger as the lens is zoomed toward shorter focal lengths. If a larger aperture size is used, it will not change when the lens is zoomed toward shorter focal lengths.

Zoom Lenses with "Macro" Setting—MAXXUM AF zoom lenses have a special setting to allow close focusing. The largest possible image is 25% as tall as the subject.

The word *macro* usually refers to equipment that can produce a life-size image, or larger. Macro-zoom lenses don't meet that standard but they are nevertheless useful.

At the macro setting, flatness of field may not be good enough to photograph flat subjects such as a postage stamp. There may also be visible distortion of straight lines, especially near the edges of the frame.

Such defects are normally not noticeable if you use the macro-zoom lens as the designer intended—to photograph non-flat objects in nature that don't have straight lines or edges, such as rocks and flowers.

Macro-zoom lenses are not repre-sented to give the same image quality at the closest focusing distance as true macro lenses such as the 50mm *f*-2.8 Macro. A macro-zoom lens gives you close focusing with slightly reduced quality. Image quality at ordinary shooting distances is excellent.

Using macro-zoom lenses at the macro setting is discussed in Chapter 7.

FISH-EYE LENS

A special lens design called *fish-eye* has a very wide angle of view— typically 180 degrees. The lenses have very short focal lengths, such as 16mm. Use of the lenses causes fish-eye distortion: any straight line that does not pass through the center of the picture is bowed away from center.

Because of the wide angle of view, accessory filters cannot be attached to the front of the lens—the filter frame would vignette the image. Filters are provided in a rotating turret, inside the lens body.

Circular Fish-Eye Lens—Such a lens makes a circular image within the film frame. The remainder of the frame is black. Circular fish-eyes are mainly useful in science and astronomy. When this book was prepared, there were no MAXXUM circular fish-eye lenses.

Full-Frame Fish-Eye Lens—This lens makes a rectangular image that fills the frame. Even though such lenses cause fish-eye distortion, the photo is more acceptable to viewers because the image is full-frame.

The MAXXUM 16mm *f*-2.8 full-frame fish-eye lens has a built-in turret with four filters: one for exposing day-light film under tungsten illumination, another for daylight film with fluores-cent lighting, an orange filter, and a clear filter which has no visible effect. Filters are discussed in Chapter 6.

TELE-CONVERTERS

Accessories called *tele-converters* fit between the lens and the camera body. They multiply both focal length and *f*-number by a factor, such as 1.4 or 2. For example, a 200mm *f*-2.8 lens used with a 1.4X tele-converter has an *effective* focal length of 280mm and an effective maximum aperture of *f*-4. The factor is written with an X to sig-nify multiplication, such as 1.4X. The minimum focusing distance of the lens is not changed.

A Minolta AF 1.4X tele-converter has been announced for use with MAXXUM Apo telephoto lenses with focal lengths of 200mm and longer. Electrical contacts on the tele-converter "tell" the camera the *effective* focal length and aperture, and the camera operates accordingly. Auto-focus capability is preserved.

An accessory 2X tele-converter, to mount earlier Minolta MC-type and MD-type lenses on MAXXUM cameras, has been announced. The lens cannot be automatically focused and some automatic-exposure modes are not usable.

DEPTH OF FIELD

Photos are not always in sharp focus at all distances from the camera. The zone of acceptable focus is called *depth of field*.

For technical photography, such as the photos of equipment reproduced in this book, it is usually best to have everything in sharp focus, if possible. For artistic photography, it is often desirable to limit depth of field. For example, a portrait against a distracting background usually looks better if the background is out of focus.

Two factors affect depth of field: aperture size and image size. When all other conditions are identical, photos made at a small aperture have greater depth of field than those made at a large aperture. Similarly, large images have less depth of field than smaller images of the same subject.

Longer focal lengths reduce depth of field because they make a larger image of the subject. Short focal lengths, such as 24mm, produce images with great depth of field because the image is smaller than if made with a longer focal length from the same distance.

Image size is affected by subject distance. Therefore, if aperture and focal length are not changed but the subject is farther away, depth of field is greater because the image is smaller. If the subject were nearer, the image would be larger and depth of field would be more limited.

All of the foregoing applies to depth of field of the image on film in the camera. The following rules apply.

DEPTH-OF-FIELD RULES

When other factors are identical, depth of field is increased by:
- Smaller aperture.
- Shorter focal length.
- Greater subject distance.

When other factors are identical, depth of field is decreased by:
- Larger aperture.
- Longer focal length.
- Shorter subject distance.

After the film is removed from the camera and processed, depth of field of the resulting print or projected slide is affected by the size of the image and viewing distance.

Larger prints or projected images appear to have less depth of field. A short viewing distance decreases depth of field whereas moving back from the image increases depth of field.

DEPTH OF FIELD IN THE VIEWFINDER

Viewing the scene in the viewfinder is done at maximum aperture, so you see minimum depth of field. If the lens stops down to a smaller aperture to take the picture, there will be more depth of field on the film than you saw in the viewfinder.

The MAXXUM 9000 has a Depth-of-Field Preview Switch that you can use to *preview* depth of field in the viewfinder before making an exposure. It closes the lens to shooting aperture while you look through it.

You see the same depth of field in the viewfinder that will be recorded on film. The viewfinder image will become noticeably darker because of the smaller aperture but you can usually judge depth of field adequately.

The MAXXUM 5000 and MAX-XUM 7000 don't have a Depth-of-Field Preview Switch.

READING DEPTH OF FIELD ON THE LENS SCALE

With a camera that doesn't have a Depth-of-Field Preview Switch, you can't check depth of field in the viewfinder.

MAXXUM AF fixed-focal-length lenses have a depth of field scale adjacent to the focused-distance scale. For each focused distance, it shows depth of field for several aperture sizes. The photo on page 26, right, shows how to read it.

MAXXUM AF zoom lenses don't have a depth-of-field scale because depth of field varies with focal length. You may find the depth-of-field tables at the end of this book helpful.

MAXXUM AF LENSES

Lens	Angle of View (deg)	Minimum Focus ft (m)	Minimum Aperture	Filter Diam. (mm)	Dimensions (dia x leng) in. (mm)	Wt oz (g)
20mm f-2.8	94	0.8 (0.25)	f-22	72	3.1 x 2.1 (78 x 54)	10 (285)
24mm f-2.8	84	0.8 (0.25)	f-22	55	2.6 x 1.8 (66 x 44)	7.6 (215)
28mm f-2.8	75	1.0 (0.3)	f-22	49	2.6 x 1.7 (66 x 43)	7.4 (200)
28mm f-2	75	1.0 (0.3)	f-22	55	2.6 x 1.9 (66 x 50)	10 (285)
50mm f-1.4	47	1.5 (0.45)	f-22	49	2.6 x 1.5 (66 x 39)	8.3 (235)
50mm f-1.7	47	1.5 (0.45)	f-22	49	2.6 x 1.5 (66 x 39)	6.9 (195)
135mm f-2.8	18	3.3 (1.0)	f-32	55	2.6 x 3.3 (66 x 83)	13 (365)
200mm f-2.8	12.5	4.9 (1.5)	f-32	72	3.3 x 5.3 (84 x 134)	28 (795)
300mm f-2.8 Apo	8.17	8.2 (2.5)	f-32	Drop-in (Note 2)	5.1 x 9.4 (130 x 239)	88 (2480)
600mm f-4 Apo	4.2	20 (6.1)	f-32	Drop-in (Note 3)	6.6 x 18 (168 x 460)	194 (5467)
ZOOM LENSES WITH MACRO RANGE (See Note 1)						
28—85mm f-3.5—4.5	75—29	2.6 (0.8)	f-22—32	55	2.8 x 3.4 (69 x 86)	18 (490)
28—135mm f-4—4.5	75—18	4.9 (1.5)	f-22—27	72	2.9 x 4.3 (75 x 109)	27.2 (770)
35—70mm f-4	63—34	3.3 (1.0)	f-22	49	2.7 x 2.1 (68 x 52)	9.1 (255)
35—105mm f-3.5—4.5	63—18	4.9 (1.5)	f-22—32	55	2.7 x 3.4 (68 x 87)	17.5 (495)
70—210mm f-4	34—12	3.6 (1.1)	f-32	55	2.9 x 6 (74 x 152)	24.5 (695)
75—300mm f-4.5—5.6	32—8.2	4.9 (1.5)	f-32	55	2.9 x 6.4 (74 x 163)	31 (880)
ZOOM LENS WITHOUT MACRO RANGE						
100—200mm f-4.5	24—12.5	6.2 (1.9)	f-22	49	2.8 x 3.8 (70 x 95)	13.3 (375)
MACRO LENSES						
50mm f-2.8	47	0.6 (0.2)	f-32	55	2.7 x 2.3 (68.5 x 59.5)	10.9 (310)
100mm f-2.8	24	1.2 (0.35)	f-32	55	2.8 x 3.9 (71 x 99)	18.3 (520)
FISH-EYE LENS						
16mm f-2.8 Full-Frame	180	0.7 (0.2)	f-22	built-in	3 x 2.6 (75 x 67)	14.1 (400)

NOTES:
1. Maximum magnification in macro range is approx. 0.25. Minimum focused distance shown is for normal range, not macro.
2. 300mm f-2.8 has 114mm front threads for clear lens protector.
3. 600mm f-4 has 154.5mm front threads for clear lens protector.

Viewing and Focusing

MAXXUM cameras have two ways of focusing the lens—manual or automatic. There are also two ways to check or confirm focus—visually by looking at the focusing screen and electronically by the camera autofocus system. The autofocus system operates a display in the viewfinder to tell you if the image is in focus.

ELECTRONIC FOCUS DETECTION

Visual observation of focus is done in the top of the camera—the viewfinder. Electronic focus detection is done independently, using an electronic focus sensor in the bottom of the mirror box. Both are done at the same time, with the mirror down, before making the exposure.

The Light Path—The main mirror of MAXXUM cameras reflects the light upward into the viewfinder. The mirror has a central, semi-transparent area that allows some of the light to pass through.

A sub-mirror, behind the main mirror, reflects light from the scene downward to the focus-detection system, as shown in the drawing on the next page.

The Principle—Minolta refers to the focus-detection method as *phase detection*. It is based on observation of the image from two off-center locations, left and right of center (see Figure 3-1, page 31).

The Focus Detector—In the bottom of the mirror box is a row of light sensors of a type called Charge-Coupled Device (CCD). Optically, one side of this row views the image from the left of center and the other side views it from the right. The CCD array takes both views simultaneously.

Viewing through the camera lens assists greatly in composing an image accurately. Part of the creativity in photography consists of focusing selectively—not necessarily having everything in a scene in sharp focus. Here, the main subject is sharp but the background is slightly out of focus, although still sharp enough to be recognizable.

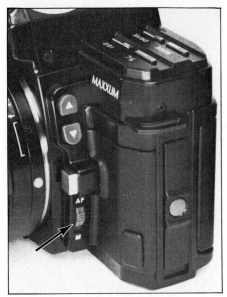

MAXXUM cameras have a Focus-Mode Switch (arrow) just below the Lens-Release Button. It has two positions. At AF (AutoFocus), the autofocus system does three things: It checks focus at the center of the frame, focuses the lens and operates a focus display in the viewfinder to show when the image is in focus. At M (Manual), the autofocus system does not focus the lens. You focus the lens manually, using the viewfinder focus display as a guide.

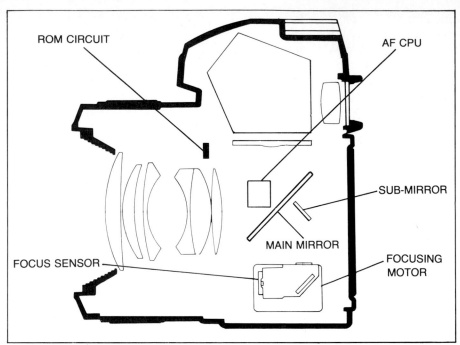

A ROM (Read-Only Memory) computer chip supplies lens data for autofocus and automatic exposure. An AF CPU (Autofocus Central Processing Unit) receives lens data and the output of a focus sensor in the camera body, then controls the focusing motor to focus the lens. The FOCUSING MOTOR focuses the lens under control of the AF CPU. The FOCUS SENSOR checks focus of the image in the Focus Frame at the center of the image and reports the focus status to the CPU.

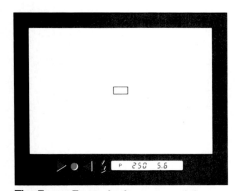

The Focus Frame in the center of the image area shows what the autofocus system is "looking at" to check focus. The focus display is at lower left. If the green dot glows, the image in the Focus Frame is in good focus.

The light pattern on the row of CCDs is examined electronically more than 33 times each second. The physical arrangement of the focus detector causes the two images to move farther apart when focus is behind the subject, closer together when focus is in front of the subject.

The focus computer in the camera "knows" how far apart the images should be when the subject is in focus. Therefore, the computer can determine if the image is out of focus and, if so, which way.

FOCUS FRAME

The CCD array in the focus detector examines a narrow horizontal line at the center of the image. The standard focusing screen for MAXXUM cameras has a small rectangle at the center of the image area called the *focus frame*. It designates the part of the scene that is used to check focus.

When using autofocus, hold the camera so the focus frame overlays the subject to be focused.

FOCUS DISPLAY

The focus computer operates a focus display in the viewfinder, below the image area. If the image is in focus, the green dot glows.

On Manual Focus—If you are focusing the lens manually, and the focusing ring should be turned to the right to improve focus, the right-pointing red arrow glows. If the focusing ring should be turned to the left, the left-pointing red arrow glows.

If the electronic focus detector cannot function, for reasons discussed later, both red arrows blink on and off.

On Automatic Focus—If the camera is set to focus the lens automatically, it will try to find focus and then report success or failure using the focus display.

If the camera succeeds in focusing the lens, the green dot glows. If the electronic focus detector has difficulty—perhaps because of dim light on the scene—the camera will focus the lens to the closest possible distance and then scan outward all the way to infinity. If focus is not found, both red arrows blink.

If the subject is closer than the mini-

mum focusing distance of the lens, the right-pointing arrow glows. Because the camera has *already* attempted to find focus, the lens is *already* set to its closest focusing distance. On automatic focus, the right-pointing arrow means that focus is impossible because the subject is too close. Move the camera farther away.

A subject can never be too far away because the camera can focus the lens to infinity. Therefore, the left-pointing arrow alone never glows when the camera is focusing automatically.

FOCUSING AUTOMATICALLY

The electronic focus detector determines not only which way the subject is out of focus but also how much. Using the electrical contacts on MAXXUM lenses, the lens "tells" the camera computer the distance at which it is focused.

With that information, the focus computer calculates how much the focus motor must turn to bring the lens exactly to focus. The focus motor has four speeds. If the lens is a long way from focus, the motor starts at top speed. As the lens nears focus, the motor slows down so it doesn't overshoot. When the image is in focus, the motor stops.

When set for manual focus, the camera will expose a frame each time you press the shutter button whether the image is in focus or not.

FOCUS LOCK

The autofocus operation must stop changing the focused distance of the lens before each exposure is made. Making a shot while the lens is changing focus is inconsistent with the purpose of autofocus. You can do that on manual, if you wish.

To ensure that the camera autofocus system does not change focus during an exposure, focus is locked just before the shutter opens. The method of locking focus varies among models, as discussed later in this chapter.

Recomposing with Focus Locked—

The autofocus system focuses on whatever is in the viewfinder focus frame.

You may wish to make a photo with the subject at the edge of the frame. Center the subject and allow the autofocus system to find focus. Then, lock focus at that distance. Move the camera so the subject is off center and make the exposure.

Controlling Focus Lock—With the Focus-Mode Switch set to AF, the camera is in the autofocus mode. The camera exposure system and autofocus system are both controlled by the Operating Button, which has three stages: touching the button, depressing it partway and depressing it fully. The table on page 32 shows what happens at each stage, with the specified camera models.

Single-Frame Autofocus—This is used by the MAXXUM 5000 and MAXXUM 7000. When you touch the Operating Button, it turns on the camera exposure system but not the autofocus system. In the viewfinder, you can check exposure and compose the scene.

When you are ready for the lens to focus, press the Operating Button partway. The autofocus system will attempt to focus on whatever is designated by the focus frame. If not possible, it blinks both red arrows.

If good focus was achieved, it turns on the green light in the focus display and *locks focus* at that distance.

As long as you hold the Operating Button partially depressed, focus remains locked. You can recompose the scene if you wish. To focus on a different object in the scene, you must lift your finger from the Operating Button and start again. If the subject moves out of focus while you are preparing to shoot, lift your finger and focus again.

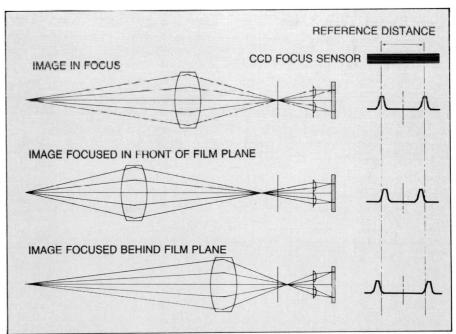

Figure 3-1/The focus sensor forms two images by "looking at" the scene from two off-center locations, one to the left and one to the right. By comparing the distance between the images to a reference distance, the autofocus system calculates how much the image is out of focus and in which direction.

CONTROLLING AUTOFOCUS WITH THE OPERATING BUTTON

	MAXXUM 5000	MAXXUM 7000	MAXXUM 9000*
Operating Button Stage			
1	Turns on exposure system & display.	Turns on exposure system & display.	Turns on exposure system, AF system & displays. AF system focuses continuously without locking.
2	Turns on AF system, focuses and locks.	Turns on AF system, focuses and locks.	Locks focus—wherever lens is focused.
3	Makes exposure if focused at Stage 2.	Makes exposure if focused at Stage 2.	Makes exposure whether image focused or not.

*Motor Drive MD-90 used with the MAXXUM 9000 provides an additional focusing mode, discussed in Chapter 10.

You control the steps that lead to making an exposure of a focused image by controlling the three stages of the Operating Button.

When ready to make the exposure, press the Operating Button all the way. If focus was not achieved at stage 2, the green dot does not glow and the shutter will not operate.

This mode uses *focus priority* because the shutter will not operate unless the subject in the Focus Frame is in good focus and the green dot is glowing. It's called *single-frame* autofocus because the AF system focuses once for each frame. Then, you must either take the picture or lift your finger and start over.

Single-Frame Autofocus with Continuous Film Advance—The MAXXUM 5000 and MAXXUM 7000 can expose and advance frames continuously using a built-in motor—as long as the Operating Button is held fully depressed. The camera pauses before each frame to focus. It will not open the shutter unless the image is in focus. This mode also uses focus priority.

Focus Priority with a Moving Subject—Either of the modes just discussed may have a problem with a moving subject. If the subject moves faster than the camera can find focus, an exposure will not be made.

For most photography, this is not a serious limitation. I found that the MAXXUM autofocus system could maintain focus on a jogger moving directly toward the camera. I believe that the system will track a moving subject as well or better than most photographers can do using manual focus.

With moving subjects—or any subject—that cannot be autofocused, you always have the option of focusing manually. A handy trick with very fast objects, such as racing cars, is to prefocus at a location and trip the shutter as the subject arrives at that location.

Continuous Autofocus—The MAXXUM 9000 used without a motor drive can make only single exposures. There is no focus priority. The camera will make an exposure when you press the Operating Button all the way down, whether the image is in focus or not.

Touching the Operating Button turns on *both* autofocus and exposure control. If you move the camera around in a scene, while just touching the button, it will refocus each time it "sees" a subject at a different distance—rather than focus once and lock. Minolta refers to this as *continuous autofocus*.

The focus display tells you if the image is in focus, as does your vision if you are looking at the focusing screen. To make an exposure, focused or not, press the Operating Button fully. This passes through stage 2, which locks focus before the shutter opens.

To lock focus so you can recompose, press the Operating Button partway. If the autofocus system has not found focus, it will continue to search. When it finds focus, the green light turns on and focus is locked at that distance. Recompose and then make the exposure.

With a MAXXUM 9000, *continuous autofocus* applies only to stage 1 of the Operating Button. It doesn't mean that the subject is continuously in focus. It means that the autofocus system is continuously *trying* to find focus. Because the autofocus system works very quickly, it will usually succeed, except with fast-moving subjects.

MAXXUM 9000 with Motor Drive—With motor drive MD-90, the MAXXUM 9000 has some additional modes, discussed in Chapter 10.

THE BEEPER

MAXXUM cameras have an unobtrusive built-in beeper that you can turn on or off. It is used for several purposes, listed in Chapter 10. One purpose is to indicate good focus, which it does with a distinctive beep-beep that occurs simultaneously with the green dot. When working fast, or concentrating on the image in the viewfinder, you may not wish to look at the green dot to see if the image is in focus. Turn on the beeper and the friendly beep-beep sound will tell you.

GOOD SUBJECTS FOR AUTOFOCUS

Because the CCD array in the electronic focus detector is horizontal, it works best on vertical lines or the edge between two areas of greatly different brightness or contrast, in a brightly lit setting.

Good common subjects that are suitable include people, buildings, trees and so forth, in light that isn't dim.

BAD SUBJECTS FOR AUTOFOCUS

Any subject in very dim light is unsuitable for autofocus. The focus detector must be able to "see" the subject. MAXXUM flash units have built-in scene illuminators that allow autofocus in the dark. These are discussed in Chapter 8.

Also unsuitable are blank areas. The focus detector must have some lines or detail to examine. Areas with very low contrast are also not good subjects. If possible, focus on a better subject at the same distance. Use focus lock and recompose.

The focus detector needs vertical lines. If a scene contains only horizontal lines, rotate the camera 90°, focus, and use focus lock.

Scenes that offer the focus detector a choice may be bad. For example, shooting a scene through a grille. The camera may focus on the grille instead of the scene.

JUDGING FOCUS VISUALLY

MAXXUM cameras use interchangeable focusing screens made of precision-molded plastic. Most have a matte surface resembling ground glass. The matte surface intercepts light rays from the lens and shows you the condition of the image at that surface. If in focus, the image will be sharp. If not, it will be blurred.

If your camera has a Depth-of-Field Preview Switch, you can see depth of

> ### NOTES ON USING AUTOFOCUS
>
> Autofocus works best on a vertical line or edge between two areas of different contrast. If the scene has only horizontal lines, rotate the camera 90°. When the camera has focused the image, lock focus, rotate the camera back as it was before and shoot.
>
> Autofocus works well when it "sees" detail to focus on. If the subject has a plain blank area with no detail, move the camera so the Focus Frame in the viewfinder includes details elsewhere on the subject, at the desired distance, or place the Focus Frame over the edge of the subject. Lock focus and then recompose as desired.
>
> Verify focus by looking at the image on the focusing screen. Occasionally, the autofocus system may see two places to focus, at different distances from the camera. It may focus on the wrong one.
>
> If one part of a scene or subject is too dark for automatic focusing, perhaps another part isn't. Try placing the Focus Frame over the lightest area. If focus is found, lock focus, recompose and shoot.
>
> To prefocus the lens at a location where you expect a moving subject to arrive, try focusing on the ground at that location. Lock focus. When the moving subject arrives, shoot.
>
> A handy way to lock focus for long periods is to turn the AF system off. The lens will remain focused at whatever distance it was before you turned the system off—unless you change focus manually.
>
> For best focus of two objects at different distances from the camera, the lens should be focused at a point a little nearer to the camera than midway between the two objects.

field at shooting aperture on the matte screen.

Aerial Image—The MAXXUM Type C screen is clear instead of matte. The image is brighter. The lens will make a focused *aerial image* in the vicinity of the screen. Your vision will find the focused image but won't tell you if it is in focus exactly at the screen.

You can check focus visually by the parallax method using the focus frame, which is engraved on the surface of the screen. Move your eye from side to side. If the image moves in respect to the focus frame on the screen, image and screen are not at the same location.

With a clear screen, you can't see depth of field.

OPTICAL FOCUSING AIDS

Judging focus by observing image blur in the matte area of a focusing screen is usually satisfactory, but there are more precise ways. Before auto-focus was developed, focusing screens had optical focusing aids at the center to help you find focus visually. Such focusing aids are discussed in this section.

Most screens for autofocus cameras have a focus frame at the center which shows you what the autofocus system is focusing on, rather than optical focusing aids to help you find focus visually.

A Type PM screen is available to replace the standard screen. It has two optical focusing aids at the center, a *split-image biprism* and a *micro-prism*—and no focus frame. It is mainly useful when focusing the lens manually.

Split Image—This focusing aid is at the very center of the screen. It appears as a circle with a horizontal line through the center. It will split a vertical line or edge if the image is not in focus. Part of the line moves in one

direction part in the opposite direction.

To obtain correct focus, manually turn the lens focus control so the two parts of the line move toward each other. When the line is continuous, not split, the image is in best focus.

Microprism—The microprism is a ring that surrounds the biprism. On a textured surface, such as foliage or a wall, there are no clearly visible straight lines to split with a biprism. For such surfaces, a microprism is a better focusing aid.

It consists of an array of tiny pyramids whose intersections work like small biprisms. When the image is in focus, you are unaware of the microprism. When the image is out of focus, it breaks up into a grid pattern caused by the tiny pyramids. If the camera shakes, as it does when handheld, the image seems to break up or scintillate when out of focus.

Autofocus with the PM Screen—Autofocus works as usual with a PM screen installed because electronic focus detection is independent of the viewing system. The horizontal line of the biprism shows where the CCD array checks focus.

Usually, when the autofocus system indicates good focus by turning on the green dot, the visual focusing aids will also show good focus. However, if your eye is off center in the viewfinder eyepiece—to the left or right—the two focus indications may not agree. If that happens, move your eye slightly and the indications should agree.

Acute-Matte Screens—All MAXXUM screens with a matte surface are manufactured by a special technique that makes the matte surface more regular and uniform than earlier types. The result is a much brighter image. Screens of this type are called *Acute-Matte*.

VIEWING AIDS

There are some attachments that fit on the viewfinder eyepiece frame to make viewing better or more convenient.

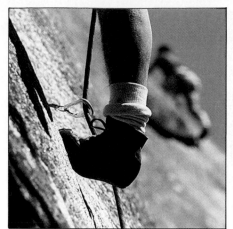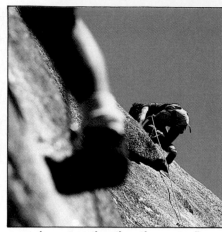

The telephoto effect makes these climbers seem closer together than they actually were. They were too far apart to be included in the depth of field. Using autofocus, I focused both ways. Notice how your interest is drawn to the subject in focus. The extent of the depth of field is visible in the texture of the rock face.

INTERCHANGEABLE FOCUSING SCREENS FOR MAXXUM 7000 CAMERAS

Screen	Appearance	Uses and Description
Type G		Standard screen. Matte field with Focus Frame.
Type L		Matte field with grid and Focus Frame. For general and architectural photography.
Type S		Matte field with scales and Focus Frame. For macro- and astro-photography.
Type PM		Matte field with optical focusing aids. Horizontal line at center shows autofocus area. For general photography.

Screens for the MAXXUM 7000 are called Focusing Screen 70 plus the Type identification shown above. Screens for the MAXXUM 9000 are called Focusing Screen 90 plus a Type identification. The MAXXUM 9000 uses four screens that are similar, but not identical, to those shown here, plus another one. They are shown in Chapter 10.

Angle Finder V**N** fits on the MAXXUM viewfinder eyepiece and redirects the light path. It is useful at locations where it's difficult to put your eye to the camera eyepiece—for example, on the floor. The finder rotates on its mount so you can view from a variety of angles. The finder has two magnifications, selected by a lever at its base. When set to 1X, the view is the same as without the finder. When set to 2X the focusing-screen image is magnified by 2. The ring below the eyepiece adjusts the angle-finder optics to match your eyesight, over a range of −9 to +3 diopters.

Magnifier V**N** enlarges the central part of the image on the focusing screen. The magnifier can be flipped up out of the way, allowing you to view the entire screen. When vertical as shown here, the hinge prevents installation of a flash in the hot shoe. The magnifier can be rotated on its base, to move the hinge out of the way, when necessary. You can adjusts the magnifier optics to match your eyesight, over a range of −7.5 to +3.1 diopters.

RUBBER EYEPIECE HOOD

This accessory fits over the eyepiece and makes viewing easier by excluding stray light. Stray light entering the eyepiece, such as when the sun angles over your shoulder, can also cause incorrect exposure metering.

EYEPIECE CORRECTORS

The viewfinder optics provide an image of the focusing screen that appears to be about one meter distant. If your vision is good at that distance, you can judge focus accurately.

If you wear eyeglasses to correct your vision at that distance, you have the choice of wearing your glasses while using the camera or placing your eyeglass prescription into the viewfinder optical system so you can use the camera without wearing your glasses. Eyeglass prescriptions are written in diopters and the strengths of the following eyepiece correctors are stated in diopters.

MAXXUM 5000 and 7000—These models use accessory EC-1000 Eyepiece Corrector Lenses that snap into the viewfinder eyepiece, with strengths from −4 to +3 diopters.

The best way to select one is by trial, testing corrector lenses from your dealer's stock. One way is to let the camera focus a subject automatically. Then choose a corrector lens so the focus looks best to your eye. An alternate method is to choose a corrector lens so the focus frame is sharp.

MAXXUM 9000—This camera has an Eyepiece Adjustment Dial to adjust the viewfinder optics to match your eyesight, using either of the procedures just described. The range of the Eyepiece Adjustment Dial is −3 to +1 diopters.

If more correction is required, an EC-1000 Eyepiece Corrector Lens may be snapped into the viewfinder eyepiece.

HOW TO CHANGE FOCUSING SCREENS

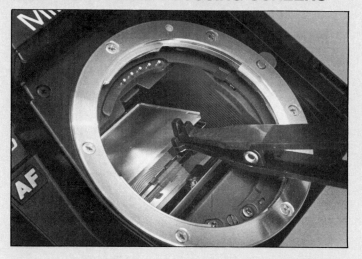

Remove the lens. Focusing screens are held in a metal frame, called a holder, that is normally latched in position at the top of the mirror box. Using tweezers supplied with accessory focusing screens, press upward on the latch tab just below the row of electrical contacts at the top of the lens opening. The focusing-screen holder, very close to the mirror, will drop down, as shown here. Using tweezers, grasp the tab on the front of the screen and lift the screen out of the camera. Be very careful not to touch or scratch the mirror.

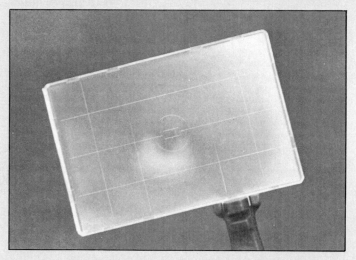

Transfer the screen just removed to a holding slot in the plastic accessory-screen case. Using tweezers, grasp the tab on the accessory screen to be installed and remove it from the case. This is a Focusing Screen 90, Type L, for a MAXXUM 9000. The difference between this screen and the same Type L for MAXXUM 7000 cameras is the circle surrounding the Focus Frame at the center.

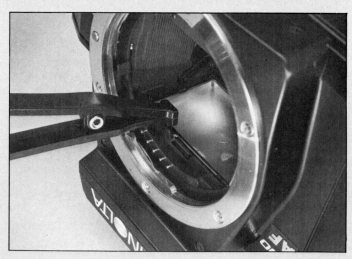

Carefully place the new screen in the empty focusing-screen holder in the camera. The tab on the screen fits over a tab on the front of the holder. When the screen is correctly positioned in the holder, gradually invert the camera so the holder swings back up to its normal position. Use tweezers to press the metal tab on the holder toward the latch until it locks in place. A slot in the tweezers fits over a metal projection adjacent to the tab on the holder. This prevents the tweezers from slipping and possibly scratching the bottom of the focusing screen.

HOW TO HOLD THE CAMERA

When using horizontal format, if the lens is physically long, you can support the body of the lens in your left hand. If using autofocus, avoid touching the Manual Focusing Ring on the lens. If the lens is physically short, you may find it more convenient to hold the left side of the camera body in your left hand.

For a vertical-format shot, with your right eye at the viewfinder, this is a convenient way to hold the camera.

If you view with your left eye, you may prefer this method.

When possible, brace yourself and the camera against something rigid.

BRACE YOURSELF AND THE CAMERA

If the camera moves while you are taking a picture, the image will probably be blurred. Camera shake or jiggle is the most common cause of fuzzy photos. The accompanying pictures show good ways to handhold a camera. Don't jab the Operating Button—*squeeze* it gently without moving the camera.

Stabilize yourself and the camera. Plant your feet firmly. Tuck one or both elbows firmly against your body. The world is well equipped with objects to help stabilize you and your camera. Lean against a wall or tree. Press the side of the camera firmly against a telephone pole or the wall of a building. Rest your elbows on a railing or the back of a chair.

A RULE FOR HANDHOLDING A CAMERA

Lenses with longer focal lengths increase image blur due to camera movement. Faster shutter speeds reduce blur because less of it occurs while the shutter is open. Here is a rule that suggests shutter speeds for handholding with various lenses: The *slowest* recommended shutter speed for any lens is 1 divided by the focal length. For example, with a 200mm lens, the slowest shutter speed should be 1/200 second. Use the next faster standard speed, 1/250 second.

Sometimes you may find it necessary to handhold your camera at shutter speeds slower than this rule suggests. If you have no choice, do the best you can. However, the best method of ensuring sharp images is to use a sturdy tripod.

Films

A good color photo is dependent not only on the faithful recording of colors, but also on detailed tonal values.

This chapter discusses color and black-and-white films. There are several types of film that you can use in a 35mm camera. Each is available in a range of film speeds.

Black-and-White Negative Film—This produces a negative black-and-white image of the scene. In a negative, brightnesses are reversed. White becomes black; black becomes white.

To make a positive image, the negative is exposed onto photographic printing paper. When developed, the brightnesses are reversed again, so the image looks normal. Usually, when an image is printed it is also enlarged.

Color Negative Film—This film makes a negative image in color. Brightnesses are reversed in a way similar to black-and-white negative film. Also, the colors are "reversed". The reverse of a color is called its *complement,* discussed later in this chapter.

The reversed brightnesses and colors of the negative are exposed onto color printing paper and a normal-looking image results. Color negative film is usually labeled Color Print film because a color print is the end result.

Color Slide Film—This film produces positive, transparent color images, suitable for projection or viewing by transmitted light. The processed slides are on the actual film that was exposed in the camera.

Special Films—There are a lot of special-purpose films. Some are discussed briefly later in this chapter.

EXPOSING FILM

Film has a clear base on which is coated a light-sensitive photographic *emulsion* composed of silver-halide particles dispersed in gelatin. It is ex-

posed by allowing light to reach the emulsion surface. Where light strikes the emulsion, silver-halide particles are sensitized. Brighter light sensitizes more of the particles. An invisible, *latent* image is formed.

After exposure, the film is processed chemically. Development changes the sensitized particles of silver halide into metallic silver particles, which are black and opaque to light.

Although black-and-white film is simpler and easier to understand than color film, the basic concepts apply equally to both. The essential difference is that color film produces a color image. The concepts discussed here, such as underexposure, are illustrated with color photos.

Brightness Range—The various parts of a scene or subject reflect light toward the camera. The subject has a range of brightnesses.

Density Range—When negative film is exposed and then developed, a white area of the scene causes the negative to be black. Black areas in the scene cause the negative to be clear. Intermediate brightnesses in the scene produce intermediate tones. The darkness of an area on the film is called its density. The film has a range of densities.

Exposure Range—The goal of photography is to record each part of a scene by a tone that is proportional to its brightness. Each brightness of the scene must have a corresponding density on the negative.

The scene must be exposed in such a way that the brightness range of the scene fits within the density range of the film. This is possible only within a specific exposure range.

Characteristic Curve—Figure 4-1, on page 42, shows how negative film responds to exposure. It shows a range of exposures along the bottom of the graph—caused by the scene brightness range.

The resulting range of film densities is shown along the left. Each different value within the exposure range causes a different density on the film. This

To duplicate an old black-and-white photo from the family album, I used a MAXXUM AF 50mm Macro lens to make this black-and-white negative. The brightnesses, or tones, are reversed.

This is a print from the negative. Brightnesses are reversed again in the printing process, so the image looks normal.

graph shows the film's characteristic curve. The curve is relatively straight along the middle but it has a *toe* at the bottom and a *shoulder* at the top.

Notice that the toe of the curve flattens out toward horizontal. If exposure extends into the toe area, the resulting densities can not be distinguished from each other. This causes loss of shadow detail in the print. Similarly, if the shoulder of the film curve is used, highlight detail is lost. Brighter objects in the scene blend together and are lost in solid white.

Fitting Scene Brightnesses onto the Curve—To make a good exposure, the scene brightness range must fit in the straight-line section of the characteristic curve of the film.

By using exposure controls on the camera, as discussed in the next chapter, you can center the scene brightness range on the straight section of the curve. Then, if the brightness range is not too wide, neither the toe nor the shoulder will be used and an acceptable

exposure results. That is the situation shown by Figure 4-1.

Underexposure—If you place the exposure too far to the left on the curve, the toe section will be used and the photo will lose shadow detail. That is underexposure.

Overexposure—If the scene brightness range is too far to the right, the shoulder is used and you lose highlight detail. That is overexposure.

Over- or underexposed negatives can usually be improved during printing. However, shadow or highlight details that are lost on the negative cannot be restored.

Brightness Range Too Wide—If the scene brightness range is wider than the straight part of the curve, the photo loses shadow or highlight detail or both, depending on how the exposure is placed on the curve.

Calculating Brightness Range—The exposure range on the film is determined by the scene's brightness range. Exposure is measured in steps.

Each step is double the next smaller value.

A very dark object may reflect about 3% of the light that falls on it. A white object may reflect about 96%. It's easy to calculate the number of exposure steps between those extremes by doubling numbers starting with 3%:

3 - 6 - 12 - 24 - 48 - 96

The dashes represent exposure steps. The range is 5 steps.

General-purpose black-and-white film can accept about seven steps of exposure without getting too far into the toe or shoulder and losing detail.

Uneven Scene Illumination—If 100 "units" of light fall everywhere on a scene, then the part that reflects 3% will reflect 3 units, and so forth.

The brightness range of a scene is determined both by the reflectivity of objects in the scene and variations of illumination on the scene. If part of the scene receives 100 units of light but another part receives only 25 units because it is in shadow, the scene brightness range may be increased.

Suppose the darkest object in the scene is in shadow. It reflects 3% of 25 light units, which is only 0.75 units. There are now seven exposure steps:

0.75 - 1.5 - 3 - 6 - 12 - 24 - 48 - 96

To avoid losing highlight or shadow detail, exposure must now be very accurate.

In bright sunlight with shadows, the usable exposure range of the film may be exceeded. You can set exposure to lose shadow detail, or highlight detail, or some of each. Setting exposure is discussed in Chapter 5.

EXPOSURE LATITUDE

Exposure latitude depends both on the number of exposure steps the film can accept and the brightness range of the scene.

The color print, left, was made from the color negative, right. In a color negative, scene brightnesses as well as colors are reversed. Making a color print reverses brightnesses and colors again, so the print resembles the original scene. Photo by Josh Young.

If the usable part of the film's characteristic curve is seven steps wide and the brightness range of the scene is also seven steps, there is no exposure latitude. The exposure must be exactly centered on the usable part of the curve.

If the brightness range of the scene is only four steps, then there is some exposure latitude. You can place the exposure a little to the left or right on the curve without losing picture detail. The overall appearance of the photo will be a little lighter or darker than if you had centered the exposure.

COLOR SYNTHESIS

The human eye responds to three *primary* colors: red, green and blue. All other colors are made up by combinations of these three.

If your eye sees a mixture of equal amounts of red, green and blue, your brain "sees" white light. If the brightness of all three colors is reduced, you perceive a shade of gray. When there is no light, you see black.

There are three *complementary* colors, formed by combining primary colors. The combination of red and green produces yellow. Red and blue combine to make a purple color called magenta. Green and blue make cyan.

Each color has many shades. Lighter shades are made by adding white. If no white is present, a color is very strong and we say it is *saturated*.

COLOR NEGATIVE FILM

In its simplest form, color negative film has three layers of emulsion, each similar to the emulsion of black-and-white film. The film is manufactured so that each layer responds to only one of the three primary colors.

When color negative film has been exposed, each layer has a latent image that records a single primary color. For example, the red-sensitive layer has a "map" showing the amount of red at each point on the scene.

In processing, the latent silver-halide image in each layer is developed and then replaced with a visible color image formed by a chemical dye. The colors are complementary—"reversed" compared to the actual colors of the scene. The layers are cyan, magenta and yellow. The layers are negative—each has reversed colors and reversed brightnesses of the scene.

To make a color print, white light is projected through the color negative to expose color printing paper. Color printing paper also has three layers, similar to the three layers of the negative. The result is that the scene brightnesses and colors are reversed again to provide a positive image that resembles the original scene.

Exposure Considerations—The usable exposure range of color negative film is *narrower* than that of black-and-white film. Typically, it is about five exposure steps, which is enough to record most scenes and subjects under uniform illumination but not enough for outdoor scenes with bright sunlit and dark shaded areas.

If you can control the lighting, such as in a studio, avoid large variations of light on the scene. Outdoors, shooting on an overcast day will avoid loss of shadow detail. In sunlight, you can lighten the shadows by using flash or a reflector card.

A reasonable amount of overexposure and a little underexposure of the negative can be compensated during printing.

COLOR SLIDE FILM

Color slide film also has three silver-halide layers, each responding to a single primary color. In the developing procedure, each layer is converted to the original primary color and brightness. The result is a positive image on the same piece of film that was originally exposed in the camera.

Exposure Considerations—Slide film also has a characteristic curve with a toe and shoulder. The usable exposure range is about five or six steps.

Because there is no separate printing operation during which exposure errors may be corrected, correct exposure of the positive image is dependent on the original camera exposure.

FILM SPEED

Each film type is assigned a film-speed number, such as 25 or 400, by the manufacturer. The purpose is to tell the camera how much exposure the film needs to place the brightness range of an *average* scene at the correct location on the film's characteristic curve.

THE STANDARDS

The system of ASA film-speed ratings shown in Figure 4-3 was developed by the American Standards Association (now called the American National Standards Institute).

In Germany, a system called DIN has been used. DIN film-speed numbers are followed by a degree symbol.

The International Standards Organization (ISO) method of specifying film speed simply combines ASA and DIN numbers, as shown in Figure 4-2.

Most cameras use ASA numbers on film-speed dials. In literature, and on camera controls, they are referred to as ISO/ASA, or just ISO.

EFFECT ON EXPOSURE

In Figure 4-3, the standard film speed series is shown by the bold numbers, such as 25, 50, 100, 200 and so forth. These numbers double as the series progresses.

Higher film-speed numbers represent faster films, requiring less exposure. Each *larger* number in the standard series asks for an exposure that is *half* that required for the preceding value.

The difference in exposure between one standard film-speed number and the next is one exposure step. ISO 400 film requires one step *less* exposure

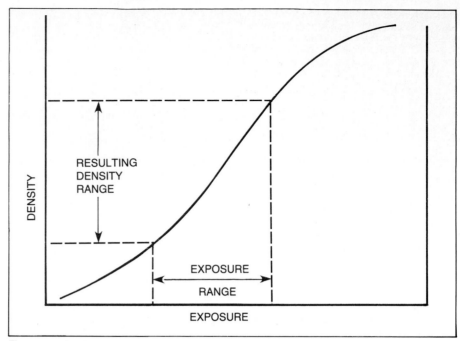

Figure 4-1/Each type of film has a characteristic curve similar to this. It shows how the exposure range is converted to a range of densities in the processed film. The center part of the curve is straight, or nearly so. When the exposure range falls mainly on that part, the result will be a satisfactory record of the scene.

than ISO 200 film.

Not all films have speeds that can be stated by numbers in the standard series. Between the standard speeds are two intermediate speeds, representing one-third steps of exposure. The intermediate settings are shown in the right column of Figure 4-3.

CHOOSING FILM SPEED

Most types of film are available in a range of film speeds. To shoot in dim light, you may prefer a fast film, such as ISO 400 or faster. Fast film requires shorter exposure times, which may allow you to handhold the camera rather than putting it on a tripod.

In bright sunlight, fast film may be a disadvantage because it forces you to use both small aperture and fast shutter speeds. To control depth of field, you may prefer a larger aperture.

Usually, slower films produce sharper images with less visible grain.

COLOR BALANCE

If colors are believable and satisfactorily close to the original scene, the film has good color balance. Films of various types have slightly different color balance. Some show skin tones that are *warm,* meaning slightly reddish, or *cold,* meaning slightly bluish.

Photo magazines often publish surveys of color films with test photos, so you can judge color balance and other factors relating to image quality.

Daylight and Tungsten Films— Color print and slide films are both available with color balance suitable for use either with daylight illumination or incandescent lamps with tungsten filaments. The film carton is marked Daylight or Tungsten. More information on this topic is provided in Chapter 6.

FILM STORAGE

After manufacture and during storage, film changes its characteristics slowly until it is developed. The changes are accelerated by high temperature and high humidity. They are reduced by storage at low temperatures and virtually stopped by freezing.

In the underexposed photo, large areas are black and without detail. More exposure resulted in an acceptable photo, with detail in the shadow areas. Excessive exposure would have burned out the colors in the highlight areas.

Film cartons are imprinted with an *expiration date*. After this date, image quality *may* no longer be satisfactory.

Films are available as professional or general-purpose. The difference is mainly in storage requirements.

General-Purpose Films—Films for the general public are held at room temperature until sold and usually held by the user at room temperature until exposed and processed.

During this time, the color balance will slowly change. For general use, the change is so small that it is usually acceptable or perhaps not even noticed. The expiration date shows the approximate end of the usable life, when stored at room temperature.

If you store general-purpose film in a refrigerator, the change in characteristics will slow down greatly. However, it does not guarantee that the film is at its optimum color balance when you use it.

Professional Films—After manufacture, professional films are held at the factory until they have aged to the best color balance. They are refrigerated to stop further changes and shipped under refrigeration to retail suppliers of professional films. At the store, they should be held under refrigeration. After purchase, and after exposure, they should be refrigerated until processed.

Deliberate underexposure can sometimes produce interesting silhouettes.

Storage—Store film as suggested on the carton. If you must store film a very long time, you can freeze it. This may protect its quality even beyond the expiration date on the carton.

Film packages are sealed, to protect film from humidity. Leave film in the original packaging until just before you use it.

If you refrigerate film, keep it in the original packaging while being refrigerated and for a sufficient time afterward to allow it to return to room temperature. If you open it while it is still colder than the surrounding air, moisture may condense on the emulsion, which will ruin it.

For 35mm film cartridges refrigerated in individual cartons, three hours is normally enough time for it to return to room temperature. If frozen, allow about 24 hours.

Color photos with strong, vivid colors tend to attract attention. The presence of people in a photo adds interest and "tells a story." These hot-air balloonists are erecting the balloon by filling it with hot air, preparing to launch.

FILM-SPEED RATINGS

ISO	ASA	DIN
6/9°	6	9°
8/10°	8	10°
10/11°	10	11°
12/12°	12	12°
16/13°	16	13°
20/14°	20	14°
25/15°	25	15°
31/16°	32	16°
40/17°	40	17°
50/18°	50	18°
64/19°	64	19°
80/20°	80	20°
100/21°	100	21°
125/22°	125	22°
160/23°	160	23°
200/24°	200	24°
250/25°	250	25°
320/26°	320	26°
400/27°	400	27°
800/30°	800	30°
1600/33°	1600	33°
3200/36°	3200	36°
6400/39°	6400	39°

Figure 4-2/This table shows film speed using three film-speed rating systems. The ISO system merely combines the earlier ASA system and the DIN system.

RECIPROCITY FAILURE

The equation shown earlier,

$$Exposure = Intensity \times Time$$

represents the *reciprocity law*. It says that doubling exposure time, at a specific light intensity, will double the exposure of film.

That is true over a wide range of exposure intervals. However, with very short and very long exposure times, it is not exactly true. Those deviations are referred to as failures of the reciprocity law, or *reciprocity failure*.

When reciprocity failure occurs, at either long or short exposures, the film does not receive as much exposure as it should. The basic adjustment is to give more exposure by using larger aperture or extending the exposure time.

With black-and-white and color films, exposures longer than about 1 second may cause long-exposure reciprocity failure.

Exposures of about 1/1000 second cause noticeable reciprocity failure

with very few films. Color films generally tolerate even shorter exposures and corrections are usually not needed.

Very short exposures are produced by electronic flash. Because you can't make the flash last longer, use a larger aperture, should a correction be needed.

With long exposure times, there are two ways to give more exposure: larger aperture or even longer exposure time. Larger aperture is better, because longer time adds more reciprocity failure.

Effect on Color—Color films suffer long-exposure reciprocity failure. The three emulsion layers go into reciprocity failure at different exposure times and to different degrees. This causes a change in color balance.

Correction for Color Films—The correction is increased exposure plus use of a color filter over the lens to correct the change in color balance. Filters are discussed in Chapter 6.

Correction for Black-and-White Films—The correction is both in-

creased exposure and a change in development time.

SPECIAL FILMS

There are a lot of special-purpose films. Here are a few types:

Black-and-White Infrared Film—This film is sensitive both to visible light and to infrared. It is normally used with a dark red filter over the lens, which blocks all or most of the visible light. The film then records mainly the IR light reflected by the scene. This often gives a surrealistic effect or makes a daylight photo appear to have been taken at night.

Color Infrared Film—This is color slide film. The three emulsion layers record red, green and IR images of the scene. This film has medical and scientific uses. It is also used, with color filters, to produce startling color slides whose colors are greatly altered from the original scene.

Chromogenic Black-and-White Film—The word *chromogenic* means

FILM-SPEED NUMBERS USED IN MAXXUM CAMERAS

Standard ASA Values	One-Third Steps
6	
	8
	10
12	
	16
	20
25	
	32
	40
50	
	64
	80
100	
	125
	160
200	
	250
	320
400	
	500
	640
800	
	1000
	1250
1600	
	2000
	2500
3200	
	4000
	5000
6400	

Figure 4-3/MAXXUM cameras display ASA film-speed numbers in full steps and intermediate one-third steps.

Monochromatic scenes, containing various shades of just one color, or very similar colors, can make very effective photographs. We sometimes overlook the excellent opportunities provided by such subjects. Here's a green Louisiana swamp, "muddy" Mississippi mud, and an equally gray and muddy rear view.

to produce color. This film produces black-and-white images in a way similar to color films. The latent silver image is replaced with a black or near-black dye image. The result is similar to a normal black-and-white negative except that the image is formed by dye rather than particles of metallic silver. Processing is the same as for color negative film and most film labs can do it.

The advantages are less visible grain in the image and variable film speed. Chromogenic film can be exposed over a range of film-speed settings without any change in processing.

Instant Slide Film—This is a self-developing color slide film, similar to instant print film. It can be used in any 35mm SLR camera. It is developed in a small accessory developing machine.

FILM INFORMATION

Manufacturers regularly introduce new films and often change the characteristics of existing film types. For up-to-date information, consult the film manufacturer or your photo dealer.

Exposure Metering and Control

MAXXUM cameras have a built-in exposure-control system that measures scene brightness and then calculates aperture size and shutter speed to correctly expose an *average* scene. The camera is designed on the assumption that you will photograph average scenes. When you photograph non-average scenes, you have to correct the exposure.

Because the camera "knows" the film speed, it also "knows" how much exposure the film needs.

AVERAGE SCENES

An average scene reflects 18% of the total light falling on the scene. Lighter areas reflect more than dark areas but, on the average, 18% of the light is reflected toward the camera.

Average scenes are usually those without large areas that are very light or dark. Most of the scenes that we photograph, such as landscapes, are average.

GRAY CARD

Camera shops sell cards called *18% gray cards* that have the same reflectance as an average scene. A gray card represents an average scene. It can be used as a substitute for the scene when measuring and setting exposure. Visually, a gray card is a medium shade of gray—sometimes called "middle" gray.

When a lot of water vapor or haze is present in the atmosphere, distant scenes appear indistinct and lack color saturation. To improve such images, include nearby objects with strong colors, such as the boats in the foreground.

An average scene has an overall reflectance of 18% even though no object in the scene may reflect exactly 18% of the light. This scene is average because it is a mixture of light and dark that totals a reflectance of approximately 18%. A camera's exposure meter will correctly expose average scenes.

This is an 18% gray card, shown in comparison with a black camera and a white lens box. The background is gray paper, about one step lighter than the gray card.

The Main Switch of this MAXXUM 5000 is set to ON. To turn on the camera exposure meter and display, touch the Operating Button (arrow).

With the camera switched on and your finger on the Operating Button, the viewfinder display shows the metered shutter speed and aperture settings. This camera is set to 1/250 second and f-5.6. If you prefer a different shutter-speed or aperture setting, make the change before shooting.

EXPOSURE METERING

The combination of a light-measuring sensor and an exposure calculator is called an exposure meter. The exposure meter measures light coming through the lens. Such meters are called Through-The-Lens (TTL) exposure meters.

OPEN-APERTURE METERING

MAXXUM cameras hold the aperture wide open until the moment of exposure, so you get the brightest view of the scene.

Exposure metering is done before exposure, with the lens wide open. This is called *open-aperture metering* or *full-aperture metering*.

ON-OFF

With the camera Main Switch set to ON, the exposure meter and display are turned on by touching the Operating Button. If you remove your finger from the button, the meter remains on for 10 seconds. The Operating Button also controls the autofocus system.

THE LIGHT SENSOR

A light sensor responds electrically to the amount of light falling on it. MAXXUM cameras use silicon sensors, called silicon photo cells, abbreviated SPC. The location of the sensor is discussed later.

METERED EXPOSURE

Based on the amount of light from the scene and on the film speed being used, the camera calculates suitable aperture and shutter-speed settings to provide correct exposure of an average scene.

That is the metered exposure. It's what the camera "recommends" for the scene being metered. You can use that exposure or a different amount. If the scene is average, the metered exposure is usually correct.

This is not an average scene because it is predominantly white. Unless corrected, the camera exposure meter would record it as a medium gray. Correction is to give about 2 steps more exposure than the camera meter suggests.

Visible in the viewfinder is an exposure display that shows the metered shutter speed and aperture. MAXXUM cameras also have a display on the top of the camera, called a Display Panel. MAXXUM 7000 and 9000 cameras also show the meter reading on that panel.

ADJUSTING FOR NON-AVERAGE SCENES

The main reason to use an exposure that is different from the camera-recommended value is to photograph scenes that are not average.

The camera exposure meter "assumes" that every scene you photograph reflects 18% of the light. It will always recommend an exposure that makes the picture look that way.

If you photograph snow and use the metered exposure, the result will be snow that looks 18% gray. The snow will be underexposed. If you photograph black velvet using the metered

exposure, the result will be velvet that is overexposed so it looks 18% gray. Neither snow nor black velvet are average scenes.

Corrections—If snow is the subject of your photo, and you want it to look white in the picture, you must prevent the camera exposure system from recording it on film as an 18% gray tone. *Increase* exposure about 2 steps more than the camera meter suggests.

If black velvet is the subject, you must use about 2.5 steps *less* exposure than the meter reading.

Light Background—If you photograph a person against a snow bank, the exposure meter reads light reflected from both. The metered exposure depends on how much of the light is from the subject and how much from the background.

If the person is small compared to the snow background—as you view the scene in the viewfinder—then the exposure meter sees mainly background, which is similar to the situation just discussed. If you use the metered exposure, the snow is underexposed by about 2 steps. The subject is also underexposed by about 2 steps. The subject will appear as a silhouette against a gray background.

If the subject is large compared to the background, then the exposure meter sees mainly the subject. People wearing clothing that is medium-toned look like an average scene to the exposure meter. No exposure correction is required.

Dark Background—A subject against a large dark background will also "fool" the exposure meter. The camera will recommend too much exposure. If you shoot that way, the result will be an overexposed subject against a medium background. The correction is to use *less* exposure than the metered value.

When is Correction Needed?—If the subject is small compared to the background, and the background is unusually light or dark, correction is needed.

If the subject is large compared to the background, expose for the subject. No correction for background is needed.

SKIN TONES

The reflectance of light skin is about 36%, which is one exposure step greater than 18%. If the meter reading is dominated by light skin, and you shoot at the recommended exposure, the skin tone will end up near 18% in the image.

Theoretically, that is too dark and correct exposure should require one more exposure step. If the meter reading includes both skin and background, you should also consider the effect of the background. If the background is darker than skin, the camera will give more exposure automatically.

METERING PATTERNS

Some exposure meters have greater sensitivity in one part of the frame than in other parts. A "map" showing the area of increased sensitivity is called a metering pattern.

Full-Frame Averaging—The simplest metering pattern is no pattern at all. The light meter measures light at all parts of the scene and averages the result. MAXXUM cameras don't use this pattern.

Center-Weighted Averaging—Usually, the main subject is near the center of the frame. A center-weighted meter-

EXPOSURE CORRECTION FOR NON-AVERAGE SCENES

Background	Correction
White	2 steps more
Light	1 step more
Average	Metered exposure
Dark	I step less
Black	2 to 2.5 steps less

This table shows how to correct exposure for a small, medium-toned subject against a large background that is visible to the exposure meter. The corrections suggested are approximate.

Light measurement by the center-weighted averaging method uses a metering pattern with maximum sensitivity at the center, decreasing toward the edges of the frame.

ing pattern is more sensitive at the center of the frame. That reduces the effect of the background on the meter reading. The meter measures light from the entire frame, but assigns more "weight" to the brightness in the center of the frame. MAXXUM cameras use center-weighted metering.

Spot Metering—Spot meters measure light in a small circular area at the center of the frame and ignore the scene outside that spot. In addition to center-weighted metering, the MAXXUM 9000 offers spot metering as an option. The metering spot is shown by a circle on the focusing screen.

Exposure Considerations—With center-weighted metering, exposure correction for non-average scenes may be needed. It depends on how much background appears in the more sensitive central metering area. The center-weighted metering area is not marked in the viewfinder.

If the subject is at the center of the frame, and occupies about one-third of the area in the frame, the subject will dominate the meter reading. You can ignore the background.

With spot metering, the metering area is precisely defined. You don't have to worry about anything outside that circle. You do have to evaluate what's in the spot because the metered exposure will cause that area to record on film as though it had 18% reflectance—whether it does or not.

EXPOSURE MODES

MAXXUM cameras have several exposure modes, selected by a control on the camera. In each mode, the camera presents an exposure display in the viewfinder.

METERED MANUAL

In this mode, you set both aperture and shutter speed using controls on the camera. The mode is called *metered manual* because the camera exposure meter serves as guide while you set exposure manually. You can use the metered exposure or any other exposure.

When you select manual, the camera display shows an M symbol and the shutter-speed and aperture you selected manually. The display also shows whether or not the exposure you are using agrees with the metered exposure. The method of comparing set exposure to metered exposure varies among models and is discussed later.

Using Manual—The manual mode provides creative control of photographs. Here are some examples:

You want to record an average scene so it looks dark and gloomy. Use less than the metered exposure.

You want to control depth of field, therefore the aperture setting has *priority*. Set the aperture size that gives the desired depth of field. Then, use whatever shutter speed is needed to control exposure.

You want to control image blur of a moving subject, therefore shutter speed has *priority*. Set the shutter speed that gives the desired amount of blur. Then use whatever aperture size is needed to control exposure.

As you will see, there are ways to create those effects in automatic exposure modes, too. Automatic modes are usually more convenient to use.

With center-weighted metering, changing composition often changes exposure. These photos were made with a MAXXUM zoom lens, using automatic exposure. When zoomed in, only people were in the frame and exposure was satisfactory. When zoomed out for a wider view, the sky affected the meter reading. The camera used less exposure and faces were underexposed.

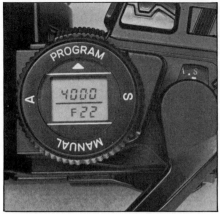

On the MAXXUM 9000, the Exposure-Mode Selector surrounds the camera's Display Panel. Rotate the selector to choose an exposure mode. This camera is set for programmed automatic exposure. On other models, exposure modes are set by pressing control keys.

ANGLE OF VIEW OF MAXXUM 9000 SPOT METER		
Lens Focal Length (mm)	Lens Angle of View (degrees)	Spot Angle of View (degrees)
24	84	13
28	75	11
35	63	9
50	47	6.3
70	34	4.5
85	29	3.6
100	24	3.1
135	18	2.3
200	12.5	1.6
300	8.2	1.0
600	4.1	0.5

Because the diameter of the spot metering circle is a fixed proportion of the frame diagonal, the spot metering angle is closely proportional to the lens angle of view.

APERTURE-PRIORITY AUTOMATIC

You set aperture manually, which allows control of depth of field. The camera then sets shutter speed automatically for correct exposure of an average scene. In this mode, the camera displays an A symbol, the aperture setting made by you, and the shutter-speed setting made by the camera.

SHUTTER-PRIORITY AUTOMATIC

You set shutter speed manually,

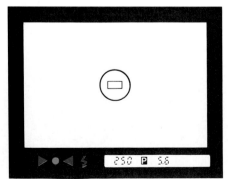

Spot metering measures light in a central spot only. The MAXXUM 9000 offers both center-weighted averaging and spot metering. A 5.5mm circle at the center of the frame defines the spot-measuring area.

which allows control of image blur. The camera automatically sets aperture for correct exposure of an average scene. In this mode, the camera displays an S symbol, the shutter-speed setting made by you, and the aperture setting made by the camera.

PROGRAMMED AUTOMATIC

Using a built-in program, the exposure computer in the camera sets *both* aperture and shutter speed for correct exposure of an average scene. The camera displays a P symbol, or the word PROGRAM, and the exposure settings made automatically by the camera.

Multiple Programs—When hand-holding the camera, faster shutter speeds should be used with long-focal-length lenses to reduce image blur due to camera shake. For that reason, MAXXUM cameras have three built-in programs that are designed to use faster shutter speeds with longer focal lengths, and slower speeds with shorter focal lengths.

Program Selection—The program to be used is selected automatically, depending on the focal length of the lens. Minolta refers to this as *Automatic Multi-Program Selection (AMPS)*. Using the electrical contacts on the back of each MAXXUM lens, the lens

"tells" the camera what its focal length is. Then, the camera selects the program for that focal length.

With a zoom lens, the program will change automatically if you zoom from one focal-length range to another.

Standard Program—This program is used with focal lengths from 35mm to 105mm. Programs for the MAXXUM 7000 are shown in Figure 5-1. The top right corner represents the smallest aperture and the fastest shutter speed. Those values would be used with a very bright scene.

If scene brightness decreases, both aperture and shutter speed change gradually, following the graph labeled STANDARD. When aperture has changed to f-11, shutter speed is approximately 1/500. At f-1.4, shutter speed is midway between 1/30 and 1/60.

If the light becomes still darker, aperture remains at f-1.4 and shutter speeds become progressively slower until the slowest available shutter speed is reached.

Tele Program—Automatically selected with focal lengths longer than 105mm, this program provides faster shutter speeds than the standard program. Faster shutter speeds require larger apertures, so depth of field is reduced.

Wide Program—Automatically selected with focal lengths shorter than 35mm, shutter speeds are slower than the standard program. The aperture is relatively smaller and depth of field is increased.

Comparison—In the program graph of Figure 5-1, at f-5.6 the Tele program uses a shutter speed of about 1/600 second. The Standard program uses 1/250 second. The Wide program uses 1/60 second.

Notice that the difference among the three program graphs is their slopes—how steeply they angle upward from the bottom.

Program Limits—The program graph in Figure 5-1 is for a lens with an aperture range of f-1.4 to f-32 and ISO 100 film. If a different lens or film speed is used, the slopes of the program lines don't change, but all of the programed values may not be available. In the camera descriptions in Chapter 10, more detailed program graphs are shown, so you can see what the limits are.

Other Models—The MAXXUM 5000 and 9000 have similar programs, shown in Chapter 10. The differences are in the range of shutter speeds along the bottom.

PROGRAM SHIFT

In a programmed exposure mode, touching the Operating Button causes the selected aperture and shutter speed to be displayed in the viewfinder, along with a P (program) symbol.

With the MAXXUM 7000 or 9000, if you prefer a different shutter speed, use the camera shutter-speed control keys to select the desired speed. Aperture will change accordingly to keep the same exposure.

If you prefer a different aperture, use the aperture control-keys to change it. Shutter speed will change automatically to maintain the same exposure.

This is called *program shift*. The P symbol in the viewfinder blinks as a reminder that the program has been

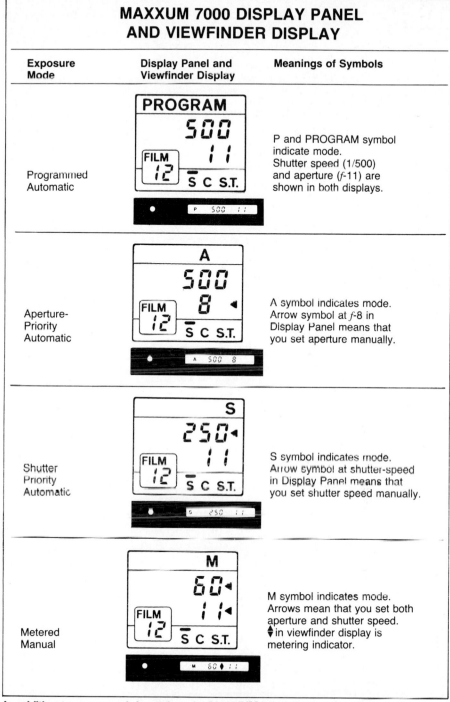

MAXXUM 7000 DISPLAY PANEL AND VIEWFINDER DISPLAY

Exposure Mode	Display Panel and Viewfinder Display	Meanings of Symbols
Programmed Automatic	PROGRAM 500 11 FILM 12 S C S.T. / P 500 11	P and PROGRAM symbol indicate mode. Shutter speed (1/500) and aperture (f-11) are shown in both displays.
Aperture-Priority Automatic	A 500 FILM 12 8 ◄ S C S.T. / A 500 8	A symbol indicates mode. Arrow symbol at f-8 in Display Panel means that you set aperture manually.
Shutter Priority Automatic	S 250 ◄ FILM 12 11 S C S.T. / S 250 11	S symbol indicates mode. Arrow symbol at shutter-speed in Display Panel means that you set shutter speed manually.
Metered Manual	M 60 ◄ FILM 12 11 ◄ S C S.T. / M 60 ♦ 11	M symbol indicates mode. Arrows mean that you set both aperture and shutter speed. ♦ in viewfinder display is metering indicator.

In addition to exposure information, the MAXXUM 7000 Display Panel shows frame count and drive mode. This camera is set for single frames and will expose frame 12 next.

shifted. Shifting can be done in half-step increments of shutter speed or aperture.

When you shift the program, the camera continues to operate in the programmed mode. If the light changes, aperture and shutter speed change. But, they follow a *different* program graph, created by the program shift.

METERING INDICATORS IN MANUAL MODE

MAXXUM Camera	Viewfinder Display	Indication
5000 and 7000	M 250 ↕ 5.6	Manual exposure setting agrees with camera meter reading. Exposure should be OK for an average scene.
	M 60 ▲ 5.6	Manual exposure setting is 1/4 step or more higher than meter reading.
	M 500 ▼ 5.6	Manual exposure setting is 1/4 step or more lower than meter reading.
9000	250 5.6 M+0 ☐	Either +0 or -0 mean that Manual exposure setting agrees with camera meter reading. Exposure should be OK for an average scene.
	60 5.6 M+2 ☐	Exposure-Deviation Indicator shows manual exposure setting is 2 steps higher than camera meter reading. Upper limit of indicator is +6.5 steps. Above that, +6.5 blinks.
	500 5.6 M-1 ☐	Exposure-Deviation Indicator shows manual exposure setting is I step lower than camera meter reading. Lower limit of indicator is -6.5 steps. Below that, -6.5 blinks.

MAXXUM 5000 and 7000 cameras use "up arrows" and "down arrows" to show if manual exposure setting is greater or less than metered exposure. MAXXUM 9000 uses Exposure-Deviation Indicator numbers to show actual deviation of manual exposure setting from metered exposure. Limit of exposure-deviation indication is plus or minus 6.5 steps.

Figure 5-2 is an example. The original settings were f-8 and 1/500 second, approximately, selected by the program. Then, the user shifted aperture two steps smaller to get more depth of field. Shutter speed changed by two steps to maintain exposure. The shifted values are f-16 and 1/125 second, approximately.

The new values are on a new program line that is similar to the original except it has been *shifted* to the left. The new line is parallel to the original and has the same slope.

If the light changes, the camera will use the shifted program line. If you shifted aperture to make it two steps smaller, the new program line will always provide an aperture that is two steps smaller than the original program line.

The shift will remain in effect as long as you touch the Operating Button, even if you make more than one exposure. Before making an exposure, you can lift your finger for up to 10 seconds without losing the shift. After exposure, when you remove your fin-ger, the shift is canceled immediately.

Shifting changes program limits, as you can see on the shifted graph. If you can't get an aperture or shutter speed that you would like to use, you have encountered a limit.

With a zoom lens, set focal length first, then shift. If you shift and then change focal length, the camera may change programs. The new program will be shifted, but both aperture and shutter speed will be different than you had set.

SENSOR LOCATION

Two locations for exposure-meter light sensors are used in MAXXUM cameras, as shown in the drawings on page 55.

Sensor in Viewfinder—A sensor in the viewfinder, above the focusing screen, measures image brightness on the focusing screen. Metering is done with the mirror down, before the exposure. The camera "remembers" the exposure reading because, when the mirror moves up, light to the viewfinder is blocked and the exposure meter can no longer operate.

Sensor in Mirror Box—Another sensor location is the bottom of mirror box, looking backward toward the film. Depending on the camera model, a sensor at this location may be used for more than one purpose. One is TTL (through the lens) autoflash metering.

With the mirror up and the shutter open, the flash is fired. The sensor measures light on the film—actually light reflected by the front surface of the film. When exposure is sufficient, the camera turns off the flash.

Controlling flash exposure with a sensor in the mirror box works because the emulsion surfaces of most general-purpose films have about the same reflectivity. Some special-purpose films have different reflectivities. If so, exposure correction may be necessary. The correction can be found by testing.

With a special mirror arrangement, a sensor at the bottom of the mirror box can also be used to measure light from

The middle photo was made at metered exposure. The darker shot received one step less exposure. The lighter shot received one step more. The underexposed photo tends to lose detail in the deepest shadows. The overexposed photo has lost detail in the brightest area.

the scene, before exposure. When so used, it replaces a sensor in the viewfinder by providing the same function. This requires a special sub-mirror behind the main mirror.

All MAXXUM cameras have a semi-transparent main mirror and a sub-mirror to reflect light downward to the electronic focus detector. The MAXXUM 9000 uses a special sub-mirror with two reflecting surfaces. The center part is angled to reflect light downward into the focus detector. The rest of the sub-mirror is angled to reflect light to the light sensor at the bottom of the mirror box, adjacent to the focus detector.

Before exposure, with the mirrors down, the light sensor measures light from the scene, transmitted through the main mirror and reflected downward by the sub-mirror. The camera exposure system calculates aperture and shutter speed.

The MAXXUM 9000 light sensor has two parts. The center portion performs spot metering. The surrounding area is used for center-weighted metering.

EXPOSURE LIMITS

There are two kinds of exposure limits that you may occasionally encounter. They have different warnings in the camera viewfinder.

Metering Range—Exposure meters have a range of scene brightnesses over which they measure accurately. With automatic exposure, the range of accurate metering is also the range of accurate exposures.

MAXXUM cameras warn you by a flashing symbol in the viewfinder if the light is outside the metering range. You can make the exposure anyway, if you wish.

Exposure Range—Another possibility is that metering is accurate, but the necessary exposure setting cannot be made. This can happen with fast film in bright light or slow film in dim light. For example, a film might require f-45

and 1/8000 second. Those settings are not available on the camera.

In the program mode, the camera will set the fastest possible shutter speed and the smallest aperture and then *blink* the values in the viewfinder display as a warning. You can make the shot if you wish, but it may be overexposed.

If maximum aperture and the slowest shutter speed are blinking, the film needs more exposure than the camera can provide. If you make the shot, underexposure is likely.

OVER- AND UNDEREXPOSURE WARNINGS

Over- or underexposure can happen when the camera cannot make suitable settings of the exposure controls, as just described. The table on page 56 shows the warnings for the automatic modes.

On metered manual, there is a metering-range warning but no over- or underexposure warning.

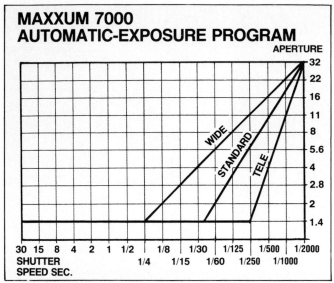

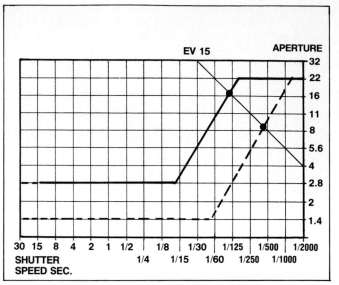

Figure 5-1/MAXXUM cameras have three built-in automatic-exposure programs. One is selected automatically, depending on the focal length of the lens in use. The programs set aperture and shutter speed automatically.

If the WIDE program is being used, *f*-5.6 is paired with a shutter speed of 1/60 second, as you can see on the graph. No other program offers that combination. For example, in the STANDARD program *f*-5.6 is paired with 1/250 second. Only pairs of aperture and shutter speed that fall on one of these program graphs can be used. If you want to use other pairs, you can do so by using other exposure modes.

Figure 5-2/The dotted line represents the original program and the solid line shows the result of shifting. The diagonal line labeled EV 15 represents correct exposure for the scene. In the original program, the exposure settings were approximately *f*-8 at 1/500 second. The shifted program uses *f*-16 at 1/125 second, approximately. This provides the same *amount* of exposure but with different aperture and shutter-speed values.

EV NUMBERS

Exposure Value (EV) numbers are used to state the measuring range of an exposure meter and the operating range of an electronic focus detector. EV units are similar to exposure steps. A change from EV 5 to EV 6 is one exposure step.

The exposure-meter range of the MAXXUM 7000 is EV -1 to EV 20. EV 20 is brighter than a sunlit scene. Bright light is rarely a problem to exposure meters. EV -1 is dim, such as at twilight.

Technically, EV -1 is the scene brightness required to correctly expose ISO 100 film with an aperture of *f*-1.4 and a shutter speed of 4 seconds.

To see how dark that is, using a camera on manual, set film speed to 100, aperture to *f*-1.4 and shutter speed to 4 seconds. Then find a place that is dark enough so the camera exposure display indicates correct exposure.

The autofocus range of the MAXXUM 7000 is EV 2 to EV 18. The exposure meter works farther into darkness than the autofocus system.

AUTOMATIC-EXPOSURE LOCK

The MAXXUM 7000 AND 9000 cameras have an Automatic Exposure Lock button, labeled AEL. In any automatic-exposure mode, pressing the AEL button locks the meter reading at that instant. Exposures will be made at the locked-in meter reading.

One use is to compose with the subject off center. Place the subject in the metering area at the center of the frame. Press the AEL button to hold that exposure. Recompose to put the subject off center. While still holding in the AEL button, press the Operating Button to make the exposure.

Another use is to exclude a bright or dark background. Move close to the subject, so the meter reads mainly the subject. Lock the reading. Move back and make the exposure.

While holding in the AEL button, if you change shutter speed, aperture will

AUTOMATIC PROGRAM SELECTION

Program	Used with:	Gives preference to:
WIDE	Focal lengths shorter than 35mm.	Smaller apertures and depth of field
TELE	Focal lengths longer than 105mm.	Faster shutter speeds and reduced image blur.
STANDARD	Focal lengths from 35mm to 105mm.	Impartial. For general photography

change automatically to maintain the same exposure. Or you can change aperture, and shutter speed will change to compensate.

SUBSTITUTE METERING

This is a way to set exposure for virtually any scene, average or not.

Gray Card—Put an 18% gray card in the scene so it receives the same illumination. Arrange it so surface reflections from the card don't enter the lens. Meter on the card. If the camera is on automatic exposure, press and hold the AEL button to lock the meter reading.

On manual, set the exposure controls for correct exposure of the gray card. Manual settings are locked until you change them. The MAXXUM 5000 doesn't have an AEL button, but it does have metered manual.

If you take a picture as metered from a gray card, the gray card will be correctly exposed. Lighter and darker tones will be more or less correctly placed. Don't include the gray card in the actual picture.

If the scene is distant, hold the gray card in the same light that illuminates the scene, such as sunlight, meter on it and shoot at that exposure. The gray card is a *substitute* for a medium tone in the scene.

Without Gray Card—Any medium-toned metering surface with about 18% reflectance can be used. The substitute metering surface can be in the scene or out, but it must be in the same light.

Nature provides many surfaces that can be used. Grass, green vegetation, brown weeds and dirt, old asphalt paving and other medium tones have about 18% reflectance.

With a Different Reflectance—You don't have to meter on an 18% surface if you adjust for the reflectivity of whatever surface you are using. For example, the palm of a hand has about 36% reflectance. Meter on it and compensate by using one more step of exposure.

The back side of a commercially

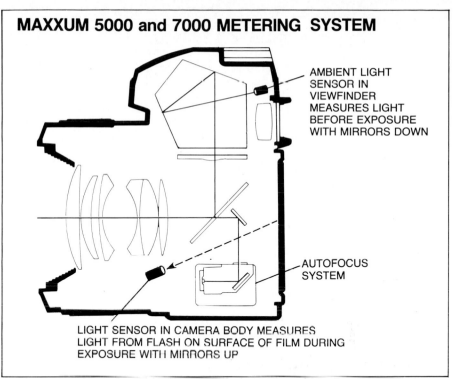

MAXXUM 5000 and 7000 METERING SYSTEM

AMBIENT LIGHT SENSOR IN VIEWFINDER MEASURES LIGHT BEFORE EXPOSURE WITH MIRRORS DOWN

AUTOFOCUS SYSTEM

LIGHT SENSOR IN CAMERA BODY MEASURES LIGHT FROM FLASH ON SURFACE OF FILM DURING EXPOSURE WITH MIRRORS UP

The sensor in the viewfinder measures image brightness on the focusing screen due to ambient light *before* exposure, with the mirrors down. Light passing through the main mirror is reflected downward by the sub-mirror to the autofocus system, also before exposure. With flash, exposure is controlled by the sensor in the bottom of the camera *during* exposure, with the mirrors up. This sensor measures both flash and ambient light on the film surface.

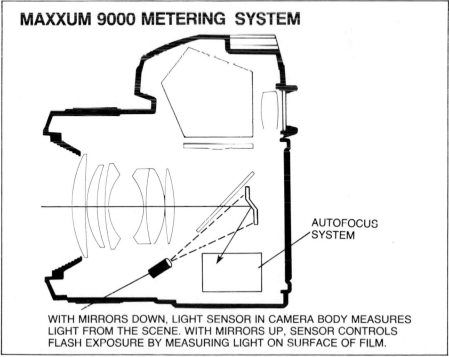

MAXXUM 9000 METERING SYSTEM

AUTOFOCUS SYSTEM

WITH MIRRORS DOWN, LIGHT SENSOR IN CAMERA BODY MEASURES LIGHT FROM THE SCENE. WITH MIRRORS UP, SENSOR CONTROLS FLASH EXPOSURE BY MEASURING LIGHT ON SURFACE OF FILM.

The MAXXUM 9000 has only one light sensor. It's a *compound* sensor with a center section used for spot metering and an outer section for center-weighted averaging.

available 18% gray card is white, with a reflectance of 90%. That's five times as much as 18%. White paper is about the same. If you meter on white, give five times as much exposure, or about 2-1/3 steps more.

EXPOSURE CORRECTION

You may wish to correct exposure for a non-average scene or for some other reason. You may wish to give more or less exposure to a scene for creative reasons.

In any automatic mode, the camera will use the metered exposure as displayed in the viewfinder unless you prevent it.

Exposure-Adjustment—MAXXUM 7000 and 9000 cameras have an Exposure-Adjustment control to temporarily cause the automatic-exposure system to give more or less exposure. The range is plus or minus four exposure steps in half-step increments.

The amount of exposure adjustment being used, or a warning symbol, appears in the viewfinder display. Be sure to set it back to zero when you have finished using it.

Backlight Compensation—The MAXXUM 5000 has a Backlight Compensation button, labeled BLC. Its purpose is to correct exposure for subjects against a light background. A subject indoors, standing in front of a window is an example. With the camera on Programmed automatic, pressing the BLC button gives two steps more exposure.

USING A SPOT METER

The MAXXUM 9000 can be set to use center-weighted or spot metering. Focusing screens for this model have a circle in the center to show the spot-metering area. You can use the spot meter in several ways. This discussion assumes that the camera is set to an automatic-exposure mode.

Measuring a Medium Tone—Set the Metering Selector to SPOT. Meter on an area that should be a medium tone in the resulting photograph, such as a

EYEPIECE CAP AND EYEPIECE SHUTTER

If your eye is not at the viewfinder eyepiece when the camera is measuring exposure, the resulting exposure may be incorrect because of stray light entering the eyepiece. This can happen when you are using the self-timer to take your own picture or when you are controlling the camera remotely, as discussed in Chapter 10.

To prevent incorrect exposure, cover the eyepiece. The MAXXUM 5000 and 7000 cameras are packaged with an Eyepiece Cap for that purpose, as shown in the accompanying photo. Slip the camera neckstrap through slots in the cap, so you don't lose the cap. The

MAXXUM 9000 has a built-in Eyepiece Shutter that is operated by a lever on the eyepiece.

METERING RANGE WARNINGS

MAXXUM Camera	Viewfinder Display	If Light Beyond Range of Accurate Exposure Metering
5000	M 2000 ✳️ 2 2	On programmed automatic or manual exposure ↕ blinks.
7000	M 2000 ✳️ 2 2	In any exposure mode ↕ blinks.
9000	250 P 5.6 ☀️	In any exposure mode ☐ blinks.

face. To recompose, lock exposure first by pressing and holding the AEL button. Make the shot.

Highlight Readings—This method ensures that a white area in the scene reproduces as a white area in a photo. Set the Metering Selector to H. Meter on the white area. Press and hold in the AEL button. Exposure is *increased* by 2.25 steps and locked. The viewfinder exposure display shows the change to the nearest half step. Recompose if you wish and make the shot.

The additional 2.25 steps causes the metered white area to appear white in the photo. If you were to shoot at the metered exposure, the white area would record as medium gray.

Shadow Readings—This method ensures that a black or dark area in the

scene records with that tone. Set the Metering Selector to S. Meter on the dark tone. Press and hold the AEL button. Exposure is *decreased* by 2.75 steps and locked. Recompose if you wish and make the shot.

AVERAGING READINGS

If a scene has light and dark tones, but no medium tones, you can often get a good exposure by averaging readings. Meter the lightest tone and the darkest tone. This is more convenient with a spot meter but can be done with a center-weighted meter by moving closer, if necessary. Count the exposure steps and shoot halfway in between. It is convenient to make the measurements using either shutter or aperture priority. In these modes, only one

value changes and the number of exposure steps between the brightest and darkest tones is easy to calculate.

BRACKETING

A good way to improve the odds of getting a good shot is to shoot at several exposure settings, centered on the exposure you think is correct. That is called *bracketing*.

With negative film, bracketing is usually done in full steps. With color slide film, half steps are usually used.

You can bracket in any exposure mode. In a programmed mode, make half-step or full-step exposure changes with the Exposure-Adjustment control. On Manual, you can change aperture in half steps; shutter speed in full steps only.

DOUBLE AND MULTIPLE EXPOSURES

The MAXXUM 9000 has a control that allows multiple exposures on the same frame.

Non-Overlapping Subjects—With a dark background, give the first subject normal exposure. While holding in the Multiple-Exposure Button with one hand, operate the Film-Advance Lever with the other. Film will not advance and the frame count will not increase. The camera will be set to make another exposure on the same frame.

Compose to place the second subject at a different location in the frame. Give normal exposure.

Repeat to make additional exposure of non-overlapping subjects. With more exposures, the dark background will become progressively lighter. If you give too many successive exposures, it would ultimately become too light to allow recording a satisfactory image of the main subjects.

Overlapping Subjects—Give reduced exposure to each subject, so the *total* exposure on film is normal. For two exposures of overlapping subjects, divide normal exposure for each subject by 2. You can do that by setting Exposure Adjustment to -1. For four

OVER- AND UNDEREXPOSURE WARNINGS

MAXXUM Camera	Exposure Mode	Viewfinder Display	Warning
5000	P	P 500 11	Overexposure: Fastest shutter speed and smallest aperture blink. Underexposure: Slowest shutter speed and largest aperture blink.
7000	P	P 500 11	Overexposure: Fastest shutter speed and smallest aperture blink. Underexposure: Slowest shutter speed and largest aperture blink.
	A	A 500 8	Overexposure: Fastest shutter speed blinks. Underexposure: Slowest shutter speed blinks.
	S	S 250 11	Overexposure: Smallest aperture blinks. Underexposure: Largest aperture blinks.
9000	P	250 P 5.6	Overexposure: Fastest shutter speed and smallest aperture blink. Underexposure: Slowest shutter speed and largest aperture blink.
	A	250 A 5.6	Overexposure: Fastest shutter speed blinks. Underexposure: Slowest shutter speed blinks.
	S	250 S 5.6	Overexposure: Smallest aperture blinks. Underexposure: Largest aperture blinks.

When both shutter speed and aperture blink in the program mode, the camera has tried all possible values of both and there are none that will provide correct exposure of the scene being metered.

When aperture blinks, in the shutter-priority mode, it means that there is no aperture size that will provide correct exposure with the set shutter speed. If you change to a different shutter speed, the camera may find a suitable aperture.

When shutter speed blinks, in the aperture-priority mode, it means that there is no available shutter speed that will provide correct exposure with the set aperture. If you change aperture size, the camera may find a suitable shutter speed.

Program Backs Super 70 and Super 90, used with the MAXXUM 7000 and 9000, handle over- and underexposure in a different way, discussed in Chapter 9.

The basic function of the AE Lock button is to lock exposure while you change composition. It has additional uses with the spot-metering modes of the MAXXUM 9000, and also with MAXXUM dedicated flash—discussed in Chapter 8.

I knew that these bad guys would come out of the saloon eventually. While I waited, I made a substitute meter reading on the medium-toned wood surface to the right of the doorway, in the shade. I held that reading by pressing the Automatic-Exposure Lock (AEL) button. When they came out, I shot 'em!

exposures, divide by 4, setting Exposure Adjustment to -2.

With a camera without an Exposure Adjustment control, you can multiply film speed by the planned number of exposures and set that value temporarily. For three exposures, multiply film speed by 3. Don't forget to reset the Exposure Adjustment or film speed when you have finished.

FILM SPEED

The procedure for setting film speed is shown in Chapter 1.

With DX-Coded Film Cartridges— If you are using DX-coded film, film speed is set automatically by the camera each time you load a roll of film. If you have been using ISO 200 film and change to ISO 400 film that is DX-coded, the camera will automatically change the film-speed setting to 400.

Without DX Coding—If you are using film without DX coding, the camera film speed setting must be made manually. It will not change from roll to roll. If you have been using ISO 400 film, and then load a roll of ISO 64 film without DX coding, be sure to manually change the film-speed setting to 64.

The Exposure-Adjustment control on the MAXXUM 7000 is a pushbutton labeled +/−. If you press it, the amount of exposure adjustment being used is displayed in the viewfinder and the Display Panel. To change it, press and hold the +/− button while pressing either of the Shutter keys. The MAXXUM 9000 works in a similar way.

The MAXXUM 9000 Metering Selector provides center-weighted averaging metering by setting the control to AVERAGE. There are three spot-metering options, labeled SPOT, H (Highlight) and S (Shadow). The H and S settings also require pressing the AEL button.

The unlabeled pushbutton to the right of the AEL button on this MAXXUM 9000 is the Multiple-Exposure Control. Press it and rotate the Film-Advance Lever. Film does not actually advance. The next exposure will be on the same frame.

RULES FOR SUBSTITUTE METERING

Metered Surface	Exposure Correction
Meter on medium tone (18% reflectance).	Follow exposure meter recommendation.
Meter on a **brighter** surface.	Use **more** exposure.
Meter on a **darker** surface.	Use **less** exposure.
Meter on white.	Use 2 to 2.5 steps **more** exposure.
Meter on black.	Use 2 to 3 steps **less** exposure.
Meter on light skin.	Use one step **more** exposure.

EXPOSURE-ADJUSTMENT RANGE AND WARNING

Camera	Range	Viewfinder Warning
9000	+4 to −4 in half steps by +/− button and shutter key.	Amount of adjustment with plus or minus sign blinks in viewfinder at left of rectangular metering indicator.
7000	+4 to −4 in half steps by +/− button and shutter key.	A plus or minus symbol appears in a rectangle at extreme right in the viewfinder display. Amount of adjustment is not shown.
5000	Fixed +2 step increase by BLC button.	No warning. However, the effect occurs only while your finger is on the BLC button.

Using a Different Film-Speed Number—Some photographers prefer to use a film-speed number that does not agree with the standard ISO value printed on the film carton and cartridge. For example, using a film speed that is one-third or one-half step faster than the ISO rating causes a small amount of underexposure that usually produces stronger colors in slides. When a number is used for film speed that does not agree with the ISO rating, the number is called an *exposure index*.

There are two ways to use your own exposure index. If the camera has an Exposure Adjustment control, you can set it to give less exposure in half steps. The other way is to change film speed, which can be done only in one-third steps.

An exposure adjustment setting is held in memory in the camera and does not change from roll to roll. It changes only when you change it manually. This method works whether or not the film cartridges are DX coded.

With film without DX coding, you set film speed manually and the setting is maintained from roll to roll unless you change it manually.

With DX-coded film, the camera automatically resets film speed each time a fresh cartridge is loaded. If you are using ISO 64 film but have been rating it at an exposure index of 80, each new roll will cause the camera to set a film speed of 64. You must remember to change the setting to 80.

You can avoid that problem by taping over the DX coding on each film cartridge. Any kind of plastic (non-

metallic) tape will do. The camera then "thinks" you are feeding it cartridges without DX coding. You can set film speed once and it will stay set until you change it.

THE SUNNY-DAY *f*-16 RULE

For an average scene in direct sunlight, good exposure will be produced by an aperture of *f*-16 and a shutter speed that is the reciprocal of film speed. If film speed is ISO 125, shutter speed should be 1/125 second. That amount of exposure with different control settings will also be OK—such as *f*-11 at 1/250 second.

With ISO 1000 film used outdoors on a sunny day, *f*-16 at 1/1000 second should produce a good exposure. Because of the fast film speed, you are forced to use small apertures and fast shutter speeds. You get lots of depth of field, whether you want it or not.

A film speed of about ISO 100 to 200 is usually a better choice for use outdoors on a sunny day. It gives you a range of aperture sizes to control depth of field and a range of shutter speeds to control image blur.

Light and Filters

Photography has been called *painting with light*. Light can be thought of in two ways—as rays or as waves. Lenses are easier to understand by using the concept of light rays, which travel in straight lines. Colors are easier to understand if light is considered as a wave motion, similar to waves on water.

THE SPECTRUM

In the visible spectrum, different wavelengths of light produce different color sensations, as shown in the accompanying chart. Light wavelengths are measured in *nanometers (nm)*. Each nanometer is one billionth of a meter.

Wavelengths longer than about 700nm are infrared (IR) and not visible. Special IR films respond to these wavelengths.

Wavelengths shorter than about 400nm are ultraviolet (UV) and not visible. All commonly available films can be exposed by UV—which we usually wish to prevent.

Sunlight—Sunlight is *white light* and is composed of all visible colors plus IR and UV. A rainbow separates and displays the visible colors that compose sunlight.

All filter types discussed in this chapter are available mounted in circular threaded rings that screw into the filter threads on the front of a lens.

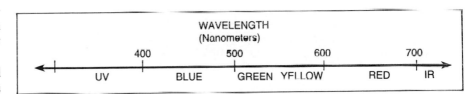

Different colors of light have different wavelengths, measured in *nanometers (nm)*. Each nanometer is one-billionth of a meter. The visible spectrum extends from about 400nm (blue) to about 700nm (red).

COLOR TEMPERATURE

Objects heated to a high temperature become *incandescent,* which means that they radiate light. When heated just to incandescence, the light is red. The heating elements of an electric stove are an example. If the temperature of an incandescent object is increased, additional shorter wavelengths are produced as shown in Figure 6-1. When heated to become white

hot, white light is radiated. The sun is an example.

The temperature of a radiant object—in degrees Kelvin—specifies the color of light that it radiates. This is called the *color temperature* of the light.

The color temperature of sunlight is about 5000K. Candlelight is about 1800K. Light from a clear blue sky is

12,000K or higher. That doesn't mean that the sky is *hot* but that *light* from the sky is the same as that produced by an object heated to 12,000K.

Photographic Daylight—On a clear day, objects receive both sunlight and light from the blue sky. The combined illumination is more blue than sunlight alone. Standard photographic daylight is defined to have a color temperature

Figure 6-1/At relatively low temperatures, incandescent materials radiate light that is predominantly red. At high temperatures, the light is predominantly blue.

APPROXIMATE COLOR TEMPERATURES

Source	Color Temperature (K)
Setting Sun	1500 to 2000
Candlelight	1800
Household Tungsten Lamp	
40 Watt	2600
75 Watt	2800
100 Watt	2900
200 Watt	3000
3200K Photo Lamp	3200
3400K Photo Lamp	3400
Clear Flash Bulb	
Aluminum filled	3800
Zirconium filled	4200
Blue Photoflood Lamp	4800
Direct Noon Sunlight	5000
Theatrical Arc Lamp	5000
Standard Daylight	5500
Blue Flash Bulb	5500
Electronic Flash	5500 to 6000
Sky: Heavy Overcast	6500
Light Overcast	7500
Hazy Blue	9000
Clear Blue	12,000 to 20,000

of 5500K.

Tungsten Lights—Light from any lamp with a glowing tungsten filament, such as an ordinary household light bulb, is called *tungsten* light. The color temperature of household tungsten lamps ranges from 2500K to 3000K, depending on the wattage rating of the lamp.

There are two standard tungsten color temperatures for photographic lamps: 3200K and 3400K. Photo lamps and tungsten studio lights have one or the other of those temperatures.

Continuous Spectrum—All incandescent light sources radiate a *continuous* spectrum. The curves in Figure 6-1 are examples. They are continuous across the spectrum, with some light at all wavelengths. All general-purpose color films are designed to work best with light that has a continuous spectrum.

Discontinuous Spectrum—Light from most non-incandescent sources doesn't have a continuous spectrum. Fluorescent lamps, for example, emit light strongly at several color temperatures but produce little or no light at other wavelengths.

One type of fluorescent lamp is labeled "daylight." It simulates daylight to human vision, but not to film.

For this reason, the color quality of non-incandescent light sources is often a problem in color photography.

COLOR BALANCE OF FILMS

Films are manufactured to be exposed by light with one of the standard color temperatures, and so labeled.

Daylight film is intended to photograph scenes in standard photographic daylight with a color temperature of 5500K. If so used, it will record colors realistically. The film is "balanced" for daylight.

Tungsten films are balanced for use with tungsten sources. Type A tungsten film is for use with 3400K light. Type B is for 3200K and is also suitable for use with household tungsten lamps. Usually, the film carton or the leaflet inside will say what color temperature the film is balanced for. If the carton just says Tungsten, it's probably Type B.

Matching Light to Film—Normally, you should use daylight film in daylight and tungsten film in tungsten light.

If you use daylight film in tungsten light, objects in the photo appear too red because the scene illumination was more red than the film "expected." Sometimes, that effect is pleasing. If you use tungsten film in daylight, the photo is too blue—an effect that is rarely pleasing.

You can use color filters to correct a color imbalance caused by using tungsten film in daylight or daylight film with tungsten light.

ATMOSPHERIC EFFECTS

Light from the sun passes through atmosphere to reach the earth. That causes changes in the light that affect photos.

Atmospheric Scattering—Sunlight is scattered by molecules of air and by particles such as smoke and dust. Clean air in the upper atmosphere scatters short, blue wavelengths more than longer wavelengths. Blue light is extracted from sunlight and scattered throughout the atmosphere. That's why the sky looks blue.

If an object is in the shade of a tree or building, it is not illuminated directly by the sun. It receives only light from

When used in daylight, color film balanced for use with tungsten light records an image that is too blue and generally unflattering.

Tungsten light, recorded on daylight film, has a warm yellow color that is often pleasing—as in this nighttime shot.

the sky, which we call *skylight*. Skylight is more blue than sunlight. For that reason, people photographed in the shade may have bluish skin tones. This can be corrected by a filter, as described later.

When the sun is near the horizon, sunlight passes through more of the atmosphere to reach the place where you are than it does at noon. Therefore, more of the blue light is extracted by scattering. At sunrise and sunset, light from the sun is more red than at midday.

Light from Distant Scenes—If the air is clear, distant objects look bluish. Blue haze in a photograph suggests great distances.

If dust or other particles are in the air, all wavelengths are scattered. Distant objects disappear in a white haze.

With a clear sky, nearby shadows are dark and distinct. Shadows of distant objects appear less dark and distinct because of scattering by the intervening air.

In warm weather, air is heated, becomes turbulent and rises to form heat waves that are sometimes visible. They

Light from the sun Is scattered throughout the atmosphere. Short-wavelength blue light is scattered more than the relatively long-wavelength red light. That's why skylight is blue.

may distort and diffuse a distant image.

SHADOWS

When light illuminates a subject, the brightest source—the sun or a studio lamp—is the *main* light. The main light casts shadows. The angle of the main light in a portrait controls facial shadows and subject modeling. Shadows indicate the location of the main light.

We are accustomed to light from above or to the side. Shadows from a light source below the subject look unnatural.

63

ILLUMINATION AND DISTANCE

To Decrease Illumination by:	Multiply Light-Source Distance by:
1 exposure step	1.4
2 exposure steps	2
3 exposure steps	2.8
4 exposure steps	4

To Increase Illumination by:	Divide Light-Source Distance by:
1 exposure step	1.4
2 exposure steps	2
3 exposure steps	2.8
4 exposure steps	4

LIGHTING AND BRIGHTNESS RATIOS

For Lighting Ratio of:	Fill-Light Distance equals Main-Light Distance Times:	Brightness Ratio is:
1:1	1	2:1
2:1	1.4	3:1
3:1	1.7	4:1
4:1	2	5:1

This table is for lights of equal brightness.

THE INVERSE SQUARE LAW

Figure 6-2/A small source produces an expanding beam of light. When the light travels twice as far, it illuminates an area that is twice as tall and twice as wide, which is four times as much area. Because the same amount of light covers four times as much area, brightness is reduced to 1/4. If the light were to travel three times as far, brightness would be reduced to 1/9. Brightness is always reduced in proportion to the *square* of the distance.

Point Source—A single, small source of light is a point source. The sun in a clear sky or a bare light bulb in a room are examples. Point sources cast shadows that are dark and distinct.

Light from a point source decreases in brightness at greater distances from the source, following the inverse square law. This is illustrated in Figure 6-2.

Large Source—A source that is physically large compared to the subject produces diffused shadows that are less dark and less distinct. Light from a large source, close to the subject, does not follow the inverse-square law.

On an overcast day, the entire sky is a large source of light. Light comes to the subject from many directions. Shadows are faint and not well defined.

If the sky is clear, but the subject is in the shade, only light from the sky illuminates the subject. Shadows are dim and indistinct.

Usually, portraits of people look better without dark and harsh shadows.

Portraits made outdoors on an overcast day, or in the shade on a clear day, look better than portraits in direct sunlight.

FILL LIGHTING

In situations where shadows cast by the main light are too dark, they can be lightened by directing another source of light into the shaded areas. That is called *filling* the shadows with light, or *fill lighting*. In sunlight, shadows can be filled by a reflector panel or by electronic flash.

STUDIO LIGHTING

Lighting principles in a studio are the same as outdoors but the light is easier to control in a studio. Studio lighting may consist of several individual lamps or a single large source.

Most of the black-and-white photos in this book, of cameras and other equipment, were made with a single large source, to reduce shadows. The source is a bank of fluorescent lights.

For artistic photography, total light control is preferred. This often calls for a fill light, background light and rim light, in addition to the main light.

The main light is positioned to establish the basic lighting pattern and direction of the shadows. Its brightness has the most effect on exposure.

When a main-light position has been established, locate the fill light to control the shadows. The fill light must illuminate the subject less brightly than the main light, so no secondary shadows are created.

There are two ways to control the amount of light reaching the subject from a studio lamp. One is to control the brightness by using bulbs of different wattage ratings. The brightness of most studio-type flash units can be adjusted by a control on the flash.

The other way is to change the distance between lamp and subject. Studio lamps can be treated as point sources that follow the inverse-square law. If the distance is doubled, brightness at the subject becomes 1/4 as

COLOR-CONVERSION FILTERS

Color-Film Type	Light Source	Conversion Filter
Daylight (5500K)	Tungsten, 3400K	80B
Daylight (5500K)	Tungsten 3200K or household	80A
Tungsten Type A (3400K)	Daylight, 5500K or Electronic Flash	85
Tungsten Type B (3200K)	Daylight, 5500K or Electronic Flash	85B

Figure 6-3/Color conversion filters change the color balance of the illumination to suit the type of color film being used.

Using tungsten-balanced film in daylight without corrective filtration gives a photo an unflattering, bluish color cast.

This photo was made in daylight on tungsten-balanced film (Type B). An 85B color-conversion filter ensured satisfactory color balance.

LIGHT-BALANCING FILTERS

Filter Color	Effect on Photo	Wratten Number
DARKER YELLOW ↕ LIGHTER YELLOW	REMOVE BLUE	81D
		81C
		81B
		81A
		81
LIGHTER BLUE ↕ DARKER BLUE	REMOVE RED	82
		82A
		82B
		82C

Figure 6-4/Light-balancing filters make smaller color changes than color-conversion filters.

much. If distance is tripled, brightness becomes 1/9, and so forth.

LIGHTING RATIO AND BRIGHTNESS RATIO

When a subject is illuminated by two light sources at different locations, there are three values of light on the subject. One is the area illuminated only by the main light. Another is the area illuminated only by the fill light—in the shadows cast by the main light. The third is the area illuminated by both lights, where they overlap.

Suppose the main light casts 2 units of light on the subject and the fill light casts 1 unit of light. The brightest area receives 3 units of light. The darkest area receives only 1 unit.

Lighting Ratio—This is the ratio of brightnesses caused by main light only and fill light only. In this example, the lighting ratio is 2:1 because the main light is twice as bright as the fill light.

Brightness Ratio—This is the ratio of actual brightnesses of the subject, as seen by the camera. In this example, the brightness ratio is 3:1 because the brightest area has 3 times as much light as the darkest area. The brightness ratio should not exceed what the film is cap-

able of recording.

Establishing the Ratios—The easiest way to establish the lighting ratio is to use lights of the same wattage at different distances from the subject. See the table on the preceding page.

You can measure lighting ratio with the exposure meter in your camera. With main light only, measure on a gray card at the subject location. With fill light only, measure again at the same location. Find the difference, in exposure steps. The lighting ratio is that number of exposure steps squared.

For example, if the readings are f-11 at 1/60 second and f-5.6 at 1/60 second, the difference is 2 steps. The lighting ratio is 4:1. To find brightness ratio, add 1 to the numerator of the lighting ratio. The brightness ratio is 5:1.

SETTING EXPOSURE

Usually, you will want correct exposure of the part of the subject that is lit by the main light. Meter on a gray card that is lit by the main light—with or without the other lights turned on. If you do it with the other light turned off, and those lights will contribute appreciably to the illumination, it's a good idea to reduce the metered expo-

SOME COMMONLY USED COLOR FILTERS

Nomen-clature	Film Type	Light	Filter Effect	Visual Color	Filter Factor
UV or Haze	Any	Day	Reduce UV exposure	Clear	IX
ND 4X or ND 0.6		Any	Reduce light 2 steps	Gray	4X
ND 8X or ND 0.9		Any	Reduce light 3 steps	Gray	8X
8 or K2	B&W	Day	Normal sky	Yellow	1.5X
15 or G	Pan	Day	Darker sky	Yellow	2X
25 or A		Day	Very dark sky	Red	8X
8 or K2		Day	Normal tones	Yellow	1.5X
11 or XI		Tung	Normal tones	Yel-Grn	4X
IA or Skylight	Color Day-light	Day	Reduce blue skylight	Lt. Pink	IX
81C		Day	Warmer image	Orange	1.5X
82C		Day	Less red with low sun	Lt. Blue	1.5X
80B		3400K	Normal colors	Blue	3X
80A		3200K	Normal colors	Drk. Blue	4X
FLD		Fluor	Normal colors	Purple	IX
85C	Color Tung-sten	Day	Normal colors, morning or late afternoon	Amber	1.5X
82C		Tung	Normal colors with household lamps	Lt. Blue	1.5X
FLB		Fluor	Normal colors	Orange	IX
85	3400K	Day	Normal colors	Amber	2X
85B	3200K	Day	Normal colors	Amber	2X

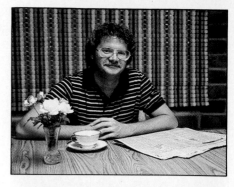

These photos were made with fluorescent lighting. The greenish tint was removed with a single, screw-in correction filter labeled CFD (Correct Fluorescent with Daylight film).

RECOMMENDED FILTRATION FOR FLUORESCENT LIGHTING

Film Type	Fluorescent Lamp Type					
	Daylight	White	Warm White Deluxe	Warm White	Cool White Deluxe	Cool White
Daylight	40M+30Y	20C+30M	40C+40M	60C+30M	30M	30C+20M
Tungsten (3200K)	85B+30M+10Y	40M+40Y	30M+20Y	10Y	50M+60Y	1OM+30Y
Tungsten (3400K)	85+30M+1OY	40M+30Y	30M+10Y	NONE	50M+50Y	10M+20Y

Figure 6-5/The filtration recommended is approximate. For best results, make test exposures.

On black-and-white film, red flowers and green leaves often reproduce with about the same shade of gray, giving a photo with little detail.

A red filter lightened the red rose and darkened the green foliage.

sure by about 1/3 exposure step.

TYPES OF PHOTO LAMPS

Tungsten photo lamps are available with color-temperature ratings of 3200K or 3400K. Because 3200K lamps operate at a lower filament temperature, their life expectancy is longer.

As tungsten lamps age, tungsten evaporates from the heated filament and forms a gray coating on the inside of the glass envelope. This gradually lowers both light output and color temperature.

Tungsten-Halide Lamps—A major improvement is the tungsten-halide lamp, also called tungsten-halogen. The tungsten that evaporates from the filament is continuously removed from the glass envelope and replaced on the filament. This gives uniformity of light output and color temperature, and longer life.

FILTERS

There are four basic categories of photographic filters:
● *Color Filters* change the color of light that passes through the filter.
● *Polarizing Filters* are used to control reflections, produce more vivid colors, darken blue skies and reduce glare without changing the color of the light.

A green filter darkened the red rose and lightened the green foliage.

● *Neutral-Density Filters* reduce the amount of light without changing its color.
● *Special-Effect Filters* do a variety of things, usually optical "tricks." Some examples are shown later.

Filters are available in a variety of materials and with several methods of attachment to the lens. Filters and their applications are discussed here without attention to how they are attached. Later in this chapter, filter materials and mounting methods are discussed.

COLOR FILTERS FOR COLOR FILM

The Wratten filter numbers used by Kodak are used by most filter manufacturers. They are also used in this book.

Color-Conversion Filters—These filters *convert* the color temperature of light from the scene to match the type of color film in the camera. For example, if you are using tungsten film but need to take a photo in daylight, you can place a color conversion filter

in front of the lens. These filters make relatively large changes in the color of the light. Common conversion filters are shown in Figure 6-3.

Light-Balancing Filters—These filters make smaller changes in color than conversion filters. Light-balancing filters are used to "fine-tune" the colors on color film.

For example, the light on an overcast day or in the shade is bluish. If you shoot without correction, colors in the photo have a blue cast that is especially noticeable in skin tones. Correction is provided by a filter that removes some of the blue. The filter will look amber or yellow.

At sunrise or sunset, the light is red-dish. To correct, use a filter that removes red. The filter will look blue or blue-green.

Figure 6-4 shows common light-balancing filters. A good way to select one is to try different filters over the lens while looking through the viewfinder.

Filter Factor—Color-conversion and light-balancing filters transmit *some* light in all parts of the spectrum. However, they cut out enough light to require exposure compensation. The compensation for each filter is provided by the filter manufacturer in the form of a *filter factor*.

The factor states light loss caused by the filter. The value is written with an X to show that it is a factor. It gives the exposure increase that will compensate for the light absorbed by the filter. A filter factor of 2X means that exposure should be doubled—one exposure step. A factor of 4X means two steps.

If you are using the camera exposure meter with the filter in place on the lens, the effect of the filter is automatically included in the measurement. No correction is necessary. Use the camera-recommended exposure.

However, there's an exception: A very dark red filter, such as a Wratten 25 or a Minolta R60, causes the MAX-XUM exposure meter to read one step low. To correct, set the Exposure-Adjustment control to +1.

With black-and-white film, a yellow, orange or red filter darkens blue sky. If there are clouds, they become more visible.

Color-Compensating Filters—Color-Compensating (CC) filters are narrow-band filters. They transmit light of one color while excluding most other colors. CC filters are made to control the three primary colors and the three complementary colors—red, green, blue, yellow, cyan and magenta.

CC filters have a special nomenclature that tells you the type of filter, its color and how "strong" that color is. For a filter labeled CC20R, the letters CC mean that it's a Color-Compensating filter. The last letter is the initial letter of its color. R means that it looks Red when viewed against white light. The number 20 indicates the darkness or density of the filter. Higher numbers mean stronger colors.

General Use—You can use CC filters to make small changes in color, just as any other color filter. A CC30Y gives a pleasant sunny look to a scene photographed on a gray day.

With Fluorescent Light—Daylight color film exposed under fluorescent light usually gives images with a yellow-green cast. Skin tones look unhealthy. For best color reproduction with fluorescent light, a combination of CC filters can be used, tailored to the type of fluorescent lighting. Figure 6-5 on page 66 gives some suggested *starting* filter sets. By testing, you can probably improve the color.

Fluorescent-Light Filters—Combining CC filters to correct fluorescent light takes time and testing. There are one-piece filters that do a reasonable job. Nomenclature is not standard but usually obvious. For example, FLA, FLB and FLD are for Tungsten Type A film, Tungsten Type B and Daylight film respectively.

Skylight, UV and Haze Filters—If a subject is in the shade, illuminated by skylight only, an uncorrected color photo will look blue. Distant scenes often have a blue haze. Films respond both to visible blue light and invisible ultraviolet which also gives color images a bluish cast. Three types of filters

A polarizing filter can remove or minimize reflections from glass and other non-metallic surfaces. Without a polarizing filter, reflection from this shop window obscures the view inside. Using a polarizer removed most of the reflection. To find the best effect, try various angles between camera and reflecting surface while rotating the filter.

are available to reduce excessive blue.

UV filters reduce ultraviolet light without much effect on visible light. Skylight filters reduce UV and the shortest blue wavelengths. They reduce haze and slightly warm the colors in a photo. Haze filters are a little warmer than skylight filters.

There is very little difference between these types. Some photographers use a skylight filter permanently on the lens as a transparent lens cap or lens protector.

COLOR FILTERS WITH BLACK-AND-WHITE FILM

On black-and-white film, different colors of equal brightness generally record at about the same shade of gray.

Contrast Filtering—In black and white, the only way to differentiate between two colors of equal brightness is to make one a darker shade of gray. This increases the *contrast* between the two shades. A color filter lightens its

own color and darkens all other colors. The photos of a rose, on page 67, are examples of contrast filtering.

Darkening Blue Sky—In most outdoor photos made on black-and-white film, the sky looks brighter than the actual scene. If there are clouds, they are about the same shade as the sky and not noticeable. A more dramatic photo usually results if the sky is darkened.

To make the sky darker, use a filter that absorbs blue light from the sky. Yellow filters have a mild effect. Red filters have a strong effect. Select a filter by looking through it. You want to darken the sky sufficiently to make white clouds stand out clearly.

Cutting Haze—A bluish haze tends to obscure distant scenes. If you photograph a distant scene without haze correction, the photo will show more haze than you saw because of exposure by UV that's invisible to the human eye.

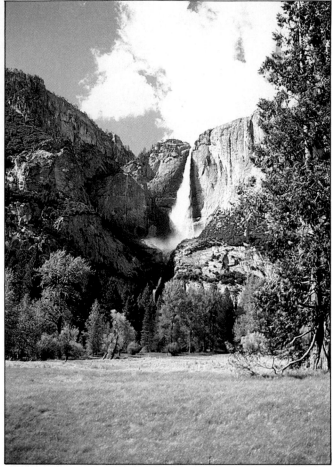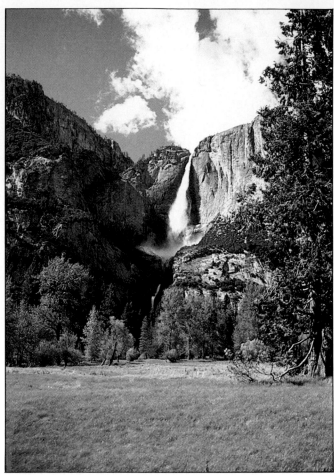

If the polarized part of the sky is in view, it can be darkened with a circular polarizing filter. Using a polarizer on outdoor scenes has other effects on a photo. By removing reflected skylight from the rock face in the photo on the right, details become bolder. The green of the grass and trees also becomes deeper, more saturated.

POLARIZATION OF LIGHT

Light travels along ray paths with a wave motion similar to waves on water. Water waves can move only up and down. Light waves can move or vibrate in all directions perpendicular to their path of travel.

Unpolarized light vibrates in all directions. Polarized light vibrates in only one direction. Much of the light that we see every day is polarized by reflection. Light becomes polarized when it is reflected by most surfaces except unpainted metal. The direction of polarization is determined by the orientation of the reflecting surface.

The amount of polarization is determined by the angle of reflection from the surface.

Polarization of Skylight—Light from a blue sky is polarized in a band across the sky. The plane of the band is at a right angle to the direction of sunlight shining toward you. If the sun is low on the horizon, the polarized band is overhead and runs approximately from north to south. If the sun is overhead, the polarized band is near the horizon.

POLARIZING FILTERS

Polarizing materials are made into polarizing filters. The filter transmits light waves that vibrate in one direction and blocks light that vibrates in other

directions. Polarizing filters that mount on camera lenses are designed so they can be rotated.

If unpolarized light enters the filter, polarized light emerges from the other side. The direction of polarization is determined by rotating the filter. Polarizing filters are gray, so they don't affect color, and can be used with any type of film.

MAXXUM POLARIZING FILTERS

Ordinary polarizing filters should not be used on MAXXUM cameras. These cameras have a semi-transparent main mirror that allows some of the light to pass through to the autofocus

NEUTRAL-DENSITY FILTERS TO INCREASE EXPOSURE TIME OR APERTURE SIZE

ND Filter Type	Multiply Exposure Time by:	Or, Open Aperture by: (Steps)
ND .1	1.25	1/3
ND .2	1.6	2/3
ND .3 or 2X	2	1
ND .4	2.5	1-1/3
ND .5	3.1	1-2/3
ND .6 or 4X	4	2
ND .8	6.3	2-2/3
ND .9 or 8X	8	3
ND 1.0	10	3-1/3
ND 2.0	100	6-2/3
ND 3.0	1000	10

A 49→55 Step-Up Ring can be used to attach a 55mm screw-in filter to a lens with 49mm filter threads.

Although you can't manually set aperture in 1/3 steps or shutter speed in decimal fractions, the camera can do it on automatic. To slow down shutter speed with an ND filter, use the camera on aperture-priority automatic. To get larger aperture, put the camera on shutter-priority automatic.

system. Mirrors of that type do not transmit all directions of polarization. This is not a problem when unpolarized light falls on the mirror.

It is possible for an ordinary polarizing filter to transmit polarized light that cannot pass through the mirror. If that happens, the autofocus system cannot operate. On the MAXXUM 9000, the exposure-measuring system will give incorrect readings.

Minolta Circular Polarizer— Minolta offers a special *circular* polarizing filter for MAXXUM cameras. It admits light of one polarization and blocks other light, the same as ordinary, *linear* polarizers, while avoiding the problem just mentioned.

The Minolta circular polarizing filter can be used as discussed in the following paragraphs.

REDUCING REFLECTIONS

Because reflected light from most surfaces is polarized, reflections can be controlled by a polarizing filter. Here are some examples: Use a polarizing filter to block reflections on a window that prevent you from seeing inside. Use a polarizer to remove surface reflections on wooden furniture that prevent you from seeing the wood grain.

With a polarizing filter on the lens, look through the camera and rotate the filter for best effect.

IMPROVING COLOR SATURATION

Direct sunlight reflects off the surfaces of leaves, flower petals, walls, cars and other objects. By reflection, some of the light becomes partially polarized. The reflected white light dilutes and obscures colors.

If you use a polarizing filter to block the surface reflection, the improvement in colors is often amazing. Rotate the filter for best effect.

DARKENING THE SKY

If you compose an outdoor scene so the polarized part of the sky is in view, you can darken the sky dramatically with a polarizing filter. That doesn't work on overcast days because an overcast sky is not polarized.

Sometimes you must compromise between the rotation of the polarizer that gives the best sky and a different setting that gives the best color improvement of other objects.

NEUTRAL-DENSITY (ND) FILTERS

With color or black-and-white film, you may want to reduce the amount of light coming through the lens without changing its color. That allows using slower shutter speed or larger aperture for creative effects.

Neutral-Density filters have optical density, so they absorb light. They are gray or neutral in color. The reduction of light is stated in the nomenclature by a filter factor or a density value.

ND 2X and ND 0.3 are examples. A filter factor of 2X or a density of 0.3 each represent one exposure step. A density of 0.6 is two steps, 0.9 represents three steps, and so forth.

Stacking ND Filters— You may stack ND filters to get more density. If density is specified by filter factors, the result is the *product* of the factors. ND 2X stacked with ND 4X is the same as ND 8X. With densities, add the numbers. ND 0.3 with ND 0.6 is equivalent to an ND 0.9 filter.

SPECIAL-EFFECT FILTERS

There are lots of special-effect filters. This section lists popular filter types, with brief descriptions.

COLOR FILTERS

Ordinary color filters can be used for special effects with color film. For example, you can make people green, if it's appropriate to the theme of your picture.

A graduated blue-to-clear Cokin filter enhanced the blue of the sky and deepened its tone without affecting the foreground color or tone. A wide selection of graduated filters is available. Photo courtesy of Minolta Corporation.

The New York skyline was reversed on itself to produce a pseudo-reflection. This was achieved with a Cokin Mirage filter. Photo courtesy of Minolta Corporation.

It's easy to add a dreamlike mood to a photo by adding an unusual color. This beach scene was transformed by the use of a Cokin magenta-pastel filter. Photo courtesy of Minolta Corporation.

Color Filters with Flash—Using a color filter over the flash window causes the flash to emit colored light. Nearby objects are illuminated mainly by the flash and will reflect that color. Distant objects, lit by ambient light, receive very little light from the flash and will have normal colors.

You can reverse the effect by using a CC filter over the flash and the complement of that color over the lens. Nearby objects will appear with normal color because the two filters cancel each other's effect. Distant objects, which don't receive much light from the flash, are colored by the filter over the lens.

Variable-Color Filters—Special filters that are combined with polarizers provide variable color when rotated. Because normal polarizers are *linear,* these filters may prevent normal operation of MAXXUM cameras, as discussed earlier.

Two-Color Filters—These have two colors or one color and a clear section. Half of the filter is one color, half the other. If the colors change gradually from one to the other it is called a *graduated* filter.

A version that is useful for exposure control has a neutral-density filter on one half, which blends into a clear area. The neutral-density portion is used to darken the sky and can be used with any film.

MASKS

Masks are black panels in a holder that fits in front of the lens. They are available with openings in the mask—such as circles, hearts, and diamonds—along with negative or reversed patterns—such as an opaque circle in a clear frame. They also are available as solid panels that cover half of the film frame.

Masks are used for double exposures. Place the first mask in position and make an exposure. The film receives an image through the opening in the mask. The rest of the frame is unexposed. Then, place the reversed mask in position and make another exposure in the unused area. Meter each shot without the mask and shoot at the metered exposure. Bracket toward increased exposure.

Common tricks with masks are to place a face in an unusual location, such as in a wine glass, or make two images of the same person.

Spot or Clear Center—These devices have a circular spot in the center that may be colored or clear. The surrounding area is another color or "frosted" to make a diffused image. Some types are dark outside of the center spot to *vignette* the image.

AUTOFOCUS OPERATION

The filter types described in the remainder of this section may prevent autofocus operation. If so, focus manually.

MULTIPLE-IMAGE PRISMS

These clear filters have molded prisms on the front surface. Each prism produces a separate image of a single subject. If the prisms are in a circular

pattern, the images form a circle around a central image. If the prisms are in a row, the images are also in a row.

STAR FILTER

A grid of narrow, opaque lines in clear glass or plastic causes star patterns around bright points of light. Some star filters have one set of lines that can be rotated in respect to the other, causing asymmetrical star patterns.

DIFFRACTION FILTER

Diffraction special-effect filters have many closely spaced opaque lines in clear glass or plastic. If the lines are parallel, linear rainbow patterns are formed in the image. If the lines are concentric circles, radial rainbow patterns are formed. The effect is noticeable mainly around bright points in the image.

SOFT-IMAGE FILTER

Clear filters with a rippled surface diffuse the image, creating a soft-focus effect. In portraiture, this obscures small details, such as facial wrinkles. Some makers offer soft-focus filters in several "strengths," identified by numbers. If the effect is very marked, the result may be a "dreamlike" photo.

FOG FILTER

This is a filter with a lightly frosted surface that gives the effect of fog in the image. The filters are available in different "strengths" to produce a greater or lesser fog effect.

FILTER MATERIALS

Filters are available in a variety of materials:

Gelatin Film—The Eastman Kodak Company manufactures a large variety of inexpensive, high-quality gelatin filters. They are square, thin and flexible. They are also delicate and difficult to clean. Handle them only by the edges, preferably with soft, cotton gloves.

A gelatin filter is placed in a metal frame and the frame fits in the slot at the top of this holder.

This Cokin filter holder accepts a wide variety of Cokin filters. Most are square, but some are round so they can be rotated in the holder. The lens hood on the front is in sections so you can adjust it to the angle of view of the lens in use.

Gelatin filters can be cut with scissors. They are made only as color filters, not special-effect devices that alter ray paths.

Acetate Film—Filters made of acetate film are similar to gelatin filters but with inferior optical quality. They are useful for coloring the light source, such as flash or studio lights. Don't use them over a camera because image quality will suffer.

Glass—Glass filters are durable, easy to clean and usually more convenient than gelatin film. They are also more expensive. Good quality glass filters have anti-reflection coatings on both surfaces. That increases light transmission and reduces surface reflections. Glass filters are made both for color changes and optical special-effects.

Plastic—Plastic filters are more durable than gelatin but scratch more easily than glass. They cost more than gelatin filters but less than glass filter. They usually don't have anti-reflection coatings.

Effect of Age—All filters may change color slowly due to age, exposure to light or heat. For longest life, store them in a cool, dry, dark place in containers that protect the surfaces.

FILTER MOUNTING METHODS

Most lenses have a threaded ring inside the front of the lens barrel to mount filters. The diameter of the filter ring in millimeters is shown in the lens table in Chapter 2 and on the front of MAXXUM lenses. Attachments that screw into the filter ring must have external threads with the same diameter.

Step-Up and Step-Down Rings—Threaded adapter rings are available to change the filter-thread diameter of a lens. The adapter screws into the lens. On the front of the adapter are threads with larger or smaller diameter than the lens. Step-Up Rings provide a larger thread diameter than the lens. Step-Down Rings provide a smaller diameter.

Step-Down Rings should be used with caution. The ring itself, or the attachment screwed into the ring, may block light around the edges and vignette the image.

SCREW-IN FILTERS

A screw-in filter is mounted in a threaded frame. It is installed by screwing it into the filter threads on the lens,

or into a step-up or step-down ring.

Stacking Screw-In Filters—These filters have internal threads on the front of the frame that are the same diameter as those on the back. That allows stacking filters with the same thread diameter. However, stacking filters may cause vignetting.

Choosing Filter Size—Both telephoto and wide-angle lenses usually have filter-thread diameters that are larger than lenses in the middle range.

To avoid purchasing the same filters in different sizes, consider buying filters to fit the largest filter-thread diameter that you own or plan to own. These can be mounted on lenses with smaller filter-thread diameters by using step-up rings.

SERIES FILTERS

Series filters are rarely found today. They are round and without threads. They fit into a series adapter, which screws into the lens. A retaining ring screws into the front of the adapter to hold the filter in place. Some lens accessories can be attached using a series adapter.

GELATIN FILTER HOLDERS

Gelatin filters are usually placed in a thin metal frame. More than one filter can be stacked together. The frame is held in a slotted holder. The holder screws into the filter threads on the lens. Some provide threads on the front to attach a threaded lens hood.

FILTER SYSTEMS

Several manufacturers offer filter-mounting systems with a great variety of companion filters. The filters are usually flat plastic squares. They may be color or special-effect types. Masks are also available.

One system uses a plastic holder with several slots for filters so they can be stacked. The holder attaches to the filter threads of the lens using threaded adapters that are available for various filter thread sizes.

For filters that require rotation, such as a polarizer, the filter itself may be round and rotate in the holder. Or, the holder itself can be rotated.

A lens hood fits on the front of the filter holder. The hood is in sections that fit together, so you can make it longer or shorter depending on the angle of view of the lens. Add sections until the image in the viewfinder begins to show vignetting. Then remove one sections, to avoid vignetting.

Advantages—Filter systems fit a wide range of lens diameters, requiring only a simple threaded adapter for each diameter. They offer a large variety of filters and special-effect gadgets, all with similar shape and size. The system idea is appealing because everything fits everything else. The total cost may be less and the end result less complicated to use than the equivalent capability acquired in bits and pieces with less compatibility among the parts.

While camping by this lake, I awoke before dawn and set up camera and tripod, hoping to catch a blazing sunrise. As the sun began to come up, I realized that the sunrise was going to be less than spectacular. There was little color in the sky (left photo). I resolved to get a good picture anyway, even if it needed an amber 85B color-conversion filter. To darken the sky without losing the reflection in the water, I also used a graduated ND filter with the dark half covering the sky. As the photo on the right shows, sometimes it pays to do some creative faking! As a bonus, the boat happened to be in the right place at just the right time.

Close-Up and Macro

Making large images of small subjects is an interesting and useful part of photography. This chapter discusses three methods: using accessory close-up lenses that fit on the front of an ordinary camera lens, using the close-focusing range of macro-zoom lenses, and using macro lenses.

Image magnification is defined as the height of the image on film divided by the height of the subject. Of course, you can compare widths or any other identical parts instead.

$$M = I/S$$

Where M is magnification, I is image size—either height or width—and S is subject size, using the corresponding dimension, height or width.

If the image on film is the same size as the subject, magnification is 1, which is called *life-size* and sometimes stated as 1:1.

Photographing objects at life size or larger is called *photomacrography,* commonly referred to as *macro* photography.

If the image fills the frame vertically, the image is about 24mm tall. Suppose the subject is 30mm tall. Magnification is 24/30, which is 0.8. The image is 80% as tall as the subject.

MAGNIFICATION
OF 50mm LENSES

If a focused subject comes closer to the lens, its image becomes larger on film. With any lens, the largest image of a subject is produced with the lens set at its minimum focused distance.

The closest focusing distance of an ordinary 50mm lens, such as the MAX-

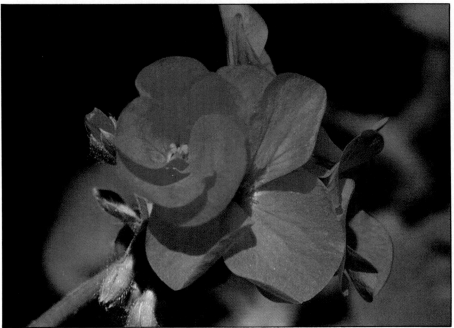

This photo was made at a magnification of 0.4 using a close-up lens attachment. The optical quality of the photo is fine although depth of field is limited because of the magnification. If the close-up attachment caused linear distortion or edge unsharpness, it would not be readily visible in an irregular subject such as a flower. If the subject were a postage stamp, such faults would be more readily evident.

XUM AF 50mm *f*-1.7, is 0.45 meters—about 18 inches. At that distance, magnification is approximately 0.15. The image is 15% as tall as the subject.

Why Won't the Lens Focus Closer?—As an ordinary camera lens is focused on closer subjects, image quality deteriorates. The lens designer sets a limit to the closest focusing distance at a value that still produces good image quality.

CLOSE-UP LENS
ATTACHMENTS

Accessory close-up attachments or close-up lenses are simple lenses mounted in circular threaded frames, like filters. They screw into the filter ring on the front of a camera lens to provide an inexpensive and simple way to increase magnification. The amount of light reaching the film is not affected significantly.

FOCAL LENGTHS OF CLOSE-UP LENSES

Minolta Close-Up Lens Label	Close-Up Lens Power in Diopters	Focal Length mm	inches (approx)
0	1	1000	40
1	2	500	20
	3	333	13
2	4 (3+1)	250	10
	5 (3+2)	200	8
	6 (3+2+1)	167	6.7
	10	100	4

Minolta close-up lenses have labels that do not indicate their strengths. As you can see in this table, for example, an 0 Minolta close-up lens has a diopter strength of 1. The center column shows diopter strengths of close-up lenses, used individually or stacked. The resulting focal lengths, in mm and inches, are in the columns at right.

When stacking, place the stronger close-up lens nearest the camera lens. Don't stack more than two lenses. Stacking an entire set, as shown here, gives the largest image—but the poorest quality.

Image quality is not as good as that produced by a macro lens, especially at higher magnifications. A rule of thumb is to use close-up lenses for magnifications up to about 0.5. If you use close-up lenses to photograph non-flat objects in nature, such as flowers, the results may be entirely satisfactory at higher magnifications. That's because lack of sharpness near the image edges and linear distortion are least noticeable with such subjects.

Nomenclature—Close-up lenses are usually sold in sets of three or four, with labels such as 1, 2, 3, 4, and 10. The labels usually express the power of the lenses in *diopters.*

$$\text{Diopters} = \frac{1000}{\text{Focal Length (mm)}}$$

A lens with a focal length of 1000 mm (1 meter) has a power of 1 diopter. If the focal length is 100 mm, the power is 10 diopters.

Stacking Close-Up Lenses—For higher magnification, close-up lenses may be stacked by screwing them together. The reason diopters are used as labels is that the diopter power of a combination is the sum of the individual diopters. A 3 close-up lens stacked with a 1 is equivalent to a 4 close-up lens.

Focal Length—To use close-up lenses, you need to know focal length in millimeters. This can be calculated from:

$$\text{Focal Length (mm)} = \frac{1000}{\text{Diopters}}$$

A 4 diopter close-up lens or combination of lenses has a focal length of 1000/4, which is 250mm. The accompanying table shows diopters and the equivalent focal lengths in both millimeters and inches.

Magnification—With the camera lens focused at infinity, image distance is

This costume jewelry was photographed with the MAXXUM AF Macro 50mm lens, using daylight film, daylight illumination, and a black velvet background.

MAGNIFICATION WITH CLOSE-UP LENS ATTACHMENTS
USED WITH 50mm CAMERA LENS

Close-Up Lens	Maximum Subject Distance mm	inches	Minimum Subject Distance mm	inches	Magnification min	max
1	1000	40	333	13	0.05	0.17
2	500	20	250	10	0.1	0.22
3	333	13	200	7.9	0.15	0.28
4 (3+1)	250	10	167	6.2	0.2	0.33
5 (3+2)	200	7.9	143	5.6	0.25	0.39
6 (3+2+1)	167	6.2	125	4.9	0.3	0.45
10	100	3.9	83	3.3	0.5	0.67

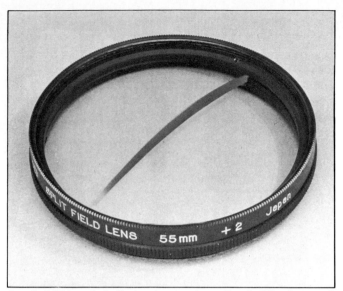

A split-field lens is half of a close-up lens. One half is glass and the other half is an empty space.

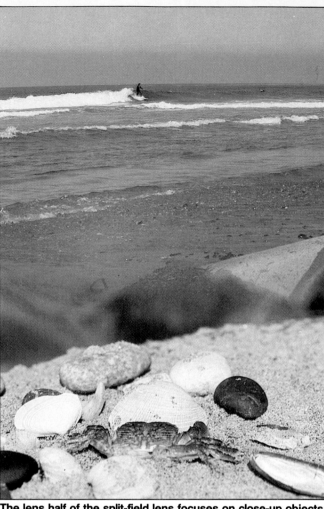

The lens half of the split-field lens focuses on close-up objects while the camera lens alone focuses on distant objects. This results in very great apparent depth of field. There will generally be an area of poor focus in between. Compose your pictures so this unsharpness is least objectionable.

the focal length of the camera lens. Subject distance is the focal length of the close-up lens. Magnification is easy to calculate. It is:

Focal Length of Camera Lens (mm)

Focal Length of Close-Up Lens (mm)

Using a camera lens with longer focal length increases magnification. Using more diopters increases magnification because larger diopter values represent shorter focal lengths of the close-up lens.

Assume you are using a 200mm camera lens with a 4 diopter close-up lens. The close-up has a focal length of 250mm.

$$\text{Magnification} = \frac{200\text{mm}}{250\text{mm}}$$
$$= 0.8$$

Magnification is 0.8 with the camera lens focused at infinity. If the lens is focused closer than infinity, subject distance decreases and magnification increases. Magnification is then less simple to calculate.

Usually, you know how much magnification you want and need to know how many diopters to use. The table at the bottom of page 77 shows the range of magnifications and subject distances with various combinations of accessory close-up lenses installed on a 50mm camera lens.

For example, the table shows that a 3-diopter close-up lens has a range of magnifications from 0.15 to 0.28 when used on a 50mm camera lens, depending on the setting of the focus control.

For another focal length, or magnifications not on the table, you can calculate the diopter strength of the close-up lens. It is:

1000 x Magnification

Focal Length of Camera Lens (mm)

HOW TO USE CLOSE-UP LENSES

Decide the amount of magnification needed and the camera lens to be used. If using a 50mm lens on the camera, use the table to find the close-up lens that will provide the desired magnification, or a little less, with the camera lens focused at infinity. For other focal lengths or magnifications, calculate diopter strength and use the nearest standard value.

Install the close-up lens or lenses on the camera lens. If you stack close-up lenses, place the higher diopter ratings

I shot this cactus flower with the AF 70—210mm zoom lens at a focal length of 210mm. The lens was focused at about 3 feet. Autofocus and shutter-priority automatic exposure made the picture. I handheld the camera, giving a 1/1000 second exposure to minimize blur due to camera movement.

The MAXXUM AF Zoom 70—210mm lens has no special Macro Control. Just set the lens to its longest focal length and focus on a close subject. A MAXXUM camera will autofocus this lens through its entire distance range.

nearer the camera lens.

Support the camera firmly to avoid image blur. Depth of field is reduced by higher magnifications. It will be improved by using a smaller aperture. Use the metered exposure. Light is not significantly reduced by the close-up lens.

The focusing ring on the lens affects both focused distance and magnification. With a close-up lens attached, the focused-distance scale on the lens will not show subject distances correctly.

With the camera lens focused at infinity, the distance to a focused subject is the focal length of the close-up lens or combination of close-up lenses. A subject at a greater distance cannot be focused except by moving the camera closer.

Manual Focus—With the camera Focus-Mode Switch set to Manual, focus the lens at infinity. Find focus by moving the camera. If magnification is not enough with the lens focused at infinity, focus it closer. Find focus by moving the camera.

Autofocus—On autofocus, the camera will focus the lens, if the image

This is the MAXXUM AF 35—70mm macro-zoom, set to the macro range—beyond the 70mm setting of the Zoom Ring. At this setting, the Zoom Ring serves as a magnification control. Its range is limited, as shown by the bracket just to the left of the symbol f70. The Manual Focusing Ring is set at its closest focusing distance of 1 meter.

is not greatly out of focus. If the subject is farther from the camera lens than the focal length of the close-up lens, the subject cannot be focused.

Therefore, it may be necessary to move the camera closer until the autofocus system can find focus. Then, if magnification is not enough, move closer and let the camera focus again. If magnification is too much, move back and let the camera focus again.

MINOLTA CLOSE-UP LENSES

Sets of three close-up lenses are available from Minolta to fit filter-thread diameters of 49mm, 52mm and 55mm. They work as already described. However, the labels on the lenses are not diopters. They are simply labels. The diopter strengths are shown in the table at the top of page 77.

SPLIT-FIELD LENSES

A split-field lens is a close-up lens

with half of it removed. The lens half is glass or plastic, the other half is air. This lens is useful for photographing a near and a distant subject, each in good focus. It is useful when the subjects are so far apart that both cannot be included in the depth of field of the camera lens alone.

Half of the image is formed by the combination of camera lens and the close-up part of the split-field lens. For that part of the image, the near subject, perhaps 20 inches away, will be in focus. The other half of the image, of the distant subject—perhaps 100 feet away—is formed by the camera lens alone.

There will be a zone of bad focus between the near focus caused by the split-field lens and the far focus caused by the camera lens. Try to compose the image so that the unsharp part is acceptable.

Split-field lenses are labeled with the diopter rating, just like other close-up lenses.

MACRO-ZOOM LENS

Most MAXXUM zoom lenses have a special setting that allows closer-than-normal focusing with a maximum magnification of about 0.25. The zone of closer-than-normal focusing is called the *macro range* of the lens.

These lenses have excellent image quality when used normally, not in the macro range. The macro range is a compromise. It gives you higher magnifications at very little extra cost. It gives images comparable in quality and magnification to those produced by close-up lenses, but more conveniently. Image quality is satisfactory for non-flat objects in nature, such as flowers.

If you use the macro range to photograph flat objects, such as print on paper, the flatness of field may not be sufficient. If the center of the image is in focus, the edges are slightly out of focus, or the reverse. Also, if the object has straight lines or straight edges, they may appear slightly curved.

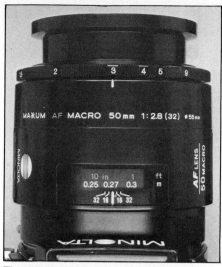

The AF MACRO 50mm *f*-2.8 lens has a magnification scale on the Manual Focusing Ring, shown here set to 3, or a magnification of 1/3. Focused distance is 0.27 meters, about 11 inches.

MAXXUM AF MACRO 50mm f-2.8 LENS	
SCALE MARKINGS AND EQUIVALENT MAGNIFICATION	
Scale	**Magnification**
1:1	1.0
1.2	0.83
1.5	0.66
2	0.50
3	0.33
4	0.25
5	0.20
9	0.11

Depending on your purpose, images with minor defects may be entirely suitable. The macro range of a macro-zoom lens is very useful and convenient when used appropriately.

The Macro Control—On the Zoom Ring is a button labeled MACRO. To make the macro setting, slide the button toward the front of the lens and turn the Zoom Ring fully clockwise—past the longest focal length.

Setting the Zoom Ring to the macro zone disables autofocus, even if the Focus-Mode Switch on the camera is set to AF. The focus detector and focus display continue to operate.

Setting Magnification—In the macro zone, the Zoom Ring affects both focus and magnification. It can be turned over a limited range, indicated by a blue band on the ring.

Focus and magnification are also affected by the setting of the Manual Focusing Ring on the lens. To turn the focusing ring, you *must* move the Focus-Mode Switch on the camera to the M setting.

For maximum magnification, turn the manual focusing ring fully clockwise to the closest focused distance and turn the Zoom Ring fully clockwise. Then, find focus by moving the camera.

Zoom Lens without Macro Setting— The AF 70—210mm *f*-4 zoom lens doesn't have a macro setting of the Zoom Ring. It provides a maximum magnification of about 0.26 at the 210mm focal-length setting. The autofocus mode works normally.

MACRO LENS

Macro lenses are specially designed to focus closer than ordinary lenses, with good image quality throughout the focusing range. At close distances, they have better flatness of field than ordinary lenses, so you can photograph flat objects, such as postage stamps.

MAGNIFICATION RANGES	
Equipment	**Range**
50mm non-macro lens	Up to 0.15 approx.
Macro range of zoom lens	Up to 0.25 approx.
Close-up lens attachments	Up to 0.5 recommended; higher possible.
AF 50mm Macro lens	Up to 1.0

Optically, they are designed to produce images of good quality at a magnification of 1. Because macro lenses focus to infinity, they can also be used for ordinary photography.

Magnification—Image magnification is determined by the lens-to-subject distance and the lens-to-image distance. The ratio of image size to subject size is the same as the ratio of their distances.

Increasing Lens-to-Film Distance—Lens-to-film distance is increased by moving the lens farther from the film, which happens when you focus the lens on closer subjects. That increases image size and therefore magnification.

Relationship Between Subject and Image Distances—Neither distance can change independently of the other. As image distance increases, subject distance *must* decrease—and the reverse.

Macro lenses can be used to photograph coins—as shown in this photo—objects in nature, laboratory and mineral specimens, stamps, and many other items. Objects with surface contours, such as a coin, usually show detail best under side lighting.

MAXXUM AF MACRO 50mm f-2.8 LENS

This lens focuses from infinity to 0.2 meters, which is a little less than 8 inches. At closest focus, magnification is 1.

The effects of most lens aberrations are reduced by using smaller aperture. Therefore, the maximum aperture is limited to f-2.8 compared to f-1.4 and f-1.7 with other 50mm MAXXUM lenses.

Depth of field is greatly reduced at higher magnifications. You can get some of it back by using a smaller aperture. The minimum aperture of this lens is f-32, compared to minimum aperture sizes of f-22 for the f-1.4 and f-1.7 50mm lenses.

Using Autofocus—This is an autofocus lens and can be focused automatically by a MAXXUM camera. Whether or not you use autofocus depends on the kind of photography you are doing. When a macro lens is used for ordinary photography, autofocus is very convenient and there is no reason not to use it. For macro photography, the autofocus system works very well

also, and you can use it if you wish.

If the exact magnification is not important, but you want to fill the frame with the image of a small object, it is convenient to use autofocus. While the camera maintains focus on the subject, move the camera closer or farther away until you see the desired image size in the viewfinder.

If you want a specific magnification, turn off the autofocus system and manually set the focusing ring for the desired magnification. Then, find focus by moving the camera closer to or farther from the subject.

Magnification Scale—The Manual Focusing Ring is engraved with a scale of magnifications, read against an adjacent index mark. At the closest focusing distance, the scale reading is 1:1 which is another way of writing the fraction 1/1.

The other numbers on the magnification scale are *denominators* of a fraction. The numerator is always 1 but is omitted. After 1:1, the next value on the scale is 1.2, which means 1:1.2. The last marked value on the scale is 9, which means 1/9. Just beyond the last scale value, the lens is focused at infinity.

I prefer to perform the indicated division and write magnification as a decimal number or percentage. For example, 1/1.2 is 0.83 or 83%. The complete magnification scale and equivalent decimal values are shown in the table on the opposite page.

USING A MACRO LENS

Lenses that provide higher-than-usual magnification without a special setup tempt you to handhold the camera. Don't do it. Use a rigid camera support. A sturdy tripod can usually be arranged to support the camera in a convenient relationship to the subject. Place a small subject on the edge of a table, with the tripod on the floor beside the table. Some tripods can support the camera on the bottom of the center post, rather than the top.

If you do a lot of high-magnification work, a copy stand is useful. It's a flat board with a sturdy vertical post at the back. A camera support is attached to the post in such a way that the camera can be moved up and down conveniently.

Higher magnification reduces depth of field drastically. With some subjects, such as an insect, it may not be

possible to get the entire subject in sharp focus. It's useful to see where the zone of good focus is and usually desirable to place it near the front of the subject. The Depth-of-Field Preview control on the MAXXUM 9000 allows you to see depth of field before you make the exposure, so you can put it where you need it to be.

As has been indicated, the 50mm Macro lens has a minimum aperture of *f*-32, for best depth of field. Earlier, I said that the optimum aperture size is usually near the middle of the aperture scale because of diffraction at small apertures. At higher magnifications, the need for more depth of field is usually compelling. If you need *f*-32, use it.

It's a good idea to avoid using the maximum lens aperture, even with flat subjects. One reason is that flat subjects, such as postage stamps, are often not exactly flat. With maximum aperture and limited depth of field, parts of the subject may be slightly out of focus. Another reason is that most lens aberrations are reduced by using smaller aperture. If possible, get enough light on the subject so you don't have to use maximum aperture.

As you will see in the next chapter, flash is a handy way to get lots of light. The camera controls exposure automatically. You can use flash off camera and use more than one flash for better control of the lighting.

Flat items, such as postage stamps, are best photographed in even illumination.

Electronic Flash

When additional light is needed to make an exposure, electronic flash is usually the simplest and best way. Light from a flash has two important characteristics that affect the way we use it. It is a pulse of light with extremely short duration, such as 1/20,000 second. Subjects at different distances from the flash receive noticeably different amounts of illumination.

In the spring, bright red snow plants emerge from the forest floor of western mountains, sometimes peeking through the snow. These were in deep shade, photographed with a MAXXUM AF MACRO 50mm lens and a 4000 AF flash in the camera hot shoe. The flash head was rotated upward, so it pointed away from the plants. The light was bounced back by a large sheet of white paper so the plants were backlit by diffused light.

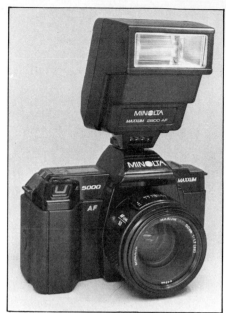

When using a MAXXUM camera on autofocus, in the programmed automatic mode, with a MAXXUM dedicated flash, all you need do is to be sure you are close enough to the subject. The camera does everything else, except press the Operating Button.

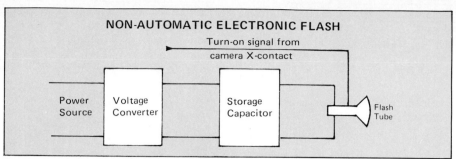

NON-AUTOMATIC ELECTRONIC FLASH

Turn-on signal from camera X-contact

Power Source | Voltage Converter | Storage Capacitor | Flash Tube

A non-automatic electronic flash is triggered by an X-sync signal from the camera. Fully charged, this type of flash gives the same amount of light each time it's fired.

BASIC PRINCIPLES

The components of a simple non-automatic electronic flash are shown in the accompanying drawing.

The power source is usually batteries, which supply a relatively low voltage, such as 6 volts. The flash requires a much higher voltage, such as 400 volts. The voltage converter is an electronic system that raises the low voltage from the batteries to the 400 volts or so that is needed.

A storage capacitor receives and stores electrical energy from the voltage converter. The capacitor is charged relatively slowly but discharged very rapidly to fire the flash.

The flash tube is a glass envelope filled with xenon gas. The electrical energy from the storage capacitor causes the flash tube to emit a pulse of very bright light.

The flash is turned on by a signal from the camera. In a simple non-automatic flash, the burst of light continues until the storage capacitor runs out of energy.

The storage capacitor must be recharged before the flash can be fired again. Recharging takes a certain amount of time, called the *recycle time*.

The color quality of light from an electronic flash simulates daylight. When used with daylight film, colors are usually realistic. With tungsten film, a conversion filter is required, as discussed in Chapter 6.

EFFECT OF DISTANCE

The brightness of the light from an electronic flash decreases according to the inverse square law, illustrated in Chapter 6. If distance to the subject is doubled, brightness decreases to 1/4, or by 2 exposure steps.

Suppose flash is used with subjects at distances of 5, 10 and 20 feet. If the subject at 10 feet is correctly exposed by the flash, the nearer subject will be overexposed by 2 step and the distant subject will be underexposed by 2 steps. The result will be visible in the photograph.

To avoid that problem, place subjects at approximately the same distance from the flash. Compose so there are no other large objects, such as furniture, at closer distances.

Another consequence of light falloff from a flash is that there's a limit to how far away from a subject flash can be used. Suppose light from a flash is sufficient to provide correct exposure at 10 feet. At 20 feet, the light is reduced by 2 steps. At 40 feet, light falloff is 4 steps. Objects at that distance are severely underexposed by the flash.

The exposure of distant objects is determined by the ambient light on the scene. With MAXXUM cameras and flash units, there is a way to control background exposure due to ambient light when using flash. This is discussed later in this chapter.

EFFECT OF DURATION

Because SLR cameras use focal-plane shutters, and because electronic flash has extremely short duration, there is a limitation to shutter speeds that can be used with flash.

Operation of a focal-plane shutter was described in Chapter 1. Each shutter curtain takes a certain amount of time to move across the shutter opening. The duration of electronic flash is much shorter than the travel time of a focal-plane shutter.

The flash cannot be fired while the first curtain is traveling across the frame because part of the frame is covered by the curtain. The part still covered would not receive exposure from the flash. The flash must be fired *after* the first curtain has fully opened but *before* the second curtain starts to close, otherwise part of the frame will be covered by a shutter curtain.

Slow Shutter Speeds—Suppose the travel time of each shutter curtain is 1/80 second and the exposure time is 1/30 second. At the beginning of the exposure interval, the first curtain starts to move. After 1/80 second, the

first curtain is fully open and the entire frame is exposed to light from the lens.

The shutter remains open until the end of the exposure interval of 1/30 second. Then, the second curtain starts to close the frame.

Notice that there is a period of time, between 1/80 and 1/30 second from the beginning of the exposure, when the frame is completely uncovered. The first curtain is fully open and the second curtain has not yet started to move. Electronic flash can be used only during that time.

With Fast Shutter Speeds—Suppose the travel time is 1/80 second and the exposure interval is 1/500 second. The first curtain starts to move. After 1/500 second has elapsed, the second curtain must start to move to end the exposure. At that time, the first curtain is only partway open.

The second curtain begins to close the frame before the first curtain has fully opened it. Electronic flash cannot be used because there is never an opportunity for it to fully illuminate the frame.

This is not a problem with continuous scene illumination, such as daylight. The frame is exposed by a narrow, traveling slit of light between the two curtains as the second curtain chases the first curtain across the frame.

FLASH SYNCHRONIZATION

An electronic flash is fired by a signal from the camera. Timing that signal, so the flash is fired when the shutter is fully open is called synchronization, abbreviated *sync*. For electronic flash, the signal that fires the flash is called *X-sync*.

The X-sync signal occurs when the first shutter curtain has just become fully open and the second curtain has not yet started to close. At that instant, the frame is fully open to flash.

To be sure the second curtain does not start to close before the first curtain is fully open, the selected shutter speed must not be too fast.

Here is the sequence of events in making a flash exposure:
- The exposure time begins and first curtain starts to open.
- The first curtain is fully open.
- The flash fires with duration of 1/500 second or less.
- The exposure time ends and second curtain starts to close.

The *fastest* shutter speed at which electronic flash can be used is called the X-sync speed. A fast X-sync speed and a short shutter-curtain travel time is desirable.

MAXXUM cameras use vertical-travel shutters rather than horizontal, to reduce curtain travel time and provide faster X-sync speeds—shown in the table on page 86.

Advantage of Fast X-Sync Speed—When flash is used, there may also be some continuous light on the scene, such as daylight or room lighting. There is some exposure due to the flash and some due to the ambient light.

If the subject is moving, you may get a sharp image due to the short-duration flash, overlaid by a blurred image of the same subject due to ambient light. The second image is called a ghost. It is usually not desired.

A fast X-sync shutter speed reduces exposure due to ambient light and therefore reduces the possibility of ghost images.

Using Slower Speeds—At any allowable shutter speed, X-sync or slower, shutter speed has no effect on the exposure caused by the flash, but it does affect exposure by ambient light.

Because light from the flash diminishes with increased distance, photos exposed mainly by light from the flash often have dark backgrounds. If there is some ambient light on the scene, you can make the background lighter by using a shutter speed that is slower than the X-sync speed.

If you are using flash with a moving subject and you want a blurred ghost image due to exposure by ambient light, a slower shutter speed will help.

Protection Against Incorrect Set-

MAXXUM flash units have a built-in AF (Auto Focus) Illuminator to enable the camera to focus in dim light or darkness. On this 2800 AF flash, the illuminator is the rectangle below the flash window.

The large center terminal in the hot shoe provides X-sync to the flash. The surrounding auxiliary terminals are used for dedicated features with MAXXUM flash units, such as automatic TTL exposure control, a flash-ready signal in the viewfinder, and to fire the AF Illuminator in the flash when needed by the camera autofocus system.

tings—With electronic flash, MAXXUM cameras will not allow shutter speeds faster than the X-sync speed to be used. Ways to use speeds slower than X-sync are described later.

AUTOFOCUS ILLUMINATOR

If you use flash because the scene is too dark for a good exposure with a reasonable shutter speed, then the scene may also be too dark for the

camera's autofocus system. MAX-XUM flash units can solve that problem. Each unit has a built-in AF (Auto-Focus) illuminator on the front. The illuminator produces a pulse of dark-red light to assist the camera autofocus system, when needed. If the MAX-XUM camera senses that the light is too dark, it will trigger the AF illuminator first, to allow autofocus. Then, it triggers the flash.

CONNECTING A FLASH

Because flash is fired by an X-sync signal from the camera, there must be an electrical connection between camera and flash unit. Flash units mount in an accessory shoe on top of the camera, which is commonly called a *hot shoe*. The word *hot* implies electrical contacts. Flash units have a mounting foot that fits in the camera hot shoe.

Hot-Shoe Contacts—A hot shoe has a central electrical contact that delivers the X-sync signal to a mating contact in the flash mounting foot. It is called the X-contact.

MAXXUM cameras and flash units have special operating features when used together. They require additional connections between flash and camera, which are provided by auxiliary contacts surrounding the X-contact in the hot shoe.

There are methods of using a MAX-XUM flash detached from the camera but connected by an electrical cable. These methods are discussed later.

GUIDE NUMBER

Exposure control with MAXXUM flash and cameras is usually completely automatic, requiring no calculations, no special control settings, and no technical understanding of electronic flash. This section provides some technical information in case you find it interesting or useful.

Exposure by electronic flash depends on the light output of the flash, the flash-to-subject distance, and the film speed. Shutter speed is not a factor

because all allowable speeds hold the shutter open longer than the duration of the flash.

The light output of a flash is expressed by a *Guide Number (GN)* which is part of the flash specifications. A higher guide number represents a more powerful flash.

Guide numbers are based on scenes having an average reflectivity of about 18%. They are based on the assumption that the flash is used indoors, where the subject is illuminated both by direct light from the flash and reflected light from the flash that bounces off walls and ceiling. Guide numbers do not take into account exposure due to ambient light.

When flash was first developed, guide numbers were used to calculate exposure settings for the camera, either with pencil and paper or by a calculator dial on the back of the flash unit. MAXXUM cameras control flash exposure automatically, so such calculations are normally not necessary. When you do need to use guide numbers, here's some helpful information.

Converting to Different Film Speed—A guide number is published

The MAXXUM 9000 has a PC socket to provide X-sync to a flash connected to the camera by an electrical PC sync cord. This connector is not used with MAXXUM flash units.

MAXXUM X-SYNC SPEEDS

Camera	X-Sync
5000	1/100 sec.
7000	1/100 sec.
9000	1/250 sec.

X-sync is the *fastest* shutter speed that can be used with electronic flash. In dim light, slower speeds are used with flash, as discussed later in this chapter.

Bounce flash gives a soft, natural-looking light. It avoids harsh shadows behind the subject and minimizes abrupt light falloff toward the background.

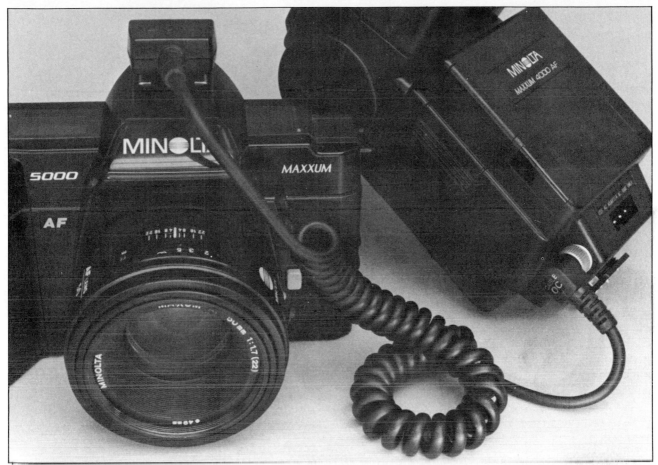

This is one way to separate a MAXXUM flash from a MAXXUM camera. An OC (Off-Camera) cord mounts in the camera hot shoe and connects to the flash. All dedicated features are preserved except that the AF illuminator in the flash is not used. The flash can be handheld or mounted on a tripod by using an accessory Off-Camera Shoe (not shown). The Off-Camera Shoe provides a tripod socket.

for a specific film speed. If you are using a different film speed, you must convert the GN so it applies to the new film speed. The new GN is:

$$\text{Published GN} \times \sqrt{\frac{\text{New Film Speed}}{\text{Publ. Film Speed}}}$$

Suppose the published GN is 20 (feet) with a film speed of 25. You are using film with a speed of 400. To convert the guide number:

$$\begin{aligned} \text{New GN} &= 20 \times \sqrt{400/25} \\ &= 20 \times \sqrt{16} \\ &= 20 \times 4 = 80 \text{ (feet)} \end{aligned}$$

Variable Guide Number—Some flash units have variable power and other variable settings that affect guide number, so the specifications show more than one number. Pick the num-

ber that applies to the settings you will use. Be sure you understand the conditions for which that number is valid.

Calculating Distance—You may occasionally want to calculate the operating distance of a flash. Here's how to do it:

$$\text{Distance to Subject} = \frac{\text{GN}}{f\text{-number}}$$

A guide number is stated in meters or feet. You must know which because the calculated distance will be in the same units. If guide number is stated in meters, the calculated distance is also in meters.

For example, the guide number of the MAXXUM 2800 AF flash is 28 (meters) with ISO 100 film. At an aper-

ture of f-5.6, subject distance is 28 meters/5.6, which is 5 meters or about 16 feet.

To find maximum distance, use the maximum available aperture of the lens. If the maximum lens aperture is f-1.4, distance becomes 28 meters/1.4, which is 20 meters or about 66 feet.

In the Program modes with flash, MAXXUM cameras set aperture automatically, using a special flash program. The flash program does not use apertures larger than f-2.8. If you set aperture manually, you may use an aperture larger than f-2.8.

Distance and Guide Number—The operating distance is proportional to the guide number. If you double the GN, distance is doubled. Using D1 and

D2 to represent operating distances at GN1 and GN2:

$$D2 = D1 \times (GN2/GN1)$$

Distance and Film Speed—If film speed is increased, the operating distance of a flash is increased. Using Dl and D2 to represent distances with film speeds of FSl and FS2:

$$D2 = D1 \sqrt{FS2/FS1}$$

Flash specifications usually give distance at only one film speed, such as ISO 100. Suppose the distance is 20 meters at ISO 100, but you are using a film speed of ISO 400:

$$D2 = 20 \sqrt{400/100}$$
$$= 20 \times 2 = 40 \text{ meters}$$

Calculating Aperture—Another use of guide numbers is to calculate the aperture setting for a specified subject distance:

$$f\text{-number} = \frac{GN}{\text{Dist. to Subj.}}$$

If flash and camera are at the same location, then flash-to-subject distance and camera-to-subject distance are the same. After focusing, you can read the distance scale on the lens. Otherwise, flash-to-subject distance is used.

Guide number and distance must be in the same units—feet or meters. The full-power guide number of the MAX-XUM 2800 AF is 28 (meters) or 92 (feet) with ISO 100 film. Suppose the subject is 66 feet away. The *f*-number setting is 92/66, which is *f*-1.4. With an *f*-1.4 lens, you can use that value if you are setting aperture manually.

FLASH TECHNIQUES

The simplest way to use flash is to mount the unit in the hot shoe, pointing it directly at the subject. However, that produces flat lighting and dark shadows on a nearby background.

DETACHING THE FLASH

You can get much more attractive lighting by using a sync cord or cable

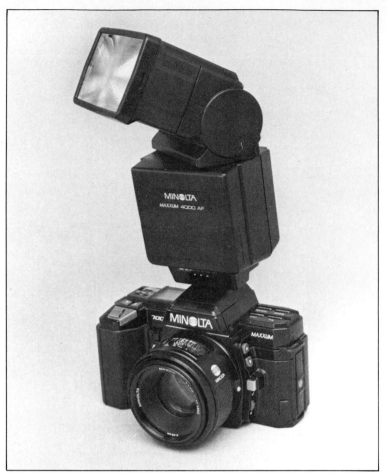

The 4000 AF flash head tilts from horizontal to vertical and swivels from left to right. It can be used for bounce flash when mounted in the hot shoe.

between camera and flash, so you can remove the flash from the camera and hold it in your hand or mount it on a tripod. Placing the flash above the subject moves background shadows downward so they are out of the picture or less obtrusive. Holding the flash to one side gives better modeling to your subjects.

BOUNCE FLASH

Pleasing illumination is produced by bouncing the light from the flash off the ceiling or a wall. The resulting light on the subject is diffused by the bounce and arrives at an angle that gives some modeling to facial features. The color of the bounced light will be influenced by the color of the bounce surface, so white walls and ceilings are best.

Less light reaches the subject because the light path is longer and because some light is absorbed by the bounce surface. With MAXXUM flash and cameras, the exposure adjustment is made automatically.

To allow bouncing with the flash mounted in a hot shoe, the head of the MAXXUM 4000 AF can be swiveled 90° to the left or right and tilted from horizontal to vertical.

The 2800 AF and 1800 AF have fixed heads that neither swivel nor tilt. With those flash units in the hot shoe, bounce flash is not possible.

Any MAXXUM flash can be detached from the camera and pointed in any direction, for bounce flash or any other purpose. Methods are described later in this chapter.

FILL FLASH

Fill lighting from one source is used to lighten shadows caused by another light source. If both sources are continuous light, or both are flash, adjustment of the lighting ratio is straightforward as discussed in Chapter 6.

A common use of electronic flash is to provide fill lighting outdoors, where the main light is the sun. MAXXUM cameras and the companion MAXXUM flash units can automatically control flash fill with sunlight. Automatic fill flash is discussed later in this chapter.

There may be occasions when you prefer to control fill flash manually, and there are situations where it may be necessary.

Manual Fill Flash with Sunlight— This procedure is complicated because the light sources have different characteristics.

Exposure due to electronic flash is affected by aperture size. It is also affected by the distance between flash and subject because flash produces an expanding beam of light that follows the inverse square law. It is not affected by shutter speed because the flash duration is always much shorter than the allowable shutter speed—the X-sync shutter speed or slower.

Exposure due to daylight is affected by both aperture and shutter speed. It is not affected by the distance between camera and subject. If a subject in daylight is correctly exposed at one distance from the camera, exposure will be correct at any other distance. The image will be larger or smaller, but exposure will be the same.

The Procedure—It is assumed that the subject is illuminated by the sun in such a way that dark facial shadows appear. If there are no shadows, there is no need for fill flash.

1. With the flash turned off and the camera set for manual exposure control, set shutter speed to X-sync or slower.

2. Meter the subject and set aperture for *full* exposure by the ambient light.

Direct flash, pointed at the subject, produces flat lighting. To avoid shadows behind the subject, place the subject close to the background, as in this picture.

This photo, taken with flash bounced from the ceiling, has improved color detail. Direct flash tends to produce surface reflections that degrade colors.

When bouncing flash, be careful not to aim the flash too low. If you do, the lower part of the flash beam strikes the background without bouncing, with the result shown.

If you took the picture at this point, it would be correctly exposed, but there would be deep shadows.

3. Determine flash-to-subject distance for *full* exposure by the flash alone at the aperture setting already made. This can be done in two ways. One is to calculate the distance using the flash guide number.

$$\text{Distance to Subject} = \frac{GN}{f\text{-number}}$$

The other method is to refer to the display on the back of the flash. The 4000 AF flash will do the guide-number calculation automatically and display the distance. With the 2800 AF flash, use the maximum distance shown on the calculator scales for the *f*-number you are using—and the power setting, Hi or Lo. With the 1800 AF flash, you must make the guide-number calculation.

4. Place the flash at the calculated distance from the subject. If the subject were indoors, the subject would receive full exposure from the flash alone. Outdoors, because there are no reflections from walls and ceiling, the subject will receive about a half step less exposure from the flash.

It will also receive full exposure from ambient light. If you take the picture at this point, the subject will be overexposed.

5. Close aperture a half step. This reduces exposure by both flash and ambient light. Exposure should be satisfactory. If you prefer less exposure, close aperture a full step.

Controlling Flash-to-Subject Distance—This flash-fill procedure suggests placing the flash at a calculated distance from the subject. There are two ways to do that.

If the flash is attached to the camera, both must be placed at the calculated distance. That will affect composition of the image. If the subject is too small or too large, use a different focal length. A zoom lens is convenient, or you can change lenses.

The flash can be detached and con-

These two photos show the effect of fill flash. The photo on the left was made in direct sunlight. Shadows are deep and lack detail. The photo on the right was also made in sunlight, but the shadows were lightened with fill flash. To maintain modeling in a picture, the fill light should not be so strong as to eliminate all shadows.

nected to the camera by a sync cable, as discussed later in this chapter. That allows you to place flash and camera at different distances from the subject. Put the flash at the calculated distance. Put the camera wherever you wish, for the best composition.

Detaching the flash allows more control of the lighting ratio. For less fill lighting, move the flash farther from the subject.

AUTOMATIC ELECTRONIC FLASH

Automatic flash requires a light sensor that measures exposure while the flash is operating. When sufficient exposure has been measured for an average subject or scene, the sensor system turns the flash off. What is controlled is the *duration* of the flash, not its brightness.

CONVENTIONAL AUTOMATIC FLASH

The light sensor is on the front of the flash, looking toward the scene. It measures exposure on behalf of the camera. MAXXUM flash units don't use this method.

TTL AUTOFLASH

MAXXUM cameras control electronic flash exposure using a light sensor, in the bottom of the mirror box, that "looks" at the film. It measures light on the film due to ambient light on the scene *and* light from the flash. When the sensor has measured sufficient exposure, the camera turns off the flash. The shutter remains open until the set exposure time has elapsed, then closes.

This method is called TTL (Through-The-Lens) autoflash because the light sensor measures light coming through the lens. Minolta also refers to this method as *Direct Autoflash Metering*. The advantage is that the light sensor measures only what is being photographed.

Operating Range—This is the distance range of automatic flash, from

This photo was made with bounced flash from a MAXXUM 4000 AF unit. The metering system "saw" mainly white in this high-key subject. To prevent recording the white areas as gray, the camera Exposure Adjustment control was set to +2.

the minimum distance to the maximum distance over which a subject can be satisfactorily exposed. The operating range is shown by a display on the back of the flash unit.

The maximum operating distance is determined by the light output of the flash, lens aperture and film speed. Distance is increased by more light, larger aperture and faster film. Subjects beyond maximum range will be underexposed.

Minimum distance is determined mainly by how fast the camera can turn off the flash after it has fired. Subjects closer than the minimum range will be overexposed.

Exposure Adjustment—Automatic TTL exposure control of flash can be "fooled" by non-average scenes. Unusually light or dark backgrounds can cause the subject to be under- or overexposed, as discussed earlier.

The camera Exposure Adjustment control works with auto flash the same as it does with automatic exposure without flash. You can use it to adjust

exposure as desired.

FLASH MODES

MAXXUM flash units are designed to be controlled by the camera and to function in any of the camera's exposure modes. Mode selection for both flash and camera is made at the camera.

In all modes, the aperture and shutter speed to be used are shown in the camera displays. There may be some differences in camera operation because of the flash. For example, with flash, the camera cannot use shutter speeds faster than the X-sync speed.

The camera recognizes the presence of the flash and operates accordingly when the flash is installed, turned on and charged so it is ready to fire.

The camera operates as though the flash were not installed during the recycle time, when the flash is charging, and when the flash is turned off.

For the remainder of this section, it is assumed that you are using flash to photograph a relatively near subject against a more distant background,

which is a typical use of flash. If the subject fills the frame, what will be said about background obviously does not apply.

Program (P) Mode—In this mode, the camera uses a special flash program when a MAXXUM flash is charged and ready to fire. Both aperture and shutter speed are set automatically and the values to be used are displayed. The automatic settings depend on film speed, the brightness of the ambient light, and the camera model.

Shutter speed is set as shown in the table on page 97. If the ambient light is dim, the camera will use a slower shutter speed to provide more exposure of the background.

Aperture is set according to the ambient light on the scene with the purpose of balancing light from the flash and ambient light on the scene, when possible.

The largest aperture size used by the flash program is *f*-2.8. This aperture is used in dim light and up to a scene brightness of EV 8, which is bright shade outdoors. If the scene becomes brighter, aperture size is gradually reduced. For each step increase in scene brightness, aperture is reduced by one step. For example, as scene brightness increases from EV 8 to EV 9, aperture is gradually reduced from *f*-2.8 to *f*-4.

The smallest aperture used by the program depends on film speed and the lens in use. With ISO 100, the smallest aperture is *f*-8, which is reached when scene brightness has increased to EV 11. Above EV 11, aperture remains at *f*-8.

At ISO 200, the smallest aperture used by the flash program is *f*-11, reached at EV 12. At ISO 400, the smallest aperture used is *f*-16, reached at EV 13—and so forth. The flash program will not attempt to use a smaller aperture than is available on the lens.

When the flash program has set aperture and shutter speed, you can see the settings in the viewfinder display. If you prefer different settings, use another exposure mode, as discussed lat-

er in this section. Program shift cannot be used to alter settings made by the flash program.

If the programmed settings are OK, check the operating-range display on the flash to be sure the subject is within range. Make the exposure.

P-Mode Automatic Fill Flash—The programmed mode allows using flash in daylight, to fill shadows in sunlight. The subject will be exposed partly by flash and partly by ambient light.

No special settings or calculations are required. Just install the flash and turn it on. Fill flash is automatic because the TTL light sensor in the camera measures *total* exposure and turns off the flash when exposure is sufficient.

To avoid overexposure of the subject with scene brightnesses greater than EV 8, MAXXUM cameras automatically reduce flash duration by approximately one step. However, there is an upper limit to the scene brightness that allows correct exposure with fill flash.

Limit of P-Mode Automatic Fill Flash—Aperture size is reduced by the flash program as the ambient scene brightness increases. This gives increased depth of field and avoids overexposure by ambient light at the shutter speed required with flash.

As ambient light becomes brighter and the flash program reduces aperture, the maximum operating distance of the flash is also reduced. If the light becomes sufficiently bright, there are conflicting requirements: The aperture must be large enough to provide a useful operating distance for the flash, but it must be small enough to avoid overexposure by daylight.

There is a point at which operating distance becomes the main consideration and overexposure is allowed. Here is an example:

With ISO 100 film, the MAXXUM flash program will not use an aperture smaller than *f*-8, no matter how bright the ambient light is. Suppose a MAXXUM 7000 camera is used to photograph an average scene in direct sun-

Flash was not used for this photo. In bright sunlight, the shutter speed was fast enough to stop the motion of the ball.

This photo was made with flash. Because the X-sync shutter speed for flash was slower than the shutter speed for ambient light, the moving baseball produced a blurred image.

light on a clear day. Using the *Sunny-Day f-16 Rule* discussed in Chapter 5, ISO 100 film requires a shutter speed of 1/100 second at *f*-16, or any other pair of settings that gives the same exposure.

With flash installed, turned on and charged, the MAXXUM 7000 will use the X-sync shutter speed of 1/100 second and an aperture of *f*-8 because that's the programmed limit. The scene will be overexposed by two steps, due to ambient light alone.

Why doesn't the program use a smaller aperture? With a medium-powered flash such as the 2800 AF, at *f*-8 the maximum operating distance is about 12 feet. At *f*-16, it would be 6 feet—probably not a useful flash range for most outdoor photography.

Even though ISO 100 film and the MAXXUM 7000 was used in this example, the situation is similar at other film speeds and with other camera models. Because the MAXXUM 9000 can use an X-sync speed of 1/250, overexposure may be one step rather than two.

With slide film, overexposure of one step or more is usually not acceptable. With negative film, overexposure can be corrected during the printing procedure. Overexposure of one step is usually acceptable. For a non-critical

viewer, overexposure of two steps is probably OK.

How to Avoid the Problem—In most cases when you need automatic fill flash in daylight, it is usable. With the sun low in the sky so it illuminates the subject from the side, and the subject oriented so there are facial shadows, automatic programmed fill flash works very well.

If the sun is high in the sky and the subject is facing the sun, overexposure is likely. A way to check is to measure the scene with the flash turned off. Use the shutter-priority mode with shutter speed set to X-sync. Notice the metered aperture value. Switch on the flash. Shutter speed should still be X-sync. Notice the aperture to be used with flash. If it is larger than the aperture needed without flash, overexposure is likely.

If you need fill flash anyway, don't use the program mode. You can use a different automatic-exposure mode or the manual mode, as discussed earlier.

With Dim Ambient Light—In the program mode, if the light is dim, the camera will use maximum aperture of the lens with the flash turned on or off. If you take an exposure reading with the camera set to the program mode and with the flash turned off, you may find that the required shutter speed for

Using shutter-priority autoflash with a MAXXUM 9000, I set the shutter to 1/250 second. The camera set the standard aperture of *f*-5.6 for this mode. The subject is overexposed by the ambient light and flash.

Still using shutter-priority and 1/250 second, pressing the AEL button caused the MAXXUM 9000 to use an aperture of *f*-11 and reduce flash duration. Subject exposure is improved.

ambient light is slow, such as 1/15 second. When you switch on the flash, the flash program will use 1/60 second. There will be very little exposure due to ambient light.

You will get a satisfactory exposure due to light from the flash, but depth of field may be insufficient because the lens is at *f*-2.8 or its maximum aperture if smaller. You may prefer to use one of the modes discussed in the following paragraphs.

Aperture-Priority (A) Mode—You set any aperture. The camera sets the X-sync shutter speed when the flash is charged. Because you set aperture, you have control over depth of field. Check the operating-range display on the flash to be sure the subject is within range at the set aperture. Make the exposure.

A-Mode Slow-Shutter Sync—In dim light, you can use a slower shutter speed to increase background exposure due to ambient light. With the flash off, meter the scene and set aperture so shutter speed is more than one step below X-sync speed.

Turn on the flash. The X-sync speed will be displayed. Press and hold the AE Lock button. Shutter speed will become one step faster than the metered speed observed earlier. If the me-

tered speed was 1/15 second, shutter speed will be 1/30 second. To avoid overexposure of the subject, flash duration is automatically reduced by about one step.

Shutter speed is one step faster than the original metered value to prevent overexposure of the background because it will receive some light from the flash. Check the operating-range display on the flash to be sure the subject is within range. While holding in the AEL button, make the exposure.

A-Mode Fill Flash—If you use the flash in bright light, flash fill is automatic. Choose an aperture that won't overexpose the scene due to ambient light. Check the flash operating range at that aperture.

If you also want to decrease shutter speed for more exposure of the background, use the procedure for A-mode slow-shutter sync. In bright ambient light, a shutter speed slower than X-sync may require a neutral-density filter over the lens.

Shutter-Priority (S) Mode—The MAXXUM 9000 has a shutter-priority autoflash mode. With the MAXXUM 7000, autoflash at the S setting works the same as Program. The MAXXUM 5000 doesn't have an S setting.

With a MAXXUM 9000 set for shutter-priority operation with a MAXXUM flash, you set shutter speed to X-sync or any slower speed except bulb. Slower settings allow more exposure of both subject and background due to ambient light. Aperture is set automatically to *f*-5.6 when the flash is charged. Check the operating-range display on the flash to be sure the subject is within range. Make the exposure.

The TTL exposure meter will turn off the flash when sufficient exposure of the subject has been measured. For the remainder of the exposure time, both subject and background will receive ambient-light exposure at an aperture of *f*-5.6. This may or may not give good exposure.

S-Mode Fill Flash and Slow-Shutter Sync—With this procedure, you can set both shutter speed and aperture for correct exposure of the background. Correct flash exposure of the subject is controlled by the TTL meter in the camera.

Set shutter speed to X-sync or slower, except bulb. Aperture will be set to a standard value of *f*-5.6 when the flash is charged. This may not be the correct aperture for ambient-light exposure at

the set shutter speed.

Press and hold the AE Lock button. Aperture will change to one step smaller than the metered value for ambient light. From the standard *f*-5.6 setting, aperture can change either way, depending on scene brightness. Flash duration will be reduced by one step to prevent overexposure of the subject.

Check the operating-range display on the flash to be sure the subject is within range. While holding in the AEL button, make the exposure. Notice that this procedure is similar to the manual flash-fill method described earlier.

MAXXUM 9000 Metering Pattern—In the preceding automatic flash modes, the camera measures ambient light and uses the measurement for several purposes—for example, to set shutter speed in the Program mode. With the MAXXUM 9000, a more accurate ambient-light measurement will result if you set the camera to use center-weighted averaging rather than spot metering.

If set for spot, the small metered area may be unusually dark or light and therefore not a good indicator of ambient-light brightness.

Manual Mode Autoflash—Set shutter speed at X-sync or slower, including bulb. Set any desired aperture. Check the operating-range display on the flash to be sure the subject is within range. Make the exposure. The TTL sensor in the camera will turn off the flash when sufficient exposure has been measured. The shutter will remain open for the set exposure time.

If you are using this mode for manual fill-flash, using the procedure discussed earlier, the flash will operate according to its guide number. That is, it will make light for its full duration without being turned off by the TTL meter in the camera.

Manual Mode Manual Flash—The MAXXUM 4000 AF flash has a push-button labeled TTL/M. With the camera set for the manual mode, if TTL is selected, autoflash operation is as just described. The display shows the op-

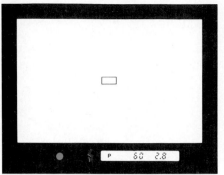

The red "lightning" symbol in the viewfinder is a flash-ready indicator. It glows when a MAXXUM flash is charged and ready to fire. If the subject received enough exposure, the symbol blinks rapidly for about one second after exposure.

erating range.

If M is selected, the flash will disregard the turn-off signal from the camera and continue the flash for its full duration. Exposure is not automatic, it is truly manual. The 4000 AF flash calculates and displays a single subject distance for correct exposure.

The distance is the same as the maximum operating range in the TTL option. The 4000 AF has more than one power setting. If the displayed distance is not suitable, select a different power level.

FLASH FEATURES

This section discusses controls and indicators used on MAXXUM flashes. As you will see in the descriptions of flash units later in this chapter, these features vary among MAXXUM flashes.

FLASH-READY INDICATOR

When the flash is charged and ready to fire, a red "lightning" symbol glows on the back of the flash. This is the Flash-Ready symbol. While the flash is recycling, the indicator does not glow.

When the Flash-Ready symbol on the flash glows, the Flash symbol in the camera viewfinder turns on and blinks slowly.

A Wideangle Adapter clips over the flash window to widen the flash beam. Using this adapter on the 1800 AF flash widens the beam so it covers the angle of view of a 28mm lens instead of a 35mm lens. The adapter reduces maximum operating range about 30%.

SUFFICIENT-EXPOSURE INDICATOR

This is a green OK symbol to indicate that the flash produced sufficient exposure. After each exposure using flash, it glows for about five seconds if the flash was turned off by the TTL light sensor.

If the flash *wasn't* turned off by the camera, it produced the maximum amount of light and then extinguished. Exposure was probably insufficient. However, it is possible that maximum light did expose the scene correctly.

If the subject is closer than minimum range, sufficient exposure will be indicated, but the subject will probably be overexposed. There is no warning of overexposure.

When the Sufficient-Exposure symbol glows on the flash, the Flash symbol in the camera viewfinder blinks very rapidly for about one second.

TEST BUTTON

The TEST button fires the flash independently of the camera. It can be used to see if the flash operates. It cannot be used to test exposure before taking a picture.

Another use is to remove the flash, open the shutter on bulb, and fire several flashes to illuminate a large, dark area. When doing this, the camera must be on a sturdy tripod and the subject must remain motionless.

POWER-LEVEL INDICATOR

This allows control of the maximum amount of light that the flash can produce and, therefore, control of the guide number.

AUDIBLE CHARGING

The charging circuit in the flash makes a faint hum that rises in pitch as it nears full charge. When the more powerful flash units are charged and ready, you may hear an intermittent high-pitched beep caused by replenishment of the charge.

AUTO TURNOFF

To conserve battery power, the flash turns itself off after a period of time if you have not touched the camera Operating Button. The time varies among models and is stated in the flash descriptions, later in this chapter. Touching the Operating Button turns the flash on again.

BEAM ANGLE

Flash units produce a rectangular beam with approximately the same shape as the 35mm film frame. The angle of the beam is stated by similarity to the angle of view of a lens. Depending on the model, MAXXUM flash units "cover" the angle of view of a 35mm or 28mm lens. If the specs say that the flash covers a 35mm lens, then it also covers the smaller angle of view of lenses with longer focal lengths.

Wideangle Adapters—Clip-on lenses that fit over the flash window to widen the beam angle are available. Widening the beam reduces the intensity of the light and the maximum operating distance.

Zoom Head—The MAXXUM 4000 AF flash has a movable lens that changes the angle of coverage from that of a 28mm lens to that of a 70mm lens. The angle can be set automatically or by a pushbutton on the flash, as described later.

BATTERIES

The number of flashes from a set of batteries, and the recycle time, is determined by the type of batteries used. Ordinary carbon-zinc batteries provide the least number of flashes. Alkaline batteries provide the greatest number of flashes.

Rechargeable Nickel-Cadmium (NiCad) batteries provide more flashes than carbon zinc, but less than alkaline. They provide shorter recycle times be-cause they can supply more current.

A 6-volt lithium battery may be used in the 1800 AF flash, instead of four AAA-size alkaline batteries. The lithium battery provides about twice as many flashes and faster recycling.

Battery Discharge—As the batteries discharge, recycle time becomes longer. Here is an indication of when batteries should be replaced or recharged:

BATTERY	RECYCLE TIME
Alkaline	30 seconds
Ni-Cad	10 seconds
Carbon-zinc	30 seconds
Lithium	30 seconds

Use batteries that are all of the same brand and type. Replace all batteries at the same time.

In cold weather, batteries lose power but recover when warmed up again. It's a good idea to keep a spare set warm in your pocket. Ni-Cad batteries are best for cold-weather use.

MAXXUM FLASH UNITS

The remainder of this chapter describes MAXXUM flash units and accessories, with specification tables. When a flash has a feature or control that has already been described, it will be mentioned but not discussed in detail. Additional information or differ-

FLASH COMPARISON TABLE

	1800 AF	2800 AF	4000 AF
Guide Number (ISO 100 with 35mm-Lens Beam Angle)	59 (feet) 18 (m)	92 (feet) 28 (m)	112 (feet) 35 (m)
P-Mode Range*	2.3—21 feet	2.3—33 feet	2.3—46 feet
AF Illum. Range*	14.5 feet	16 feet	23 feet
Exposure Control	TTL Auto only	TTL Auto only	TTL Auto or Manual
Flash Head	Fixed	Fixed	Tilt and swivel
Beam Angle (with Adapter)	35mm 28mm	35mm 28mm	28mm to 70mm 24mm
Power Levels	Full power only	HI (92 ft. GN) LO (23 ft. GN)	FULL, 1/2, 1/4, 1/8, 1/16, MD
Auto Turn Off	Yes	Yes	Yes
Power Source	One 6V lithium or four AAA	Four AA alkaline or Ni-Cad	Four AA alkaline or Ni-Cad

*Maximum range with 50mm lens at EV 1 with ISO 100.

ent operating features are discussed.

MAXXUM flash units are called *dedicated* because they have features that function only when used with MAXXUM cameras. Examples are: The camera controls exposure by the flash; the flash controls the flash-ready and sufficient-exposure indicator in the camera viewfinder.

Power Ratings—The maximum guide number in meters is indicated by the flash nomenclature. The 1800 AF has a guide number of 18 (meters). The 2800 AF and 4000 AF have guide numbers of 28 and 40 (meters).

MAXXUM 1800 AF FLASH

This is a small, fixed-head, hot-shoe mounted flash with a built-in AF Illuminator for autofocus in dim light. The AF Illuminator is triggered automatically by the camera, when needed. Flash exposure is controlled automatically by the TTL sensor in the camera, based on the film-speed setting of the camera. Sufficient exposure is indicated by the flash symbol in the camera viewfinder, not on the flash itself.

Exposure Modes—The modes are set at the camera. Modes are programmed auto with fill flash, aperture-priority auto with fill flash and slow-shutter sync capability, shutter-priority auto with fill flash and slow-shutter sync capability, and manual camera operation with TTL autoflash.

Exposure Adjustment—The camera Exposure-Adjustment control affects exposure with flash. Range is plus or minus 4 exposure steps.

Controls and Indicators—The OFF/ON switch is on the back. When the flash is turned on, if the camera Operating Button has not been touched for 60

The 1800 AF flash has only one control—the OFF-ON switch. A flash-ready indicator glows when the flash is charged. Sufficient-exposure is indicated only in the camera viewfinder. Distance ranges for programmed automatic at ISO 100 and ISO 400 are shown on the flash.

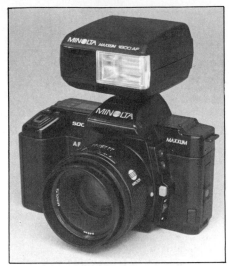

The 1800 AF flash is the smallest, simplest, and least powerful of current models. The flash head is fixed, so you can't bounce flash with the 1800 AF mounted in the hot shoe.

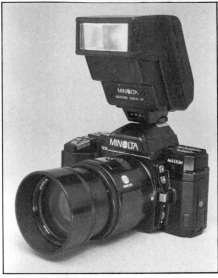

The 2800 AF flash is a fixed-head type. To use it for bounce flash, it must be removed from the hot shoe. The AF Illuminator is below the flash window. The electrical connector at bottom front is an External Power Input receptacle.

seconds, the flash turns itself off automatically. Touching the button will turn it back on.

Adjacent to the OFF/ON switch is a Flash-Ready indicator. It's a red "lightning" symbol that glows continuously when the flash is charged.

Film Speed—Usable range, set at the camera, with the MAXXUM 5000 and 7000 is ISO 25 to 1000. With the MAXXUM 9000, it is ISO 12 to 1000.

0perating-Range Display—Printed on the back of the flash are operating ranges in the program mode for two film speeds, ISO 100 and ISO 400, with lenses having maximum apertures of *f*-2.8 or larger.

Wideangle Adapter—Packaged with the flash, this adapter clips over the flash window and increases beam angle to cover a 28mm lens. Maximum flash range is reduced by 30%.

Repeating Flash—The flash can recycle and fire at speeds up to two

MAXXUM 1800 AF FLASH SPECIFICATIONS

Type: Dedicated, with AF illuminator for autoflash.
Exposure Control: By camera using TTL sensor.
Exposure Modes: Programmed auto, shutter-priority auto, aperture-priority auto, manual camera operation with automatic flash.
Film Speed: Set at camera.
AF Illuminator: Automatically triggered by camera.
AF Illuminator Range: Approx 4.5 meters (14.5 feet).
Beam Angle: Covers angle of 35mm lens.
Wide-Angle Adapter: Supplied. Covers 28mm lens.
Guide Number at ISO 100: 18 meters (59 feet).
Guide Number With Wide-Angle Adapter: 13 meters (42 feet).
Power Source: One 6V lithium or four AAA-size alkaline.
Auto Turnoff: After 60 seconds if Operating Button not touched.
Dimensions: 70 x 56 x 74mm (2-3/4 x 2-3/16 x 2-15/16 in.)
Weight: 135g (4-3/4 oz.) without batteries.

MAXXUM 2800 AF FLASH SPECIFICATIONS

Type: Dedicated, with AF illuminator for autoflash.
Exposure Control: By camera using TTL sensor.
Exposure Modes: Programmed auto, aperture-priority auto, manual camera operation with automatic flash.
Film Speed: Set at camera. Also set on back of flash to calibrate distance scales for use with ISO 25 to 1000 film.
AF Illuminator: Automatically triggered by camera.
AF Illuminator Range: Approx 5 meters (16 feet).
Beam Angle: Covers angle of 35mm lens.
Wide-Angle Adapter: Supplied. Covers 28mm lens.
Power Levels: Hi or Lo for sequential exposures.
Guide Number at ISO 100:
Without Wide-Angle Adapter—
 Hi—28 meters (92 feet)
 Lo—7 meters (23 feet)
With Wide-Angle Adapter—
 Hi—20 meters (66 feet)
 Lo—5 meters (16 feet)
Power Source: Four AA-size alkaline, carbon-zinc or Ni-Cad. AC Adapter AC-1000 may be connected to the External Power Terminal on the front of the flash to operate from commercial power.
Auto Turnoff: After 15 minutes if Operating Button not touched.
Dimensions: 99 x 70 x 86mm (3-7/8 x 2-3/4 x 3-3/8 in.)
Weight: 220g (7-3/4 oz.) without batteries.

MAXXUM 4000 AF FLASH SPECIFICATIONS

Type: Dedicated, with AF illuminator for autoflash.
Exposure Control: By camera using TTL sensor.
Exposure Modes: Programmed auto, aperture-priority auto, shutter-priority auto, manual camera operation with either auto-flash or manual flash.
Film Speed: Set at camera.
AF Illuminator: Automatically triggered by camera.
AF Illuminator Range: Approx 7 meters (23 feet).
Beam Angle: Variable by movable lens in front of flash window. Range of lens coverage is 70mm to 28mm without wide-angle adapter.
Wide-Angle Adapter: Supplied. Covers 24mm lens.
Flash Coverage: Motor-driven zoom head adjusts beam angle to match following lenses: 70mm and longer, 50mm, 35mm, 28mm, and 24mm with wide-angle adapter.
Power Levels: FULL, 1/2, 1/4, 1/8, 1/16, and MD for sequential exposures.
Power Source: Four AA-size alkaline or Ni-Cad. AC Adapter AC-1000 may be connected to the External Power Terminal on the front of the flash to operate from commercial power.
Auto Turnoff: After 15 minutes if Operating Button not touched.
Dimensions: 82 X 144.5 X 102.5mm (3-1/4 x 5-11/16 x 4-1/16 in.)
Weight: 495g (17-7/16 oz.) without batteries.

MAXXUM FLASH SHUTTER-SPEED AND APERTURE SETTINGS FOR NORMAL FLASH PHOTOGRAPHY

Expo-sure Mode	Camera Model		
	5000	7000	9000
P	1/100 at EV12 and brighter 1/60 below EV12 Aperture by program	1/100 at EV12 and brighter 1/60 below EV12 Aperture by program	1/250 above EV13 1/125 at EV12 to 13 1/60 below EV12 Aperture by program
A	Mode not available	X-sync at 1/100 Any aperture	X-sync at 1/250 Any aperture
S	Mode not available	Same as P mode	Manual speeds of 1/250 or slower f-5.6 by camera
M	1/100 or slower Any aperture	1/100 or slower Any aperture	1/250 or slower Any aperture

frames per second with the camera Focus-Mode Switch set to manual. At this setting, the AF Illuminator on the flash is not used.

Power Source—Four AAA-size batteries or one 6V lithium battery may be used. The lithium battery provides about twice as many flashes and shorter recycle times. This flash will not fit on Control Grip CG-1000.

Accessories—Off-camera shoe, Triple Connector TC-1000, Cables OC, EX, CD.

MAXXUM 2800 AF FLASH

This is a fixed-head, hot-shoe mounted, medium-power flash with a built-in AF Illuminator for autofocus in dim light. The AF Illuminator is triggered automatically by the camera, when needed. Flash exposure is controlled automatically by the TTL sensor in the camera, based on the film-speed setting of the camera.

Exposure Modes—These are set at the camera. Modes are programmed auto with fill flash, aperture-priority auto with fill flash and slow-shutter sync capability, shutter-priority auto with fill flash and slow-shutter sync

MAXXUM 4000 AF GUIDE NUMBER AT ISO 100 meters (feet)					
	Power Setting				
Beam Angle	FULL	1/2	1/4	1/8	1/16
70mm	45 (148)	32 (105)	23 (75)	16 (52)	11 (36)
50mm	40 (131)	28 (92)	20 (66)	14 (46)	10 (33)
35mm	34 (112)	24 (79)	17 (56)	12 (39)	8.5 (28)
28mm	28 (92)	20 (66)	14 (46)	10 (33)	7.1 (23)
24mm with Wide-Angle Adapter	20 (66)	14 (46)	10 (33)	7 (23)	5 (16)

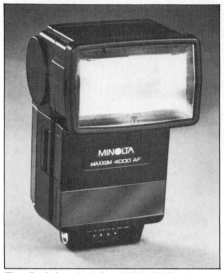

The flash head of the 4000 AF flash swivels and tilts so that it can be used for bounce flash in the hot shoe. The AF Illuminator is below the flash head. An External Power Input receptacle is below the AF Illuminator.

The 4000 AF flash has a lot of capabilities and features. It can be set so you don't have to do anything except check operating distance and press the Operating Button, or it can be set for very sophisticated flash fill and control of background exposure.

capability, and manual camera operation with TTL autoflash.

Exposure Adjustment—The camera Exposure-Adjustment control affects exposure with flash. Range is plus or minus 4 exposure steps.

Controls and Indicators—These are on the back panel of the flash.

The OFF/ON switch is a pushbutton that locks in when the flash is turned on. Depress again to turn the flash off. If the camera Operating Button has not been touched for 15 minutes the flash turns itself off automatically. Touching the button will turn it back on.

The Sufficient-Exposure indication is a green OK symbol labeled EXP.

The Flash-Ready indicator is a red "lightning" symbol that glows continuously when the flash is charged.

The TEST button fires the flash independently of the camera.

The Power Switch has two settings. Hi is full power. When set to Lo, the maximum operating range is divided by 4.

Film Speed—With the MAXXUM 5000 and 7000, the usable range is ISO 25 to 1000. With the MAXXUM 9000, the range is ISO 12 to 1000. Film speed is set at the camera.

The Film-Speed Slide on the flash control panel should be set to agree with the camera setting but does not control exposure. It calibrates the operating-range display on the flash so it reads correctly.

Operating-Range Display—The top scale shows operating range in the program mode at either power level. The range for the Lo setting is marked by diagonal lines on the scale and is to the left of the range for the Hi setting.

Additional scales, labeled with f-numbers, show operating range in aperture-priority or manual modes at each power level.

In the aperture-priority or manual modes, no scale is shown for an aperture setting of f-2.8 but it's the same as the program range. Each aperture step larger than f-2.8 multiplies the maximum range by 1.4.

The operating range shown for the program mode is valid for lenses with maximum apertures of f-2.8 or larger. For lenses with maximum apertures smaller than f-2.8, maximum range is reduced. It is the same as shown on the scales labeled with f-numbers.

Wideangle Adapter—Packaged with the flash, this adapter clips over the flash window and increases beam angle to cover a 28mm lens. Maximum flash range in all modes is reduced by 30%.

Repeating Flash—At the Lo setting of the Power Switch, the flash can recycle and fire at speeds up to two frames per second with the camera Focus-Mode Switch set to manual. At this setting, the AF Illuminator on the flash is not usable. Ni-Cad flash batteries are recommended for repeating-flash operation.

Power Source—Four AA-size batteries are used in the battery chamber. Alkaline, Ni-Cad or carbon-zinc may be used. An optional power source is

Control Grip CG-1000. Batteries in the grip augment or replace those in the flash.

External Power—A four-pin connector on the front, near the mounting foot, accepts power from Control Grip CG-1000 or Adapter AC-1000, which converts AC power to DC to supply the flash.

Accessories—Control Grip CG-1000, Cables OC, EX, CD, off-camera shoe, Triple Connector TC-1000, Ni-Cad Charger NC-2 with batteries.

MAXXUM 4000 AF FLASH

This is a dedicated, high-powered, hot-shoe mounted flash with a built-in AF Illuminator for autofocus in dim light. The AF Illuminator is triggered by the camera, when needed. For bounce flash, the flash head swivels 90° left or right and tilts from horizontal to vertical. Flash exposure is controlled automatically by the TTL sensor in the camera, based on the film-speed setting of the camera.

The 4000 AF has a motor-driven zoom head that automatically changes beam angle to match the focal length of the lens in use.

Exposure Modes—These are set at the camera. Modes are programmed auto with fill flash, aperture-priority auto with fill flash and slow-shutter sync capability, shutter-priority auto with fill flash and slow-shutter sync capability, and manual camera operation with either TTL autoflash or manual flash.

Exposure Adjustment—The camera Exposure-Adjustment control affects exposure with flash. Range is plus or minus 4 exposure steps.

Controls and Indicators—These are on the back panel of the flash.

The OFF/ON switch turns the flash unit on and off. If the camera Operating Button has not been touched for 15 minutes, the flash turns itself off automatically. Touching the button will turn it back on.

The Sufficient-Exposure indication is a green OK symbol, labeled EXP.

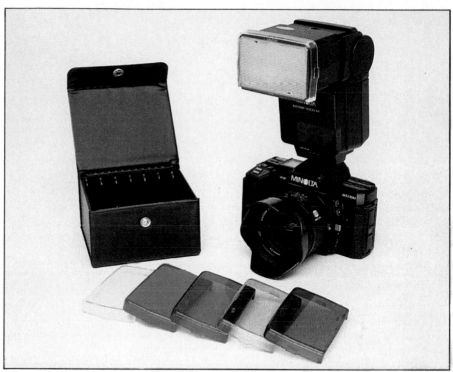

Color Panel Set PS-1000 is used with the MAXXUM 4000 AF flash. One panel is an orange 85B filter that allows the flash to be used with Type B (3200K) tungsten film. The other four panels are blue, green, red, and yellow. An installed color panel depresses a switch on the front of the 4000 AF flash. The flash then shows the word PANEL on the LCD display and reduces the indicated operating range because of light lost by absorption.

The Flash-Ready indicator is a red "lightning" symbol that glows continuously when the flash is charged. The TEST button fires the flash independently of the camera.

An LCD Flash Data Panel displays operating information. A ft/m switch enables you to select feet or meters as the distance unit used in the data panel.

A pushbutton labeled LIGHT illuminates the Flash Data Panel in dim ambient light. The illumination remains on for 8 seconds. A ZOOM pushbutton manually controls the flash-beam angle. A TTL/M pushbutton allows you to select TTL auto or manual exposure control in the manual mode.

A Power-Level Selector switch, labeled LEVEL, sets the maximum light output to one of six values.

Film Speed—This is set at the camera. Usable range is ISO 25 to 1000 with the MAXXUM 5000 and 7000. With the MAXXUM 9000, it's ISO 12 to 1000.

Power Levels—The LEVEL pushbutton changes maximum light output among six levels: FULL, 1/2, 1/4, 1/8, 1/16, and MD. In the Flash Data Panel, a bracket moves to enclose the selected power level.

Zoom Flash Head—When the flash is in the auto zoom mode, the flash zoom head is automatically positioned so the flash beam angle matches the angle of view of the lens. This requires the camera to be turned on by touching the Operating Button. Beam-angle settings are: 70mm and longer, 50mm, 35mm, and 28mm.

When the flash is in the manual zoom mode, flash beam angle can be set independently of the lens.

Flash Zoom Control—Both beam angle mode and selection are controlled

by the ZOOM pushbutton. If on auto zoom, pressing the ZOOM button selects manual zoom, indicated by a MAN. ZOOM symbol in the display, and sets the flash to its widest beam angle of 28mm. Repeatedly pressing the ZOOM button selects narrower beam widths in sequence until the 70mm setting is reached. Pressing the ZOOM button again at that setting restores auto zoom operation, indicated by an AUTO ZOOM symbol in the display.

Flash Data Panel—This LCD display is completely automatic. It shows the selected power level, the lens focal length that represents the selected flash beam angle, the flash-head zoom mode—auto or manual—and an operating range indication.

On auto zoom, the focal-length representing beam angle is the actual focal length of the lens. If a lens with focal length shorter than 28mm is installed, the display shows the symbol —mm.

Operating range is shown in feet or meters, depending on the setting of the ft/m switch. Range is shown only when the camera has been turned on by touching the Operating Button.

A TTL symbol appears when flash exposure is being controlled by the TTL sensor in the camera.

TTL/M Pushbutton—When the camera is set to its manual mode, two kinds of exposure control are available, selected by the TTL/M pushbutton. If TTL automatic has been selected, the TTL symbol appears in the Flash Data Panel. Pressing the TTL/M pushbutton changes to manual exposure control, and an M symbol replaces the TTL symbol in the display. The flash operates with manual exposure control, using its guide number. Pressing the TTL/M button again switches back to TTL operation.

Operating-Range Warnings—A left-pointing arrow may appear to the left of the operating-range display, beside the minimum distance. A right-pointing arrow may appear to the right

of the operating range, beside the maximum range. The left-pointing arrow means that the combination of aperture, film speed and flash-power level provides less *maximum* range than the minimum shown on the display. The correction is to use more power or larger aperture, or both. Shooting with the left-pointing arrow visible will produce underexposure if the subject is at minimum range or farther.

The left-pointing arrow is likely to appear only with film speeds below ISO 100, with the flash power level set to 1/4 power or less, and with a small aperture selected in the A mode.

The right-pointing arrow means that the maximum operating range exceeds that shown on the display. You can use less flash power or smaller aperture, or both. Shooting with the right-pointing arrow visible wastes flash power but will not cause overexposure if the subject is beyond the minimum indicated range.

The right-pointing arrow is likely to appear only with film speeds faster than ISO 200, the flash set at full power and a large aperture selected in the A mode.

Wideangle Adapter—With the zoom head at 28mm, attaching the Wideangle Adapter changes beam angle to cover a 24mm lens. The display shows the symbol PANEL when the adapter is installed, no matter what beam angle is being used. If the 28mm setting is not being used, the resulting beam angle will be too narrow to cover a 24mm lens.

The display also changes the operating range to show the effect of the adapter, no matter what beam angle is being used. Both maximum and minimum distances are reduced.

Color Panels—Color Panel Set PS-1000, shown on the opposite page, consists of five color panels that can be clipped over the flash window. When a color panel is attached, the display shows the word *PANEL* and the maximum range is reduced because of light loss due to the panel.

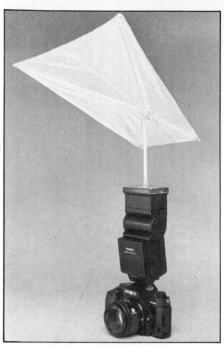

Bounce Reflector II is a portable bounce surface for the 4000 AF flash. It attaches to a transparent adapter panel that fits over the flash window.

Bounce Flash—If the flash head is tilted or swiveled for bounce flash, the range display is replaced by a series of dashes. Because of light absorption by the bounce surface the maximum range is less than for direct flash. Light-colored bounce surfaces typically reduce the light by 2 or 3 exposure steps.

A good way to make bounce shots is to use aperture-priority autoflash. Set aperture about 3 steps larger than the camera would use on Program for direct flash. The Sufficient-Exposure signal will show if there was enough exposure.

Bounce Reflector II Set—Shown in the accompanying photo, this is a portable bounce surface that attaches to the flash head.

Sync Cable Connector—A four-pin female connector for sync cables is near the flash mounting foot. This connector accepts Cable OC and allows the flash to be used separate from the camera.

Repeating Flash—At the MD setting

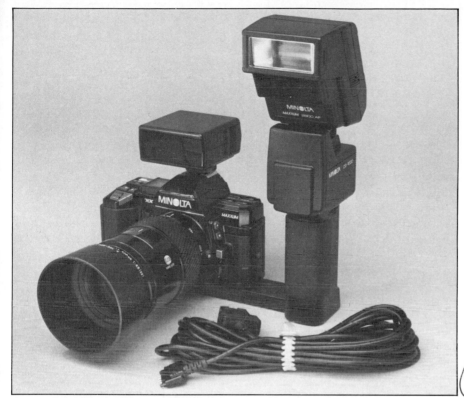

Control Grip CG-1000 Set includes the handle and bracket, Grip Extension Cable EC-1000 and AF Illuminator AI-1000. The extension cable allows separating the handle with flash from bracket and camera. The AF Illuminator in the handle-mounted flash is not used because the flash may not be pointed directly at the subject. Instead, AF Illuminator AI-1000 is installed in the camera hot shoe, as shown here, and is available to assist autofocus when needed.

of the Power-Level Selector, the flash can recycle and fire at speeds up to two frames per second with the camera Focus-Mode Switch set to manual. At this setting, the AF Illuminator on the flash is not usable. Ni-Cad flash batteries are recommended.

CAUTION: With the flash mounted on Control Grip CG-1000, using batteries in the grip, do not shoot more than 20 frames in rapid sequence. Otherwise, damage to the flash may result.

Power Source—Four AA-size batteries are used in the battery chamber. Alkaline or Ni-Cad may be used. Batteries in the flash also operate the automatic zoom of the flash head. An optional power source is Control Grip CG-1000. Batteries in the grip augment those in the flash to provide more flashes and faster recycling.

External Power—A four-pin connector on the front, near the mounting foot, accepts power from Control Grip CG-1000, or Adapter AC-1000 which converts AC power to DC to supply the flash.

Accessories—Control Grip CG-1000, Cables OC, EX, CD, Off-Camera Shoe, Triple Connector TC-1000, Color Panel Set PS-1000, Bounce Reflector II Set, AC Adapter AC-1000, Ni-Cad Charger NC-2 with included batteries.

CONTROL GRIP CG-1000 SET

The table on page 103 shows equipment that can be used with the Control Grip.

The control grip is a handle with a horizontal bracket extending from the bottom. The handle has a hot shoe on top to mount a flash. A camera is mounted on the bracket. Camera to flash connections are made internally, using contacts on the bracket that mate with contacts on the bottom of MAX-XUM cameras.

The handle can be detached from the bracket to use the flash at a distance from the camera. If so, bracket and handle are connected electrically by a Grip Extension Cable, packaged with the CG-1000.

Either way, a MAXXUM flash operates as if it were mounted in the camera hot shoe, with one exception. The built-in AF illuminator on the flash does not operate. A separate AF Illuminator AI-1000 is packaged with the control grip. It can be mounted in the camera hot shoe to provide the AF Illuminator function when needed.

Batteries—The control grip itself doesn't require batteries. If installed, they are automatically connected to the External Power Socket on the flash by a row of electrical contacts on the top of the control grip. The batteries in the grip augment the flash batteries, providing more flashes before battery replacement, and faster recycling between flashes.

Because of the electrical contacts on the grip, only flash units with an External Power Socket can be installed on the grip. For that reason, the 1800 AF flash cannot be installed.

The 2800 AF and 4000 AF flash units can be installed on the grip and operated by batteries in the grip without any batteries in the flash itself. However, the power zoom feature of the 4000 AF operates only if batteries are installed in the flash.

The grip uses 6 AA-size batteries, alkaline, carbon-zinc or Ni-Cad. Accessory Ni-Cad Battery Pack NP-2 fits into the grip. It requires Ni-Cad Charger QC-1.

With One Flash—A single MAX-XUM flash may be mounted on the handle. If autofocus in dim light is needed, install the AI-1000 illuminator

101

One end of Cable OC fits in the hot shoe. When a flash is connected to the camera by Cable OC, the flash operates as though it were mounted in the hot shoe, except that the AF Illuminator does not fire. Cable OC is about 3 feet (1 meter) long.

Cable EX, about 3 feet (1 meter) long, can be used as an extension for Cable OC and for general use in making multiple-flash setups.

Cable CD can connect one flash to another, if both have four-pin sync sockets.

in the camera hot shoe. By detaching the handle, using the Grip Extension Cord, bounce flash can be performed using flash units with fixed heads, such as the 2800 AF.

With Two Flash Units—One MAXXUM flash may be used on the camera and another on the control grip. The built-in AF illuminator on the camera-mounted flash will work normally. The TTL metering system in the camera controls exposure by turning off both flashes. Using the Grip Extension Cord, the flash on the handle may be placed away from the camera. The cord is 5 meters (16.5 feet) long.

The lighting ratio of the two flashes is controlled by the RATIO switch on the control grip. If switched off, each flash will expose for the same duration. There may be a difference in exposure caused by differences in flash light output and distance to the subject.

With the ratio switch set to ON, the flash on the control grip serves as the main flash. The flash on the camera serves as the fill flash. During exposure, the TTL metering system controls the flashes so that 2/3 of the exposure is produced by the main flash and 1/3 by the fill flash.

Three Flash Units—With this setup, a third flash with a PC socket may be connected to the PC connector on the back of the control grip. This single-conductor connector delivers only an X-sync firing signal. The TTL metering system in the camera does not control the third flash. It may be used for background illumination or an any other way that does not materially contribute to exposure.

MULTIPLE FLASH METHODS

The preceding section discussed multiple flash with Control Grip CG-1000. This section discusses other methods, using a group of sync cables and accessories. All cables are coiled and can be extended about 1 meter (40 inches).

All items to be discussed have compatible 4-pin plugs and sockets and are multi-conductor, so that all automatic features of the flash units and camera are preserved, with one exception. With this equipment, the built-in AF illuminators of MAXXUM flashes will not operate.

MAXXUM cameras provide two ways to connect flash units to the camera. One is the row of contacts on the bottom of the camera, used by Control Grip CG-1000. The other is the contacts in the hot shoe on top of the camera.

Cable OC—One end is placed in the camera hot shoe to pick up X-sync and flash control signals. The other end is a plug.

Cable EX—This is a one-meter "extender" cable with a plug on one end and a socket on the other.

Cable CD—This cable has plugs at each end.

Off-Camera Shoe—Some flash units, such as the 2800 AF, have a mounting foot that fits into a hot shoe but no other sync connectors. An off-camera shoe fits on the flash mounting foot. On the side is a four-pin sync socket that accepts the sync cables discussed in this section.

On the bottom is a tripod socket. You can use an off-camera shoe to mount any MAXXUM flash on a tripod, whether you use the sync socket or not.

Triple Connector TC-1000—This has four sync connectors, all tied together electrically inside the unit. One connector is a socket to accept an OC cable. The other three are plugs.

2800 AF FLASHES PER CHARGE WITH CONTROL GRIP CG-1000

Flash Battery Type	Flash Power Level	Ni-Cad Pack NP-2	Battery in Grip Alkaline	Carbon-Zinc	None
Ni-Cad	Hi	170-1050	300-2000	160-1100	90-750
	Lo	950-1050	1700-2000	900-1100	600-750
Alkaline	Hi	300-2400	500-3500	320-2500	180-2500
	Lo	2100-2400	2900-3500	2000-2500	2000-2500
Carbon-Zinc	Hi	170-1600	350-2500	160-1600	50-1250
	Lo	1250-1600	2000-2500	1300-1600	1000-1250
None	Hi	100-550	250-1400	65-500	
	Lo	480-550	1100-1400	400-500	

2800 AF RECYCLE TIME WITH CONTROL GRIP CG-1000 (Seconds)

Flash Battery Type	Flash Power Level	Ni-Cad Pack NP-2	Battery in Grip Alkaline	Carbon-Zinc	None
Ni-Cad	Hi	0.2-1	0.2-1.5	0.2-2	0.2-4
	Lo	0.2*	0.2*	0.2*	0.2-0.3
Alkaline	Hi	0.2-1.2	0.2-2	0.2-2.5	0.2-6.5
	Lo	0.2*	0.2*	0.2-0.3	0.2-0.5
Carbon-Zinc	Hi	0.2-1.3	0.2-2.5	0.2-3.5	0.3-10
	Lo	0.2*	0.2*	0.2-0.4	0.3-1
None	Hi	0.2-1.6	0.2-3.5	0.3-6.5	
	Lo	0.2*	0.2-0.3	0.3-0.7	

*Allows shooting at 5 frames per second with manual focus.

4000 AF FLASHES PER CHARGE WITH CONTROL GRIP CG-1000

Flash Battery Type	Flash Power Level	Ni-Cad Pack NP-2	Battery in Grip Alkaline	Carbon-Zinc	None
Ni-Cad	FULL	80-850	65-850	100-1000	40-500
	MD	650-850	700-850	1300-1900	350-500
Alkaline	FULL	140-1900	150-1900	260-2700	90-1600
	MD	1300-1900	1400-1900	1900-2700	1100-1600
None	FULL	50-450	15-450	140-1500	90-1600
	MD	300-450	400-450	1000-1500	

4000 AF RECYCLE TIME WITH CONTROL GRIP CG-1000 (Seconds)

Flash Battery Type	Flash Power Level	Ni-Cad Pack NP-2	Battery in Grip Alkaline	Carbon-Zinc	None
Ni-Cad	FULL	0.2-2.5	0.2-4.5	0.2-3.5	0.2-6
	MD	0.2*	0.2-0.3	0.2-0.3	0.2-0.4
Alkaline	FULL	0.2-3	0.2-6	0.2-4.5	0.3-10
	MD	0.2*	0.2-0.4	0.2-0.3	0.3-0.7
None	FULL	0.2-4.5	0.4-2	0.3-8	
	MD	0.2-0.3	0.4-1.5	0.3-0.6	

*Allows shooting at 5 frames per second with manual focus.

Alkaline cells offer most flashes per charge or set of batteries. The advantage of rechargeable Ni-Cads is long-term economy if you use them frequently. The advantage of Carbon-Zinc is short-term economy if you use only a few flashes and then let the batteries die. Ni-Cads usually recycle a flash faster than alkaline cells.

Basic Setup—Attach Cable OC to the hot shoe of a MAXXUM camera. Attach Triple Connector TC-1000 to the end of Cable OC. Connect up to three MAXXUM flash units to the TC-1000, using Cable EX. Additional Cable EX lengths can be used to extend any cable.

If a flash doesn't have a 4-pin sync socket built in, attach an off-camera shoe to the flash mounting foot.

Operation—The flash-ready signal in the camera viewfinder turns on only when all flashes are charged and ready to fire. Exposure will be controlled by the TTL metering system in the camera.

Both minimum and maximum operating distances are greater than with a single flash. Assuming flashes of equal power at the same distances from the subject, maximum range is the single-flash distance multiplied by 1.4 with two flashes or by 1.7 with three flashes.

The Off-Camera Shoe fits on the mounting foot of any Minolta flash. On the bottom of the shoe is a tripod socket, which provides a way to support the flash detached from the camera. On the front is a four-pin sync socket which can be used to connect the flash to the camera with Cable OC, or for a multiple-flash hookup.

Other interconnection methods can be used with similar results. Cable CD can connect one flash directly to another if both have 4-pin sync sockets.

Triple Connector TC-1000 allows one MAXXUM camera to simultaneously control up to three MAXXUM flash units. If you intend not to use one of the flash units, turn it off and disconnect it from the Triple Connector. If you leave it connected, exposure and viewfinder signals may not be correct.

Data Backs and Program Backs

An accessory back replaces the camera back cover to provide additional capabilities. Three types of accessory backs are available, plus the EB-90 which is both an accessory back and a film magazine.

Data Back 70 imprints data—the date or time—on the lower right corner of the picture.

Program Back 70 and Program Back 90 imprint data on the lower right corner of the picture and also provide an intervalometer to make a preset number of single exposures with a preset time interval between each exposure.

Program Back Super 70 and Program Back Super 90 offer data imprinting, an intervalometer, and advanced methods of exposure-control including automatic bracketing. Data is imprinted along the right edge of the frame.

DATA BACK 70

This is the simplest of the data backs. It has three pushbutton controls, referred to as *keys*. They are MODE, SELECT and ADJUST. An LCD display on the data back shows what is to be imprinted and is also used for set up.

Except for imprinting data on the film, if desired, Data Back 70 has no effect on camera operation. All autofocus modes and exposure modes can be used in the normal way.

Modes—The MODE key determines what is to be printed. It has an OFF setting, at which nothing prints. At the other settings, the word PRINT appears at the top of the display but is not imprinted on the film.

The most advanced MAXXUM accessory back is this 100-Exposure Back EB-90 for the MAXXUM 9000. It increases film capacity to 100 frames and has many automatic features. For example, it can be set to control camera and one or more flash units automatically for unattended photography over a long period of time.

ACCESSORY BACKS AND CAMERA MODELS

	5000	7000	9000
Data Back 70	Yes	Yes	
Program Back 70	Yes	Yes	
Program Back Super 70		Yes	
Program Back 90			Yes
Program Back Super 90			Yes
100-Exposure Back EB-90			Yes, with MD-90

To install an accessory back, remove the standard camera back. Open the back cover and press down on the pin that extends from the hinge. This releases the cover from the top hinge. Tilt the cover away from the top and lift it out. Installation is done in the the reverse manner.

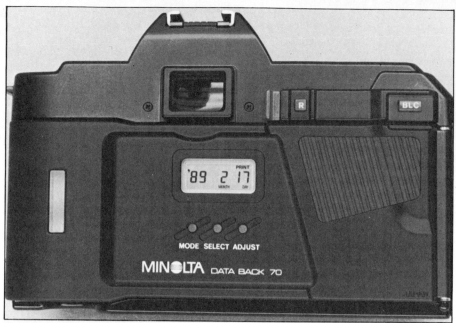

Data Back 70 can be used on the MAXXUM 5000 and MAXXUM 7000. It is shown here installed on a MAXXUM 5000 and set to imprint numerals to show the date as year, month and day. You can change that order, if you wish.

The words MONTH and DAY appear at the bottom of the display, below the appropriate numbers, but are not imprinted on the film.

What is imprinted appears in the center row of the display. The table on the next page shows what can be imprinted.

Changing Data—In any print mode, pressing the SELECT key changes the display in two steps. The first step is to display time without the PRINT symbol, so you can see what time it is without imprinting it.

Pressing SELECT again causes the *minutes* value in the display to blink, indicating that it can be adjusted. If you don't want to change the value, just press the SELECT key.

To change the displayed value, press the ADJUST key. Holding the key down changes the value rapidly. When the value for minutes is correct, press SELECT.

When minutes have been set, the next value that can be changed will blink in the display. It will be *hours*. Change it, if necessary, by pressing the ADJUST key. When the value is correct, press SELECT.

Data Back 70, Program Back 70 and Program Back 90 imprint data in the lower right corner of the picture. Data is more legible if it is placed over a dark area of the scene. This imprint is the date as month, day and year. The photo was taken on May 8, 1986.

By this procedure, you can adjust minutes, hours, day, month and year. After adjusting the year value, pressing SELECT returns to the print mode. If the print mode was OFF when you began adjusting data, it returns to OFF. If not, it returns to the print mode and displays year, month and day.

Exposure—Exposure of the imprinted data is controlled automatically, according to the film speed setting of the camera. The data may not

DATA BACK 70 IMPRINT MODES

Data	Typical Imprint
Y M D	'89 2 17
M D Y	2 11 '89
D M Y	11 2 '89
Time (AM)	A 8:02
Time (PM)	P 4:27

PROGRAM BACK 70 AND PROGRAM BACK 90 IMPRINT MODES

Mode	Display	Controls
Time	24 17:33	MODE key sets mode. Number-Changing keys change values.
Date	'88 1 23	MODE key sets mode. SELECT key sets order. Number-Changing keys change values.
	1 23 '88	
	23 1 '88	
Counting Numbers	+ 12 34 56	MODE key sets mode. Select key sets + or −. + means counting up. Number-Changing keys change values.
	− 12 34 54	− means counting down. Number-Changing keys change values.
	+ 12 _ 56	Right pair count up. Left pair fixed.
	− 12 _ 56	Right pair count down. Left pair fixed
Fixed-Number	77 88 99 FIXNO.	MODE key sets mode. Number-Changing keys change values.
	88 99 FIXNO.	Any pair blank.
	_ 88 99 FIXNO.	Any pair replaced by dashes.

be visible when using films with ISO speeds below 32 and when using special-purpose films such as instant slide film. Visibility of the imprinted data is improved by composing so the lower right corner of the image is dark and uniform.

Power Source—The Data Back is supplied with a built-in 3 volt lithium battery that should last about three years.

PROGRAM BACK 70 AND PROGRAM BACK 90

These backs are not mechanically interchangeable, but are otherwise similar. They have five modes, with four imprint data in the lower right corner of the picture. The fifth is an intervalometer. While the intervalometer is controlling the camera, any of the four imprint modes can be used. They are:

● Imprint time and day of the month.
● Imprint date as month-day-year, or a different order.
● Imprint counting numbers, counting up or down.
● Imprint fixed number.

DISPLAY

As shown on page 108, in a row across the center of the LCD display are large digits with punctuation, such as a colon. What appears on this row is imprinted on the film. Above or below the center row, a variety of smaller symbols appear to show the mode being used or to assist you in using the data back.

Typical displays for each mode are shown in the accompanying table. In addition, Program Back 90 displays a blinking dot at the upper right corner to show that the internal clock is working.

CONTROLS

The controls are pushbuttons, referred to as *keys*. To the right of the display is the PRINT key. Press it to select imprinting. The symbol PRINT appears in the display. Press it again to stop imprinting and the PRINT symbol disappears.

Below the display are three unlabeled pushbuttons called *Number-Changing Keys*. Each key controls two digits in the display, in left-to-right order.

Pressing the MODE key repeatedly causes the display to cycle through the available modes. The SELECT key selects options within a mode. The INTERVAL key is used to start and stop the intervalometer.

IMPRINT MODES

The accompanying table shows displays and controls for each mode.

Time—This mode has no identifying symbol in the display. The first pair of digits is day of the month, such as 3 or 31. The remainder is time, using a 24-hour clock.

Setting the Time—With the time values displayed, press the Number-Changing Keys. The left key changes day of the month; the middle key

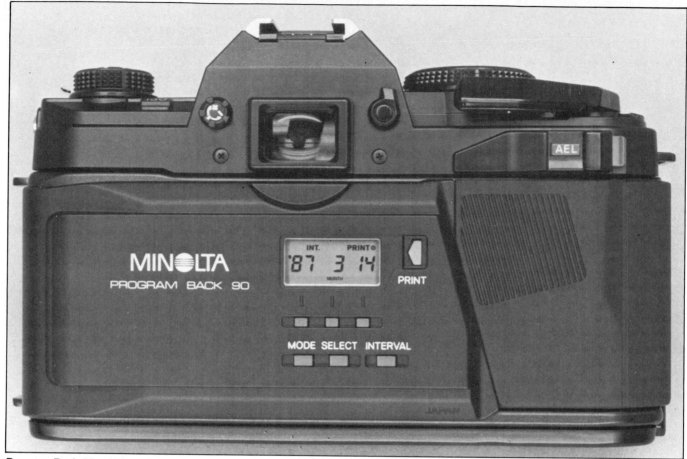

Program Back 90 and Program Back 70 are similar in functions but not mechanically interchangeable. This is Program Back 90, installed on a MAXXUM 9000. The three unlabeled buttons just below the display are the Number-Changing keys. Each controls the two digits just above the key. This back is set to imprint the date in year, month, day order. The order can be changed.

changes hours; and the right key changes minutes. When you set the minute value in the display, seconds are automatically set to zero in the internal clock.

Date—This mode is identified by the symbol MONTH beneath the month number. The order of the values for year, month and day can be changed using the SELECT key. Only the last two digits of the year are shown, such as '89.

Setting the Date—Press the Number-Changing Keys to change the displayed values in left-to-right order. In the display, the year is identified by an apostrophe preceding the two digits. The month value, l to 12, appears above the MONTH symbol. The remaining pair of

digits represent day of the month, l to 31.

Counting Numbers—This mode is identified by a plus or minus symbol in the display. There are six digits, in pairs, allowing a counting range from 00 00 00 to 99 99 99. Each time film is advanced, the count changes, *except* when film is advanced to frame 1.

Counting is up or down, as indicated by the plus or minus symbol. The SELECT key changes the symbol. Unless reset between film cartridges, the count will continue from one cartridge to the next.

Setting the Starting Value—Press the Number-Changing Keys in any order. The keys change values rapidly if held down. When setting values,

each pair of digits changes from 00 to 99, then becomes two dashes, then two blanks, then 00 again.

Combination Fixed and Counting—In the Counting Numbers mode, if the center pair of digits is set to two dashes or two blanks, the left pair will not count. They remain fixed at whatever value you set. The right pair count from 00 to 99 and repeat.

Fixed Number—This mode is identified by the symbol FIXNO. at lower right in the display. Using the Number-Changing Keys, each pair of numbers may be set from 00 to 99, or as two dashes or blanks. Whatever is set will imprint on the film and will not change.

IMPRINT CONTROL

The digits shown along the center row of the display will be imprinted if the symbol PRINT appears in the display. Pressing the PRINT key displays the symbol. Pressing the key again turns it off.

Imprint Exposure—Exposure of the imprinted data is controlled automatically, according to the film speed setting of the camera. The data may not be visible when using films with ISO speeds below 32 and when using special-purpose films such as instant slide film.

Composing for the Imprint—The data will be more legible if you compose so the area in the lower right corner of the frame is dark and has uniform brightness.

Autofocus—Autofocus can be used in any of the imprint modes.

INTERVALOMETER MODE

This mode automatically makes a preset number of single-frame exposures with a preset time interval between each frame. It is selected by pressing the MODE key until a blinking INT.S symbol appears at top left in the display.

Setting Timing Data—Blinking symbols mean that the intervalometer can be programmed by setting in timing data, which is done by changing displayed values if they are not correct. Values are changed by pressing the Number-Changing Keys.

Each item to be changed is displayed in sequence and indicated by a different letter following the INT. symbol. When the value is correct, press the SELECT key. The next item to be changed will automatically be displayed along with its identifying symbol. The meaning of the INT. symbol is determined by the letter that follows it.

INT.S means starting time. When blinking, set in a starting time as day-of-the-month, hour and minute. To start timing immediately, set the right two digits to dashes. The other digits will disappear from the display. Press

the SELECT key to advance to the next item to be changed.

INT.I means time interval between frames. When blinking, set in the desired interval between exposures as hours, minutes and seconds. Up to 99 hours, 59 minutes and 59 seconds can be set. The interval must be longer than the exposure time for each shot—plus film-advance time, which is less than 1/2 second. Press the SELECT key to advance to the next item to be changed.

INT.F means number of frames to be exposed. When blinking, set in the total number of frames to be exposed. As exposures are made, the display counts down. Normally, exposure of each frame is controlled by the camera, using one of the automatic-exposure modes. Press the SELECT key to advance to the next item to be changed.

INT.L means long exposure. This is a way to shoot a preset number of frames with the shutter at bulb. Exposure is not controlled automatically by the camera. Manual exposure settings are used.

When the blinking INT.L symbol appears, you can set in the length of time for each exposure. When long exposures are not desired, set the display to zero time. This is equivalent to turning this mode off.

If long exposures are desired, set an exposure time up to 99 hours, 59 minutes and 59 seconds. Holding the shutter open uses battery power. Actual long-exposure time is limited by the batteries in the camera.

When using long exposures with the intervalometer, set the camera for manual exposure and set the shutter to bulb.

When Set—After setting the INT.L value, the intervalometer is ready to use. If you press SELECT, the display will return to the starting point, a blinking INT.S symbol.

When the INT.L value has been set, press the MODE key. The display will show date and time. If the Program Back had previously been set to imprint data, the PRINT symbol will also appear. By continuing to press MODE, you can select any imprint mode.

PROGRAM BACK 70 and PROGRAM BACK 90 INTERVALOMETER MODE

Symbol	Display	Control
INT.S (Start)	INT.S 29 8:00	Press SELECT key to display blinking symbol. Use Number-Changing Keys to change values.
	INT.S —	Dashes cause immediate start.
INT.I (Interval)	INT.I 0:15 00	Press SELECT key to display blinking symbol. Use Number-Changing Keys to change values.
INT.F (Frames)	INT.F 6	Press SELECT key to display blinking symbol. Use Number-Changing Keys to change values.
INT.L (Long Exposure)	INT.L 1:30 00	Press SELECT key to display blinking symbol. Use Number-Changing Keys to change values. Press INTERVAL key to start intervalometer.

Using Both Intervalometer and Imprint—For both imprinting and intervalometer operation, change the display to the desired imprint mode by pressing the MODE key. Then press the PRINT key, if necessary, to display the PRINT symbol. Then start the intervalometer.

Starting and Stopping—The camera should be set to expose single frames. If your eye will not be at the eyepiece, attach the eyepiece cover or close the eyepiece shutter if the camera has one. Otherwise, incorrect exposure may result.

To start the timer, press the INTERVAL key. A non-blinking INT. symbol will appear at top left in the display. It doesn't matter what is being displayed when you begin operation by pressing the INTERVAL key.

If a future start time was programmed, operation will begin at that time. If the start time is represented by two dashes in the display, operation will begin within one second.

Pressing INTERVAL a second time cancels intervalometer operation.

Autofocus—Autofocus can be used in any of the imprint modes, but not with intervalometer operation. Set focus manually before starting operation.

Self-Timer—The camera self-timer cannot be used in the intervalometer mode.

Flash—With flash, the intervalometer will turn on the flash one minute before opening the shutter, so the flash can charge. After exposure, a MAXXUM flash will turn itself off again.

Startup—With a new Data Back, a plastic insulating strip extends from the battery compartment. Pull out the strip and discard it.

When that has been done, or when fresh batteries have been installed, the display should show 1 0:00 in the Time mode. If not, suspect the batteries.

If the display is OK, close the back and press the PRINT key. The word PRINT should appear at the upper right in the display.

Turn on the camera and press the Operating Button to make an exposure, with or without film in the camera. The PRINT symbol in the display should blink for about 3 seconds. If it doesn't operate that way, have it checked by an authorized Minolta service facility.

Battery Check—When the batteries need replacement, the numerals in the display blink.

Batteries—Use two silver-oxide S-76 or EPX-76 batteries, or alkaline-manganese A-76 batteries, or equivalent.

PROGRAM BACKS SUPER 70 AND SUPER 90

These backs are not mechanically interchangeable, but are otherwise similar. They have built-in microcomputers to provide a great range of capabilities in three domains:

● Imprinting data such as the date and time, or the exposure settings used to make a photo.

● An advanced intervalometer to control preset *groups* of exposures at preset time intervals.

● Sophisticated exposure-metering and exposure-control methods with ambient light, including automatic bracketing.

Super backs are turned on by installing batteries and remain on until the batteries fail, whether or not the back is installed on a camera. They have an internal memory and a built-in exposure-control system that uses the exposure meter in the camera.

Exposure control by the super back is referred to as the EXPOSURE function, which has an on-off control. When this function is turned off, exposure is controlled by the camera and the camera control settings in the usual way.

When the exposure function is turned on, the super back *takes over* ambient-light exposure control from the camera. The camera exposure controls are replaced by controls on the super back. The viewfinder display and the display panel on top of the camera are controlled by the super back and show settings made by the super back. However, the camera Exposure-Adjustment control and Automatic-Exposure Lock (AEL) continue to function and affect exposure settings made by the super back.

When a MAXXUM flash is installed and turned on, it assumes control of the camera when it is charged and the flash-ready signal is on. That allows the dedicated features of flash and camera to work together, as usual.

When flash is used, the exposure function of the super back is automatically turned off. When you have finished using the flash, exposure control reverts to the camera. If you want to use the super back, its exposure function must be turned on again.

The super-back LCD display is unique because it presents data in graphic form, such as program graphs.

Because the super backs do so many things, this section starts with an overview. Then, it discusses the graphic display and some of the functions in more detail.

FUNCTIONS AND MODES

Each of the three domains mentioned earlier may have more than one *function*. Each function may have more than one *mode*. Within each mode are *values* that you may change. Figure 9-1, on page 112, shows what the super backs can do.

Automatic Exposure Bracketing—You can automatically bracket as many as nine frames with exposure increases of 1/4, 1/2, 1 or 2 steps between frames.

Multiple Exposure Readings—Exposure is set based on up to eight readings of individual areas in the scene. Minolta refers to this as Multiple Memory.

Exposure Control—When the EXPOSURE function is turned on, the super back replaces the ambient-light exposure-control system in the camera. It has the same exposure modes, plus one more, and additional features.

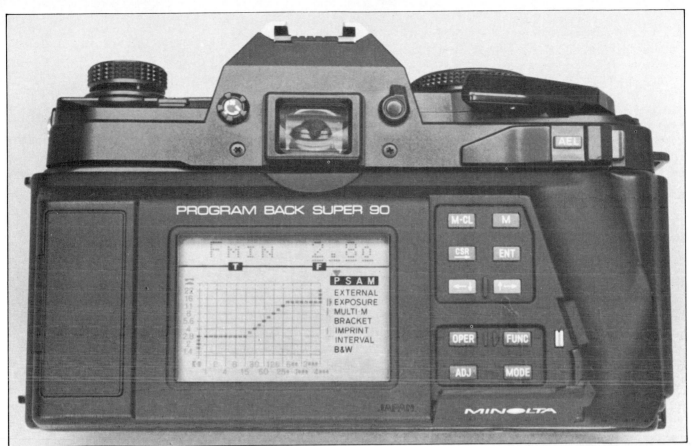

Program Back Super 70 and Program Back Super 90 are similar in functions but not mechanically interchangeable. Super-back control keys are in two groups. Keys used for set-up are at the bottom, normally covered by a hinged panel, which is shown open in this photo. The keys used for operation are at the top, uncovered and always available. The graphic display shows a variety of things, depending on mode. Here, it shows a graph of the exposure program being used. The display along the top shows that the minimum aperture used by this program is ƒ-2.8. The program can be changed to use different minimum and maximum apertures.

Three automatic-exposure programs—Programs 1, 2 and 3—are built into the super back and displayed as program graphs. They replace the three programs built into the camera and offer a wider range of control. They can be tailored to your shooting situation or preferences, using controls on the super back. They are not selected automatically, according to lens focal length. Any program can be used with any lens.

Aperture-priority auto, shutter-priority auto and manual are similar to operation with the camera alone, except that over- and underexposure are handled differently, as discussed later.

In these modes, the graphic display on the super back may give you a better idea of the exposure options.

The added exposure mode is automatic timing of long exposures on Manual—as long as 9990 seconds.

Imprinting Data—You can set the super back to imprint the shutter speed and aperture used to make each exposure, or date, or time, count up or down, or imprint a fixed number.

Intervalometer—This function exposes *groups* of frames at preset intervals with a preset starting time. Flash can be used under automatic control. Frames are advanced by the built-in motor of MAXXUM 7000 cameras or by an

MD-90 motor drive on the MAXXUM 9000.

Combined Functions—Several functions can be used simultaneously. The super back can control exposure, imprint data, and operate as an intervalometer—all at the same time.

THE GRAPHIC DISPLAY

The display on the super backs is an LCD panel with alphanumeric characters and a graphic display. It shows the metered exposure and a graph of the exposure mode being used. The display literally shows you how exposure settings are decided by the super back and lets you make changes if you wish.

CAPABILITIES OF PROGRAM BACK SUPER 70 AND PROGRAM BACK SUPER 90

Function	Mode	Values
Exposure Control	Programmed	Program 1 graph Program 2 graph Program 3 graph
	Aperture-priority automatic	Aperture & resulting shutter speed
	Shutter-priority automatic	Shutter speed & resulting aperture
	Manual	Aperture & shutter speed
	Long-time exposure	Aperture & shutter speed
Multiple Exposure Readings	Average Center Highlight Shadow	Average of readings Center of high and low White + 2.25 steps Black − 2.75 steps
Exposure Bracketing	From Step Frame	Lowest exposure Size of step-increases Number of frames
Imprinting Film	Exposure data	Shutter speed & aperture
	Date	Year Month Day or Month Day Year or Day Month Year
	Time	Day Hour Minute or Hour Minute Second
	Count Up Count Down Fixed Number	Increasing numbers Decreasing numbers Unchanging number
Interval-ometer	Interval between groups	Up to 99 hrs., 59 mins., 59 secs.
	Frames per group Number of groups Start date and time	l to 9 frames 1 to 99 groups Day, hour and minute

Figure 9-1/The Super Backs offer advanced exposure control, versatile data imprinting and a sophisticated intervalometer function.

The Metered-Exposure EV Line— In Chapter 5, I discussed using EV numbers to express the light-measuring range of exposure meters: Another use of EV numbers is to represent all possible *combinations* of shutter speed and aperture that produce the same exposure. The line labeled EV 11 in Figure 9-2 has that significance.

The EV line slants downward to the right. Notice that at the lower end of the line aperture is *f*-1.4 and shutter speed is 1/1000 second. That pair of settings produces a certain amount of exposure. Moving upward along the line, the next marked pair of settings is *f*-2 and 1/500 second, which produces the *same* amount of exposure—one step smaller aperture with one step slower shutter speed.

All pairs of aperture and shutter-speed values represented by that line will produce the same amount of exposure. All of them are collectively referred to as EV 11.

On this graph, the EV line shows the *metered exposure* of the scene. Any pair of aperture and shutter-speed values on the EV line can be used because they all give the same exposure.

The Program Line— The graph of Figure 9-2 also shows the automatic-exposure program being used. It's the line that angles downward to the left. Only values on the program line can be selected by the program.

The exposure settings to be used by the camera *must* be on the EV line and *also* on the program line. The only place where that happens is at the *intersection* of the two lines. Those values are chosen by the program and used in the camera.

In this example, the exposure settings are a little below *f*-4 and a little to the right of 1/125 second—where the EV line and the program line intersect.

Program Mode— Figure 9-3 shows the graphic display in a program mode. Program 2 is being used. Along the right side of the display is a menu, discussed later.

The graph has a shutter-speed scale along the bottom and an aperture scale at left. The graph shows an EV line angling downward and to the right and a program line angling downward and to the left. Their intersection designates the shutter speed and aperture to be used.

If scene brightness changes, the EV line moves to show that a different amount of exposure is required. The EV line always has the same slope or angle on the graph. When it moves, the new line is parallel to the old.

If scene brightness increases, the EV line moves to the right. It will intersect the program line at a point that represents both smaller aperture and faster shutter speed. If scene brightness decreases, the EV line moves to the left. Aperture becomes larger and shutter speed slower.

Changing scene brightness causes the EV line to move on the graph, which causes different exposure settings to be made by the program.

Program Shift—If the program line moved on the graph, that would also cause different exposure settings. Moving the program line is called *program shift*. It can be done by controls on the super back. When a program line is shifted, the angle of the sloping part never changes. It remains parallel to its former position.

The effect of shifting is shown in Figure 9-4. If the EV line doesn't change, but the program line moves upward and to the left, their intersection is at a different location on the graph. On the program line, smaller aperture and slower shutter speed will be used. Exposure remains the same because those values are on the same EV line.

The purpose of program shifting is to control depth of field or image blur.

Program Limits—In Figure 9-4, the old position of the program line is shown with dashes. Notice that it stops moving downward at *f*-1.4 and becomes horizontal. That happens because the largest aperture of the lens is

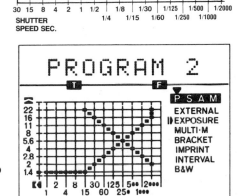

Figure 9-2/Correct exposure for an average scene is shown by the diagonal line labeled EV 11. Values that can be selected by the automatic-exposure program are shown by the program line. The exposure settings used by the camera are at the intersection of the two lines.

Figure 9-3/The program graph is built into the super back. The location of the EV line, angling downward to the right, is determined by scene brightness.

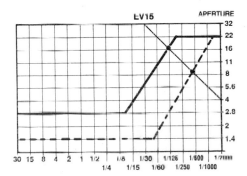

Figure 9-4/The original program line is shown by dashes. The shifted line has moved upward and to the left.

f-1.4. The program has reached the limit of aperture size. The only way to increase exposure is with slower shutter speeds.

A horizontal line in a program graph is a limit. Notice that the *shifted* program line runs into a limit at *f*-22, the smallest aperture on the lens.

The lower limit of the *shifted* program line has changed to *f*-2.8 even though the lens still has a maximum aperture of *f*-1.4. That's a program limit. When the program line was shifted, it moved up and to the left. Moving up caused some of the line to

go off the graph at the top and "pulled" the bottom up to *f*-2.8.

CHARACTER DISPLAY

Above the graphic display is a row of characters—letters or numbers—that show which function or mode has been selected by displaying its name. The name is referred to as a *label*.

The character display is also used to show values, such as shutter speed, aperture, and time intervals. You can change the values if you wish.

Increments—When shutter speed or aperture are shown in the character dis-

SUPER-BACK PROGRAMS 1, 2, AND 3

Figure 9-5/This graph shows the slopes of the three programs built into the super backs. The line labeled EV 12 represents required exposure. For that amount of exposure, Program l uses the fastest shutter speed. Program 3 uses the smallest aperture.

play, a standard value, such as f-2.8, plus an increment is shown. An example is 2.8₃. The small 3 is an increment.

Increments are shown in 1/4 steps. 0 is no additional increment; l is $+$ 1/4 step; 2 is $+$ 1/2 step; 3 is $+$ 3/4 step. These increments are added to the associated values. A shutter speed of 1/125 second with an increment of 2 is halfway to 1/250 second. An aperture of f-5.6 with an increment of 2 is halfway to f-8.

In the character display, shutter speed appears above the T (Time) symbol and aperture appears above the F (f-number) symbol.

SUPER-BACK PROGRAMS

Super backs have three built-in programs, shown in Figure 9-5, which replace the three programs built into the camera. The super-back programs are not selected automatically, according to the focal length of the lens. They are manually selected at the super back. You can use any program with any lens.

The super-back programs are labeled Program 1, 2 or 3. With controls on the super back you can set upper and lower limits on each program, shift it to the left or right, and store it for future use. What you cannot change is the slope of the angled part.

Slopes—The programs have different slopes. The slope of Program 2 is 1/1. It makes *equal* changes in aperture and shutter speed. When aperture has changed by 1 step, shutter speed has also changed by 1 step.

Mathematically, slope is defined as a change along the vertical scale (aperture) divided by the corresponding change along the horizontal scale (shutter speed).

The slope of Program l is 2/1. If a scene becomes darker, aperture becomes 2 steps larger while shutter speed becomes 1 step slower. That tends to retain fast shutter speeds. Program l is the "stop action" program.

The slope of Program 3 is 1/2. If a scene becomes darker, aperture becomes l step larger while shutter speed becomes 2 steps slower. That tends to maintain smaller apertures. Program 3 favors depth of field.

Comparison to Camera Programs— The programs in the camera are Tele, Standard and Wide, shown in Chapter 5. Their counterparts in a super back are Programs 1, 2, and 3.

Program l favors depth of field more than the Tele program. Program 2 has the same slope as the Wide program. Program 3 favors depth of field more than any of the built-in camera programs.

The general character of the super-back programs is to favor depth of field more than the camera programs. With any program, the program line can be shifted as shown on page 120.

SHUTTER-PRIORITY AUTOMATIC

Even though shutter-priority automatic is not a program, it can be graphed as shown in Figure 9-6. The vertical line shows that shutter speed is set at 1/250 second. It is the shutter-speed line.

Aperture is determined by the intersection of the EV line and the shutter-speed line. As scene brightness changes, the EV line moves. In this example, the exposure settings are *f*-5.6 at 1/250 second. You can move the shutter-speed line to the left or right by changing the shutter-speed setting.

Override Feature—Without a super back, or with the exposure function turned off, the camera exposure-control system is used. Suppose the camera is set at *f*-5.6 at 1/250 second and the scene becomes brighter.

The camera will use smaller apertures up to the minimum aperture of the lens, perhaps *f*-22. If the light becomes still brighter, the *camera* exposure-control system will blink *f*-22 in the viewfinder to show overexposure with a shutter speed of 1/250 second.

The super back doesn't do that. At minimum aperture of the lens, it will *abandon* the shutter-speed setting and use a faster shutter speed to prevent overexposure. Minolta refers to this as *override*.

Only when the super back has tried the smallest aperture and the fastest shutter speed will it declare overexposure if the light is too bright. It will then blink *f*-22 in the display, just as the camera does.

What the super back actually does is switch to aperture priority. With a fixed aperture of *f*-22, it changes shutter speed to get correct exposure. It does a similar thing in dim light at maximum aperture.

In the graph of Figure 9-6, the vertical shutter-speed line represents operation with shutter priority. The horizontal extensions at top and bottom are the override feature.

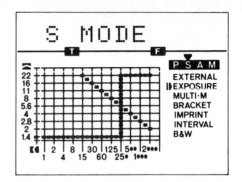

Figure 9-6/Even though shutter-priority isn't a program, a graph can show how the camera operates. The vertical line shows that shutter speed is fixed at a setting of 1/250 second for lens apertures from *f*-1.4 to *f*-22. The graph automatically changes for lenses with different maximum and minimum apertures.

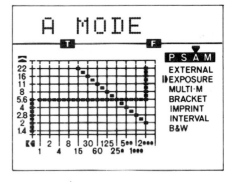

Figure 9-7/When operating with aperture-priority, aperture has a fixed value, from the fastest shutter speed to the slowest. This graph shows aperture set at *f*-5.6.

Figure 9-8/In the manual mode, the intersection of the shutter-speed line and the aperture line shows the settings of those two controls. For correct exposure of an average scene, the EV line should pass through that intersection.

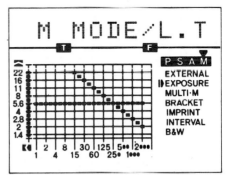

Figure 9-9/This graph shows a Super Back, set to time a long exposure at the bulb setting. Aperture has been set manually to *f*-5.6. Shutter speed has been set to a time of 10 seconds or longer, so the shutter-speed line is off scale to the left.

APERTURE-PRIORITY AUTOMATIC

This mode is similar to shutter priority except that aperture size is fixed. In Figure 9-7, aperture is set at *f*-5.6. The vertical lines at the ends of the aperture line show operation of the override feature.

The vertical line at a shutter speed of 1/2000 second is valid for Program Back Super 70 and the MAXXUM 7000. With Program Back Super 90 and the MAXXUM 9000, the fastest shutter speed is 1/4000 second, so the display shows the vertical line at that speed.

The vertical line at the left end of the aperture line is actually at the slowest available speed of the camera being used—such as 30 seconds. On the shutter-speed scale, the slowest marked speed is 1 second. The adjacent arrow symbol means that the scale extends farther but is not shown. A similar arrow is at the top of the aperture scale, for the same reason.

MANUAL EXPOSURE CONTROL

With manual exposure, both shutter speed and aperture are fixed values. The display is shown in Figure 9-8. The intersection of the shutter line and aperture line represents both settings. For correct exposure of an average scene, the EV line should pass through that intersection.

In this example, the exposure settings are *f*-4 at 1/125 second. Exposure is not correct for an average scene. Correct exposure for that EV line would require changing aperture to *f*-8, or changing shutter speed to 1/500 second, or changing each a smaller amount.

Finding Metered Exposure—With a super back in the manual mode, there is no exposure-deviation indicator in the viewfinder. The viewfinder display shows the shutter speed and aperture settings but does not tell you how the set exposure compares to the metered value.

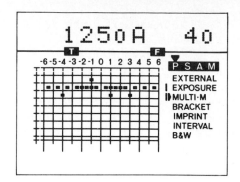

Figure 9-10/When using the Multiple Memory function, dots below the reference line on the graph show each exposure reading as it is placed into memory.

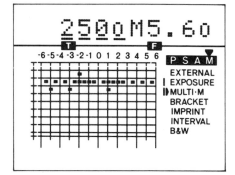

Figure 9-11/With Metered Manual exposure control, the Multiple Memory function graph shows the relationship of each metered point in the scene to the exposure that the camera is set to use.

Figure 9-12/This graph shows the bracket function set and ready to use. The upper band shows the bracket range in exposure steps. The lower band will become narrower, from the left, as bracketing proceeds. During set up, the bracket function was programmed to start bracketing at 3 steps below the meter reading and bracket upward in 1/2 steps, using a total of eight frames. By pressing the ENT key, you can review the setup data in the character display.

Metered exposure is represented by the EV line of the graph on the super back. If the camera is on a tripod, you can remove your eye from the viewfinder and use the super-back graph as a guide to setting exposure. Cover the eyepiece with a cap or close the eyepiece shutter if the camera has one. Otherwise, stray light entering the viewfinder may change the meter reading.

If you are handholding the camera, when you remove your eye from the viewfinder to look at the graph you are likely to point the camera at a different part of the scene and the metered exposure may change. When handholding on manual, I suggest turning off the super back exposure function and using the exposure system in the camera. The display will show the deviation from metered exposure. Set aperture and shutter speed as you wish, using the deviation indicator as a guide. Unless you have a reason to use the super back, make the shot using the camera exposure system.

You may wish to use the super back for some of its functions other than exposure control, such as bracketing or imprinting. If so, turn on the exposure function of the super back, so it assumes control of the camera. Make the same shutter-speed and aperture settings that you selected earlier, using the camera exposure system.

Then, select and set the other super-back functions that you want to use. When that has been done, make the shot.

MANUAL LONG TIME EXPOSURE

Figure 9-9 shows the super-back display for long time exposures on Manual. Shutter speed can be set from 10 to 9990 seconds, in increments of 10 seconds. When this mode is selected, the camera displays show the aperture setting and bulb. The super back will time the exposure.

The main use of the display is to set aperture and shutter-speed values,

PROGRAM BACK SUPER 70 AND SUPER 90 IMPRINT FUNCTION

Display	Data Imprinted
EXP.DATA	Shutter speed and aperture values
Y M D	Year, month, day
M D Y	Month, day, year
D M Y	Day, month year
M D H	Month, day, hour
D H M	Day, hour, minute
H M S	Hour, minute, second
COUNT UP	Sequentially increasing numbers
COUNT DOWN	Sequentially decreasing numbers
FIXED NO.	Unchanging number

Figure 9-13

which appear above the graph when you are setting them. The shutter-speed line is off scale to the left because it is longer than 1 second. The fastest shutter speed that can be used in this mode is 10 seconds. The aperture line shows the aperture setting.

If an EV line appears, it shows the metered exposure. If the scene needs long exposure because of dim light, the EV line probably won't appear. It will be off the graph, below and to the left.

THE MENU

To the right of the graphic display is a menu of functions. In Figure 9-9, a PSAM symbol is at the top of the menu. The letters represent exposure modes: Program, Aperture-priority, Shutter-priority and Manual. Above the PSAM symbol, an arrow shows which mode is selected.

Below the PSAM symbol, the first choice is EXTERNAL. It allows the camera to receive exposure readings from an external meter. It uses Data Receiver DR-1000 and Minolta Flash Meter IV. The EXTERNAL function is selected automatically by that equipment and will not be discussed here.

The next choice on the menu is EXPOSURE, which means exposure control. The symbol to the left of EXPOSURE has two parts. The tip is the *function pointer*. It shows which function has been selected.

The vertical bar to the left of the pointer appears if that function is turned on so it can operate. In Figure 9-9, exposure control is both selected and turned on.

I will refer to the vertical bar as the ON symbol. Selecting a function and turning it on are two separate actions, using different keys on the super back. If you have selected a function, and it doesn't seem to be working, check the ON symbol at that function. It may not be turned on.

MULTIPLE MEMORY

Multiple Memory is selected by moving the function pointer to the MULTI•M position. Operation depends on the exposure mode.

Pressing the M key enters data into memory. Pressing M-CL clears all data from memory.

MULTIPLE MEMORY ON AUTO

In any automatic-exposure mode, the super back calculates and sets exposure based on one or more readings in the scene.

Using a camera with center-

weighted metering, you can meter individual areas in the scene by moving close or using a long-focal-length lens. With a MAXXUM 9000, you can use either center-weighted or spot metering.

However taken, each reading is memorized by pressing the M button on the super back. Up to eight readings can be displayed as dots on the graphic display. If you make additional readings, earlier values are dropped from the display. Even though a reading has been dropped from the display, it may still affect exposure, depending on how exposure is calculated.

Calculating Exposure—You can select among four data-processing modes that determine how the meter readings are used to calculate the exposure setting.

In the *Average Mode,* all stored readings, up to eight values, are averaged to give an exposure for the midtone of the readings. For example, to assure good exposure in a dimly lit area, take several readings of different brightnesses in that area. Then, take a reading or two in the bright area, so it is included in the exposure calculation. In this mode, the data processing is scientific, but using it is somewhat of an art.

In the *Center Mode,* exposure is calculated by averaging only the highest and lowest readings that have been made. The number of individual meter readings is not limited to eight. Take several readings in bright areas of the scene, then several in the darker areas.

The super back will choose the brightest and darkest automatically and set exposure accordingly. If their difference does not exceed the exposure range of the film, this should produce good exposure for all brightnesses between the two readings.

The *Highlight Mode* assures that a white area in the scene is white in the picture. Measure the brightness of one or more areas in the scene. If you take a single reading of a bright area, you designate that brightness to become

white in the picture. If you take several readings, the highest reading is *increased* by 2.25 exposure steps, as discussed in Chapter 5. The number of individual meter readings is not limited to eight.

The *Shadow Mode* assures that a black area in the scene is black in the picture. If you take a single reading of a dark area, that area will become black in the picture. If you take several readings, the lowest reading is *decreased* by 2.75 exposure steps. The number of individual meter readings is not limited to eight.

Instant Recalculation—In any of the modes, the super back recalculates exposure each time a new reading is placed into memory. If you make three measurements and then shoot, exposure will be based on those three readings.

In the Highlight and Shadow modes, exposure changes only when you measure a higher or lower brightness than has already been stored.

Exposure Locking—Without a super back installed, the MAXXUM 7000 and 9000 cameras have procedures that require holding in the AEL button to lock exposure. With spot metering, the MAXXUM 9000 has Highlight and Shadow modes that require holding in the AE button.

The Multiple Memory function locks in each calculated exposure setting, so you don't have to press or hold the AEL button.

To do substitute metering, or meter and recompose, use either the Average or Center mode. Make only one reading. The super back will "average" that and lock in the exposure. Make the shot. A super back locks in highlight and shadow readings with the appropriate exposure adjustments without pressing the AEL button.

The Display—Figure 9-10 shows the display when using Multiple Memory in an auto-exposure mode. In the character display, the digits 125 indicate a shutter speed of 1/125 second. The small 0 is an additional increment, ex-

pressed in 1/4 steps. In this example, the increment is zero.

The A symbol means that the averaging mode of data processing is being used. The number 4 is aperture, *f*-4. The following small 0 is an increment.

In the graphic display, a scale of exposure steps is across the top with a zero at the center. The zero is symbolic. It represents the exposure that will be used. In this example, zero represents *f*-4 at 1/125 second.

The dot below the scale shows the current meter reading with respect to zero. In this example, it is -1.

The row of dots across the graph, with a gap at the center, is a reference line. Its pattern suggests a film characteristic curve. The closely spaced dots represent the straight part of the curve. The toe is at the left and the shoulder at the right.

Below the reference line, individual dots appear for each individual meter reading that has been memorized. In this example, three measurements have been made, with exposure recalculation after each measurement. The exposure settings for the last recalculation are *f*-4 at 1/125 second.

The display shows where each measured brightness in the scene will be placed on the symbolic characteristic curve. For example, the lowest measured brightness is in the toe region. It is four exposure steps below the average of the three measurements and therefore four steps below the calculated exposure setting.

If the M button were pressed, to record the current meter reading, another dot would appear below the reference line. It would appear at -1 because the current meter reading is -1. The average value of the four readings will be different and the displayed shutter speed and aperture will change accordingly.

With each reading, exposure is recalculated and all of the metered dots below the line move to the left or right. In the Average Mode, the dot pattern is moved to place its *average* value at

zero on the scale. In the Center Mode, the *center* value of the high and low measurements is placed at zero.

MULTIPLE MEMORY ON MANUAL

With Multiple Memory and manual exposure control, there are two significant differences: Exposure is not calculated based on the meter readings because it is controlled manually. Each meter reading is shown by a dot below the reference line, but the dots do not move to the left or right as each new reading is made.

The dots are a visual record of meter readings made in the scene. An example is Figure 9-11. The purpose is to make a "map" of brightnesses. The zero point on the scale represents the manual shutter speed and aperture settings. Zero represents an 18% gray card.

Make a series of readings in the scene, including light areas and dark areas. Each will place a dot in the display. Some may be above the zero reference point, some below.

When you have finished, you can see if the meter readings are balanced in respect to the center—the gray card. If all or most readings are to the right, the scene will be overexposed; if they are to the left, the scene will be underexposed.

To make an adjustment, change shutter speed or aperture, or both. That will change the exposure represented by the zero reference point. On the display, the reference point doesn't move, the dots move. They are repositioned to show how they relate to the new reference point.

When you have the measured scene brightnesses arranged as you wish—perhaps balanced around the gray-card reference—make the exposure.

AUTOMATIC BRACKETING

I have observed that experienced photographers bracket often. Those with more experience bracket even more, which suggests that experience

teaches us something.

Automatic bracketing is really convenient. You can bracket up to nine frames rapidly in the continuous drive mode of a MAXXUM 7000, faster with a motor-driven MAXXUM 9000.

Setup is quick and simple. Suppose you want to bracket from 3 steps below the meter reading to 3 steps above, in increments of 1 step. When you are setting up the BRACKET function, the display asks three questions:

The first question is indicated by FROM. To reply, adjust the bottom end of the bracket range, −3 in this example.

The second question is indicated by STEP. Adjust the size of the step-increases in exposure. In this case, the increase is 1 step.

The third question is indicated by FRAME. Adjust the number of frames to be bracketed. It takes seven frames to bracket from 3 steps under to 3 over, with one frame at metered exposure, using increments of 1 step.

When you have answered the three questions *and* turned on the bracketing mode, bracketing will occur in each series of seven exposures until you turn bracketing off or reprogram it. Figure 9-12 shows a display after the bracketing function has been programmed.

Bracketing begins at the lowest exposure and increases in the programmed steps. In a program mode, both aperture and shutter speed are changed. On aperture-priority, shutter speed is changed. On shutter-priority or manual, aperture is changed.

Standardized Bracketing—If you use the same type of film often, you may develop a standard bracketing pattern, such as two frames under and two over, in half steps. Store it in the super back. To use it, just select bracketing and turn it on.

You may find scenes that don't need balanced bracketing. You may prefer one frame under and three over, or four under. To do that, you don't need to reprogram the bracket function. Use the Exposure-Adjustment control on

the camera to shift the bracket range up or down with respect to metered exposure.

The Display—When bracketing has been programmed, the display lets you watch it happen. In Figure 9-12, the zero reference represents metered exposure.

The narrow horizontal band in the display shows the programmed bracket range and its relationship to metered exposure. Before any shots are made, the wide band has the same range as the narrow band. As shots are made, the wide band is nibbled away from the left. After the last shot in the bracket sequence, the wide band is restored to full width again, ready for the next bracket sequence.

You can program the bracket function and then switch the display to another function, if you wish. If the bracket function is turned on, it works no matter what other functions are selected. In an exposure mode, there is another way to watch bracketing. The exposure settings change in the programmed steps as the bracket sequence runs.

IMPRINT FUNCTION

Select what is to be imprinted and enter values as needed. The character display at the top is used. The graphic part of the display is blank. Figure 9-13 shows what can be imprinted. The display doesn't show the same characters that appear on the film. A table in the instruction booklet shows typical imprinted characters.

Imprint Exposure—To imprint black-and-white film, select the B&W function at the bottom of the menu, in addition to the IMPRINT function. Black-and-white films with ISO speeds below 50 and some special-purpose films may not record a visible image.

The imprint lamps are LEDs. To set exposure, the super back uses the film-speed setting of the camera as a guide. With slow film, it turns on the LEDs for a longer time than with fast film.

HOW TO SELECT AND ALTER A PROGRAM

To alter a program, the camera may be off or on. To turn on the Super Back display, press ENT. To use the program, the camera must be turned on. If the camera is turned on, touching the Operating Button also turns on the Super Back display. The display turns itself off after 10 seconds, if no key has been pressed.

SELECT THE PROGRAM

With the Super Back display turned on, press FUNC to move the pointer to EXPOSURE. Press OPER to turn on the EXPOSURE function. Be sure a vertical bar appears. An exposure-mode label, such as PROGRAM 2, will appear at the top. Press the MODE key to select one of the three Super Back programs. The selected program can be altered by changing the maximum and minimum aperture to be used.

SET MAXIMUM *f*-NUMBER

Press ADJ to begin the procedure. The maximum *f*-number to be used appears in the character display, underlined by the cursor. If the value is satisfactory, press ENT. To change the value, use the up-arrow or down-arrow key. When finished, the display and graph show the new maximum aperture limit. Press ENT to enter the value.

SET MINIMUM *f*-NUMBER

The minimum *f*-number appears automatically in the display. To accept the displayed value, just press ENT. To change the value, use arrow keys, then press ENT.

END THE PROCEDURE

When both aperture values have been set, the display shows COMPLETED. Press ADJ again to end the procedure. The exposure-mode label will be displayed. The altered program is ready to use. The super back will hold this program in memory until you change it again.

SHIFT THE PROGRAM, IF DESIRED

When viewing a scene, the viewfinder display shows shutter speed and aperture values to be used. If you prefer different values, you can shift the program. To shift, the Super Back character display *must* show shutter-speed and aperture values. If the exposure-mode label is displayed, press ENT to display values. You will probably take the camera away from your eye. Therefore, the values may not be the same as you saw earlier in the viewfinder—unless the camera is on a tripod.

Press the left-arrow key or right-arrow key to shift the program line. The effect appears in the program graph and the values in the character display. The shift is permanent—until you change it. When finished, press ENT to restore the exposure-mode label.

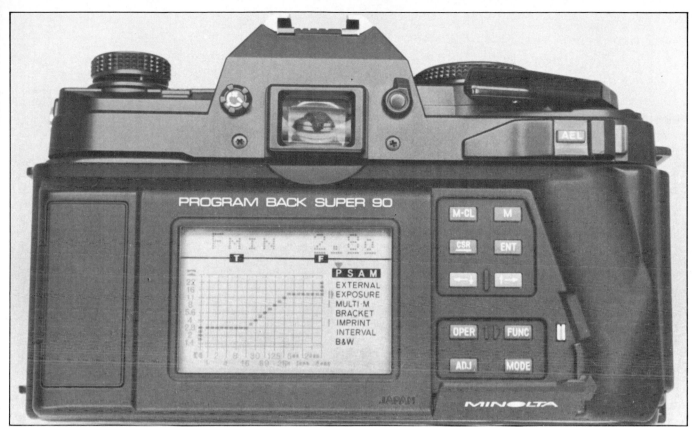

Program Back Super 70 and Program Back Super 90 control keys are in two groups. Keys used for set-up are at the bottom, normally covered by a hinged panel, which is shown open in this photo. The keys used for operation are at the top, uncovered and always available. The graphic display shows a variety of things, depending on mode.

The camera Exposure Adjustment control setting does not affect imprint exposure.

With either color or black-and-white film, when using a motor drive, slow film and fast shutter speed, it is possible to get a blurred imprint because the film was advanced while the imprint LEDs were still turned on. If that happens, set the camera film speed to a higher number and use the Exposure Adjustment control to restore correct exposure of the scene on film. For example, with ISO 25 film, change film speed to 50 and then set exposure adjustment to +1.

The higher film-speed number causes the super back to reduce the length of time that the LEDs are turned on. The imprint will be underexposed, but more legible than if blurred.

Imprint Location—Data is imprinted along the right edge of the picture. If it is a slide, the data will be fully or partially covered by the slide mount. You can ask for slide film to be returned from the processor without mounting, if you wish.

INTERVALOMETER FUNCTION

When the intervalometer function has been selected, enter the time interval between groups of exposures, the number of frames in a group, the number of groups to be exposed, and the starting date and time. This is done in the character display.

MAKING CONTROL SETTINGS

The accompanying photo shows the control keys. The instruction booklet for super backs shows detailed sequences of operations to select functions and modes.

Display—The super-back display is turned on by touching the Operating Button on the camera—if the camera is turned on—or the ENT key on the super back, whether the camera is on or off. The display remains on for 10 seconds. When off, the super back doesn't accept data or commands from the control keys.

Functions—Functions, such as EXPOSURE, are always selected by pressing the FUNC key to move the function pointer to the desired function. Only one function at a time can be designated by the function pointer.

Function On-Off—Functions are always turned on by pressing the OPER key when the function is designated by the function pointer.

Functions that are turned on have a vertical bar at left—the ON symbol. All functions, except EXTERNAL, can be turned on and operating at the same time.

A function that is on can be turned

off by moving the pointer to that function and pressing OPER again.

Modes—When a function has subordinate modes, they are selected by pressing the MODE key. For example, the EXPOSURE function has four modes, as indicated by PSAM.

One mode is always designated by an arrow symbol. To change it, select the EXPOSURE function and press MODE until the desired mode is indicated by the arrow above PSAM.

Even though an exposure mode is designated by the arrow above the PSAM symbol, that does not mean that it is turned on. If the EXPOSURE function is on, then the selected mode is also on.

Subordinate Functions—The EXPOSURE function has two subordinate functions, MULTI•M and BRACKET. Neither of the subordinates can be turned on unless EXPOSURE is already on. If EXPOSURE is turned off, any subordinate that is on will also be turned off.

Mode Labels—The name of the mode or function that is being used appears at the top of the display. The same space is used to show values, such as shutter speed and aperture.

Pressing the ENT key switches back and forth between labels and values in the character display.

Entering Data—Values such as aperture or shutter speed are entered by changing whatever is already on the display, which may be zero. Changing a value is done by the arrow keys. The up-arrow key increases the value. The new value remains in effect until changed.

When a value has been changed, it is entered by pressing ENT. If the value is already OK, just press ENT without changing it.

When Data Can Be Entered—Entering data is actually done by changing displayed data. Therefore, you can enter data only when *values* are shown in the character display. If a mode name or label is shown, values such as shutter speed and aperture cannot be changed. They are locked at the previous setting.

To change the character display from label to values, press the ENT key. Then you can change the values by pressing arrow keys.

The ADJ Key—Some setup procedures begin by pressing the ADJ (Adjust) key. When the ADJ key is used to start a procedure, it is also used to end that procedure.

Program Shift—Program shifting is done with the arrow keys. The left arrow shifts upward and to the left. The right arrow shifts to the right. Program shifting cannot be done when a label is shown in the character display. It must show shutter-speed and aperture.

Other Keys—The M key enters exposure readings into memory when using the multiple-memory function. The M-CL key clears memory. When two values are displayed and both can be changed, such as shutter speed and aperture in a manual mode, the first value to be changed is underlined by a cursor. After changing or accepting the first value, press the CSR (Cursor) key. The cursor will move to the second value, which can then be changed.

With Flash—If a flash unit is installed and charged, it takes over the exposure-control function. The ON symbol at EXPOSURE in the super-back display is automatically switched off. The subordinate exposure functions, MULTI•M and BRACKET, are also turned off, if they were on.

When you turn off the flash, the super-back exposure functions are not *automatically* restored. Exposure control reverts to the camera. To use the super back exposure function and its subordinate functions, you must turn each one on again, individually.

BATTERIES

Six batteries are used. They can be 1.5-volt alkaline-manganese batteries type LR44 or A-76, or 1.55-volt silver-oxide batteries type SR44, S-76, EXP-76, or equivalent. Chamber A, on the outside of the super back, takes four batteries, to power the exposure computer. Two batteries go into Chamber B, on the inside, to power the calendar and clock.

When installing batteries in Chamber A, or whenever the compartment cover is open, press the M-CL button to reset the exposure computer. This erases all data in memory, including stored Programs.

Low Battery Warning—When batteries are low, battery symbols and the letter A or B to designate the chamber appear on the display.

MAXXUM Cameras and Accessories

This chapter discusses MAXXUM cameras as individual models, with specifications for each. Fundamentals and theory that were presented in earlier chapters are not repeated here.

Because Motor Drive MD-90 is used only with the MAXXUM 9000 camera, and because it contributes more than just film-advance to the operation of the camera, the MD-90 is discussed in this chapter along with the MAXXUM 9000.

Also discussed are accessories not included in earlier chapters, specifically remote-control equipment.

MAXXUM cameras, lenses and accessories allow you to do virtually any kind of photography. You can set up the equipment so everything is automatic—all you do is point and shoot. Or, you can exert as much technical and artistic control as you wish. However you choose to operate, the end goal for most of us is pleasing photographs that store memories of the times and places where they were taken.

MAXXUM 5000

The MAXXUM 5000 is an auto-focus camera with a built-in focus motor and a film-transport motor to automatically load, advance and rewind film. It has programmed automatic exposure with three programs that are selected automatically, and metered manual exposure.

LENSES

MAXXUM AF (AutoFocus) lenses are used. The lens mount is a Minolta A-type, not compatible with earlier Minolta lenses.

BATTERIES

The battery holder holds four AAA-size alkaline batteries. The camera also has a built-in lithium battery with a 10-year life.

MAIN SWITCH

Sliding the Main Switch to LOCK turns the camera off. Moving the switch to the ON position turns the camera on. Sliding the switch past ON to the "sound wave" symbol also turns on a beeper.

OPERATING BUTTON

The Operating Button has three stages. Touching it turns on the exposure meter and the displays. The second stage is depressing it partway. The autofocus system focuses on the subject and locks focus. Depress the button fully to make an exposure.

If you are wearing gloves, or your fingertip is unusually dry, touching the Operating Button may not turn on the meter. However, it will be turned on when the button is depressed partway.

SELECTOR KEYS

Most controls are pushbuttons, called keys.

Aperture Keys—On the left side of the lens mount are two keys, marked with arrows, used to set aperture. The "up" arrow selects larger *f*-numbers.

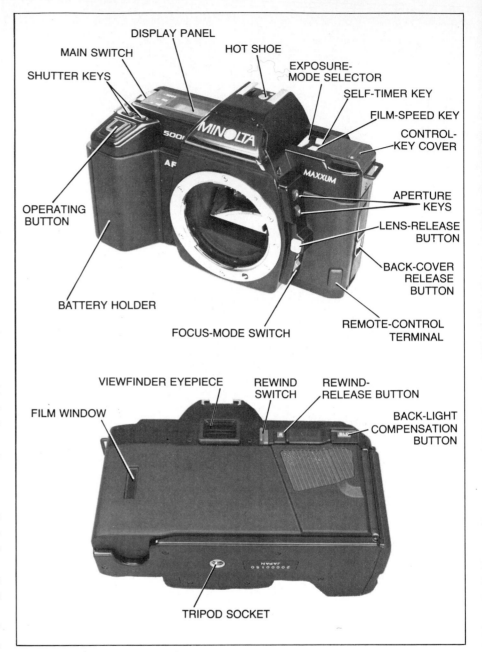

Shutter Keys—Just behind the Operating Button are two keys, marked with arrows, used to set shutter speed and film speed. The "up" arrow selects larger values. Shutter-speed range is 1/2000 to 4 seconds.

CONTROL KEYS

Under a sliding Control-Key Cover at top left are three Control Keys. One is labeled ISO (film speed), one P/M (Program/Manual), and one shows a clock face to represent the self-timer.

LOADING FILM

One of the displays is a Display Panel on top of the camera. With the camera turned on and the Control-Key Cover closed, the Display Panel shows the word PROGRAM and a frame-counter number. If the number is 0, there is no film in the camera, or film has been incorrectly loaded, or it has been rewound.

Load film as shown in Chapter 4. The camera will automatically advance to frame 1 and the counter will show the number 1. If it shows 0, film is not loaded correctly. Open the back and do it again.

FILM WINDOW

A window in the camera back allows you to see data printed on film cartridges, such as film type, the number of exposures and the film speed.

FILM SPEED

With DX-coded film, the camera automatically sets film speed. The value is displayed in the Display Panel while film is being advanced to frame 1. You can change it if you wish.

With non-DX coded film, the setting will remain as it was for the preceding roll of film.

MAXXUM 5000 SPECIFICATIONS

Type: 35mm SLR with autofocus or manual focus, viewfinder focus display, programmed automatic exposure with automatic program selection, metered manual, automatic film handling, automatic flash exposure.
Lens Mount: Minolta A-type; accepts only Maxxum AF lenses.
Autofocus System: TTL phase detection with digital control.
Autofocus Sensitivity: EV 2 to EV 19 at ISO 100.
Backlight Compensation Button: In Program mode, increases exposure by 2 steps.
Shutter: Electronic, vertical travel, stepless on automatic with nearest half-step displayed. Standard steps on manual. Range is 1/2000 to 4 seconds plus bulb. X-sync at 1/100 second.
Film Speed: ISO 25 to 6400. For TTL autoflash metering, ISO 25 to 1000. Set automatically with DX-coded film cartridges.
Metering: For ambient light, TTL center-weighted using silicon cell in viewfinder housing. A second silicon cell in bottom of mirror box is used for TTL flash metering during exposure.
Metering Range: EV −1 to EV 20 with ISO 100 and f-1.4.
Exposure Modes: Programmed auto, with automatic selection among three programs depending on focal length; metered manual.
TTL Flash Modes: Programmed automatic; manual with manually set shutter speed and aperture.
Film Transport: By built-in motor. Single-frame or continuous at rates up to 1.5 frames per second; auto loading; power rewinding.
Viewfinder: Eyelevel, fixed pentaprism shows 94% of frame. Magnification 0.85 with 50mm lens at infinity.
Viewfinder Displays: LED focus display. LCD display shows exposure mode, program shift indication, shutter speed, aperture, low battery warning, metering-range limit, over- or underexposure, flash ready, sufficient flash exposure. LCD display automatically illuminated in dim light.
Data Panel Display: LCD type shows exposure mode, film speed, frame number, self-timer countdown, low-battery warning, film-transport status, timer for bulb operation.
Batteries: Four AAA-size alkaline in battery holder or four AA-size alkaline or Ni-Cad in accessory holder. Built-in lithium cell with approximate 10-year life, for memory backup of film-speed and frame count.
Beeper: Can be switched on or off.
Self Timer: Electronic with 10-second delay. Operation indicated by flashing LED on camera front and beeper, if turned on. Can be cancelled during run.
Size: 52 x 92.5 x 138mm (2-1/16 x 3-5/8 x 5-7/16 inches).
Weight: 550g (19-3/8 oz.) without batteries.

Setting Film Speed—Open the Control-Key Cover. Depress the key labeled ISO. The set film speed will appear in the Display Panel along with the symbol ISO. To change film speed, hold down the ISO key while pressing one of the Shutter Keys. The film-speed range is ISO 25 to 6400 in increments of 1/3 step.

FILM TRANSPORT

A motor in the camera advances film automatically after each exposure. Two right-pointing arrows adjacent to the film-cartridge symbol in the Display Panel blink at each advance. Pressing and immediately releasing the Operating Button will expose one frame at a time. Holding down the button causes frames to be exposed continuously at up to 1.5 frames per second.

FOCUS MODES—The camera can be set to focus the lens automatically or manually.
Focus-Mode Switch—The switch is below the Lens-Release Button. When set to AF, the camera is in the autofocus mode. When set to M, the camera is in the manual focus mode.
Caution—Do not attempt to focus the lens manually with the Focus-Mode Switch at AF. Doing so may damage the camera. In the AF mode, be sure your hand is not touching the focusing ring on the lens while the focusing motor is turning it.
Autofocus Limits—With suitable subjects, the MAXXUM 5000 autofocus system works with scene brightnesses from EV 2 to EV 19 at ISO 100.

FOCUS LOCK

With the Focus-Mode Switch at AF, depressing the Operating Button partway causes the camera to focus on the subject and then lock. Focus is locked at that distance until you make an exposure or release the Operating Button.

If you hold the Operating Button partially depressed, you can focus on a subject at the center of the frame and

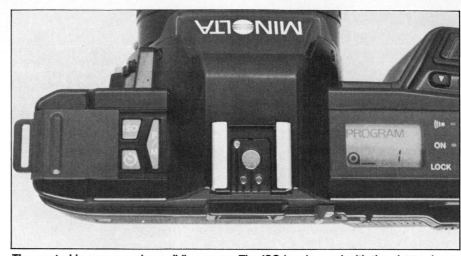

The control keys are under a sliding cover. The ISO key is used with the shutter keys to set film speed. The key with the clock face selects self-timer operation. The P/M key selects programmed automatic or manual operation. Closing the cover switches the camera to programmed automatic.

then recompose without losing focus on the subject. To focus on a different subject, release the Operating Button and then press it again to focus on the new subject.

If you hold down the Operating Button to expose frames continuously using autofocus, the camera pauses to refocus before each exposure.

FOCUS PRIORITY

On autofocus, the shutter cannot be released unless the subject is in focus. On manual focus, the shutter can be released whether or not the subject is in focus.

EXPOSURE METERING

The ambient-light system uses a silicon sensor in the viewfinder to measure brightness of the image on the focusing screen. The metering pattern is center weighted. Exposure is set before the mirror moves up.

MAXXUM flash is controlled during exposure by a silicon sensor at the bottom of the mirror box, measuring light on the film using a center-weighted pattern.

DISPLAYS

There are viewfinder displays and a Display Panel on top of the camera.

Viewfinder Focus Display—Below the image, at left, is the focus display. A green light glows when the image is in focus. The other indicators are red arrows, shown in the chart on page 128. This display operates on both autofocus and manual focus.
Viewfinder Exposure Display—Below the image, at right, is the LCD exposure display. It shows exposure mode, using the symbol P or M, shutter speed, aperture, and a low-battery warning signal. On Manual, it also shows metering indicators. In dim light, this display is automatically illuminated.
Display Panel—An LCD Display Panel is on top of the camera. With the camera on, it normally shows the exposure mode—program or manual, the frame count and the film-transport symbols. It may show other symbols temporarily, such as ISO film speed.
Display On-Off—In the viewfinder, shutter speed and aperture appear when you touch or depress the Operating Button. To conserve battery power, those values are turned off after 10 seconds if you remove your finger from the Operating Button. The exposure-mode symbol remains visible.

If you turn off the camera, the viewfinder display becomes blank. The

MAXXUM 5000 DISPLAY PANEL INDICATIONS

Display	Meaning
PROGRAM ◉_ 18	Camera is on programmed automatic exposure.
M ◉_ 18	Camera is on metered manual exposure.
ISO 100	ISO film-speed display.
PROGRAM ◉▴▴ 18	Film is being advanced by built-in motor.
◉▾▾ ___	Film is being rewound by built-in motor.
M buLb ◉_ 18	Shutter speed is on **bulb** for long exposure.
PROGRAM [▭] ◉_ 18	Batteries are low and should be replaced.
PROGRAM ◉_ 18 ⏱	Self-timer is set for next exposure.

Data panel continues to show the film-transport symbol and the frame count.

Focus Frame—In the center of the viewfinder image, a rectangle shows the area used by the autofocus system to check focus.

EXPOSURE MODES

Programmed automatic or manual can be used.

Setting Exposure Mode—Open the Control-Key Cover. Press the P/M key to switch back and forth between modes. When you close the cover, the camera is automatically switched to the Program mode.

PROGRAMMED AUTO

The camera sets both shutter speed and aperture automatically. The nearest half step is displayed.

Automatic Multi-Program Selection—Three programs are available, shown in the graph on page 129. Selection is made automatically by the camera, depending on the focal length of the lens in use. When a zoom lens is used, the program changes as the lens is zoomed.

Exposure Warnings—If both shutter speed and aperture blink, there is no available combination of settings that will produce correct exposure of an average scene.

If overexposure is indicated, the *smallest* aperture and the *fastest* shutter speed blink. If underexposure is indicated, the *largest* aperture and *slowest* shutter speed blink.

BACKLIGHT COMPENSATION

On automatic exposure, a subject against a bright background will usually be underexposed. For a better exposure, press the button labeled BLC. Exposure will be increased by 2 steps.

METERED MANUAL

To select this mode, open the Control-Key Cover and press the P/M key. An M symbol will appear in the Display Panel on top of the camera.

You set both aperture and shutter

MAXXUM 5000 FOCUS DISPLAY

Symbol	On Manual Focus	On Autofocus
▶	Turn manual focusing ring to right.	Cannot focus because cámera is too close to subject.
●	Subject is in focus.	Subject is in focus.
◀	Turn manual focusing ring to left.	Symbol not used.
◀ ▶	Focus by observing image on screen.	Autofocus not possible. Switch to manual focus.

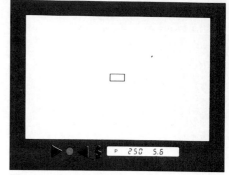

The standard focusing screen has a Focus Frame at the center of the image area. The focus display is at lower left, below the image. The exposure display is at lower right.

speed, using the Aperture Keys and Shutter Keys. The values appear in the viewfinder display. Only standard shutter speeds in full steps are available in this mode, plus the X-sync speed of 1/100 second. Aperture can be set in half steps.

Metering Indicators—The camera-recommended exposure is indicated by two arrow symbols, called metering indicators, that appear between the shutter-speed and aperture values in the viewfinder.

If both arrows appear, exposure of an average scene will be correct within 1/4 step. The up arrow alone indicates overexposure. The down arrow alone indicates underexposure.

METERING RANGE

In all exposure modes, if the light is too dim or too bright for correct metering, both metering indicators blink.

BULB SETTING

Used only on manual, the shutter remains open as long as the Operating Button is depressed. Accessory Remote Cord RC-1000S or RC-1000L can be used to lock the shutter open.

To select, press the "down arrow" Shutter Key until the bulb symbol appears in either display. The exposure meter does not operate. When you press the Operating Button, the frame-

counter in the Display Panel changes to an elapsed-time counter, counting to 99 seconds and repeating.

SELF-TIMER

Open the Control-Key Cover and press the button with the clock symbol. That symbol appears in the Display Panel. When you press the Operating Button, exposure will be delayed for 10 seconds. If the beeper is turned on, it beeps slowly, then rapidly, then continuously during the last second. The frame counter in the Display Panel changes function and counts seconds downward from 10. To cancel during the countdown, close the Control-Key Cover or turn the camera off and back on again. The Self-Timer does not function at the bulb setting.

On automatic exposure, stray light entering the eyepiece may cause incorrect exposure. When using the self-timer, if your eye is not at the eyepiece, cover the eyepiece with the Eyepiece Cap that is provided with the camera.

MEMORY BACKUP

The camera remembers exposure mode, frame count and film speed, even when turned off. Exposure mode, and frame count are displayed again when you turn the camera on. Film speed is always in memory but displayed only when the ISO key is

pressed with the camera on. Values of shutter speed and aperture that you set manually are retained when the camera is turned off and restored when the camera is turned on again.

BATTERY WARNINGS—When a battery symbol appears in the viewfinder display and in the Display Panel, the main batteries should be replaced.

When the main batteries are discharged, or the holder is removed to replace them, film speed and frame count are stored in a memory powered by the lithium battery. When the main batteries are replaced, film speed and frame count remain the same as before. If all batteries are discharged, all data is lost.

END OF ROLL

When the last frame has been exposed, the film-cartridge symbol and the frame number blink in the Display Panel. If the beeper is turned on, it beeps. The shutter is locked.

Depress the Rewind-Release Button, R, and slide the adjacent Rewind Switch to the left. It locks while film is being rewound automatically.

During rewind, the Film Transport indicator in the Display Panel shows film being drawn into the cartridge. When all film has been "pictorially"

rewound, the film is rewound and the motor stops.

Caution—If the main batteries fail during rewind, the motor will stop but the Display Panel will still show film extending from the cartridge. Do not open the camera. Move the Main Switch to LOCK. Replace the batteries. Move the switch to ON and wait for rewind to be completed.

BEEPER FUNCTIONS

When the beeper is turned on, it provides the following signals:

- Indicates good focus in autofocus mode.
- Beeps at end of roll.
- Beeps during self-timer operation.
- Warns of slow shutter speed in P mode. It beeps when shutter speed is below 1/30 second with lenses shorter than 35mm; below 1/60 second with lenses from 35mm to 105mm; and below 1/125 second with lenses longer than 105mm.

INTERCHANGEABLE FOCUSING SCREENS

Interchangeable focusing screens are shown in the chart on page 131. They are interchanged as shown in Chapter 3.

FILTERS

Color and special-effect filters can be used. Some filters may prevent autofocus operation. In that case, focus manually.

Autofocus will not work with a conventional polarizing filter. Minolta offers a special circular polarizing filter that will allow the autofocus system to work.

MAXXUM FLASH

With flash, the camera controls exposure as discussed in Chapter 8. Operation is possible only with film speeds in the range of 25 to 1000. X-sync shutter speed is 1/100 second.

If the Operating Button is pressed before the flash is charged and ready to fire, the camera makes the exposure

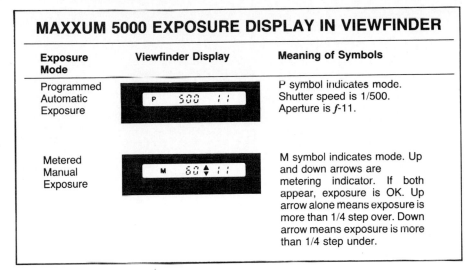

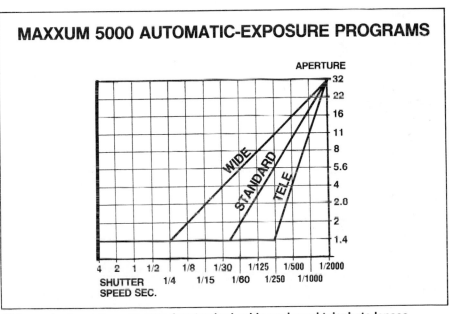

This graph shows the programs for standard, wide-angle and telephoto lenses.

This scene represents a typical situation where it's best to focus at a predetermined distance. When the fast-moving subjects reach the focused point, you shoot. To provide maximum depth of field, use the smallest possible lens aperture. To "freeze" subject motion on the film, use the fastest possible shutter speed. To satisfy both these requirements, you may need to use a fast film.

using ambient light, as though the flash were not attached.

A continuous sequence of flash exposures can be made by holding down the Operating Button. To get sufficiently fast recycle times, some flash units have a low power setting for this purpose. Manual focusing is used to avoid the delay caused by automatic refocusing for each frame.

Viewfinder Indicators—The flash symbol blinks when the flash is charged and ready to fire. After flash exposure, the symbol blinks rapidly for about one second if exposure was sufficient. If the symbol does not blink, underexposure is indicated. There is no warning of overexposure.

AF ILLUMINATOR

MAXXUM flash units have an illuminator to assist autofocusing in dim light. If needed, the illuminator is triggered when you depress the Operating Button partway. If the camera finds focus, it then makes an exposure using light from the flash.

MAJOR ACCESSORIES

MAXXUM AF lenses, MAXXUM flash units, Data Back 70, Program Back 70, Eyepiece Correctors EC-1000, Wireless Controller IR-1N Set, Remote Cord RC-1000L (5 meters long) and RC-1000S (50cm long), Battery Holder BH-70L, External Battery Pack EP-70, filters, Angle Finder Vn, Magnifier Vn, Cable OC, Cable EX, Cable CD, Triple Connector TC-1000, Off-Camera Shoe.

The standard battery holder, BH-70S, shown here, holds four AAA-size batteries. Accessory holder BH-70L holds four AA-size batteries.

This is a typical average scene. It has an overall reflectance that approximately resembles that of an 18% gray card. There are no bright highlights or dark shadow areas that could "fool" the exposure meter. Giving the meter-indicated exposure should give a satisfactory image.

MAXXUM 7000

The MAXXUM 7000 is an auto-focus camera with a built-in focus motor and a film-transport motor to automatically load, advance and re-wind film. It has programmed automatic exposure with three programs that are selected automatically, depending on lens focal length. In addition, it has aperture-priority automatic, shutter-priority automatic and metered manual exposure.

LENSES

MAXXUM AF (AutoFocus) lenses are used. The lens mount is a Minolta A-type, not compatible with earlier Minolta lenses.

BATTERIES

The battery holder holds four AAA-size alkaline batteries. The camera also has a built-in lithium battery with a 10 year life.

MAIN SWITCH

Sliding the Main Switch to LOCK turns the camera off. Sliding the switch to ON turns the camera on. Sliding the switch past ON, to the "sound wave" symbol, also turns on a beeper.

OPERATING BUTTON

The Operating Button has three stages. Touching it turns on the exposure meter and the displays. The second stage is depressing it partway. The autofocus system focuses on the subject and then locks focus. Depress it fully to make an exposure.

If you are wearing gloves, or your fingertip is unusually dry, touching the Operating Button may not turn on the meter. However, it will be turned on when the button is depressed partway.

SELECTOR KEYS

Most controls are pushbuttons, called keys. Setup procedures require pressing two keys simultaneously. Operating procedures use only one key.

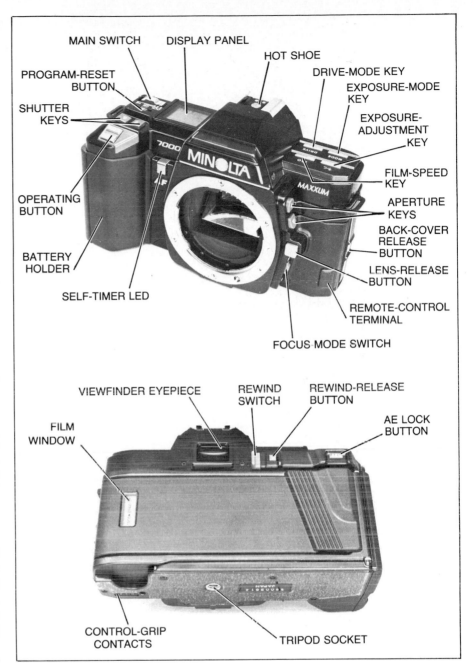

MAXXUM 7000 SPECIFICATIONS

Type: 35mm SLR with autofocus or manual focus, viewfinder focus display, multi-mode automatic exposure, automatic film handling, automatic flash exposure.

Lens Mount: Minolta A-type; accepts only Maxxum AF lenses.

Autofocus System: TTL phase detection with digital control.

Autofocus Sensitivity: EV 2 to EV 19 at ISO 100.

Metering: For ambient light, TTL center-weighted using silicon cell in viewfinder housing. A second silicon cell in bottom of mirror box is used for TTL flash metering during exposure.

Metering Range: EV −1 to EV 20 with ISO 100 and f-1.4.

Exposure Adjustment Control: Plus or minus 4 exposure steps in increments of 1/2 step.

AE Lock Button: Functions in all automatic modes.

Shutter: Electronic, vertical travel, stepless on automatic with nearest half-step displayed. Standard steps on manual. Range is 1/2000 to 30 seconds plus bulb setting. X-sync at 1/100 second.

Film-Speed: ISO 25 to 6400. For TTL autoflash metering, ISO 25 to 1000. Set automatically with DX-coded film cartridges.

Exposure Modes: Programmed auto, with automatic selection among three programs depending on focal length and program-shift capability; aperture-priority auto; shutter-priority auto; metered manual.

TTL Flash Modes: Programmed, A-mode with manually set aperture, M-mode with manually set shutter speed and aperture.

Film Transport: By built-in motor. Single-frame or continuous settings at rates up to 2 frames per second. Power rewinding.

Viewfinder: Eyelevel, fixed pentaprism shows 94% of frame. Magnification 0.85 with 50mm lens at infinity.

Viewfinder Displays: LED focus display. LCD display shows exposure mode, program shift indication, shutter speed, aperture, exposure adjustment, low-battery warning, metering-range limit, over- or underexposure, flash ready, sufficient flash exposure. LCD display automatically illuminated in dim light.

Data Panel Display: LCD type displays same data as viewfinder LCD plus frame counter, self-timer countdown, timer for bulb operation.

Batteries: Four AAA-size alkaline in battery holder or four AA-size alkaline or Ni-Cad in accessory holder. Built in lithium cell with approximate 10-year life for memory backup of film speed and frame count.

Beeper: Can be switched on and off.

Self-Timer: Electronic with 10-second delay. Operation indicated by flashing LED on camera front and beeper, if turned on. Can be cancelled during run.

Size: 52 x 91.5 x 138mm (2-1/16 x 3-5/8 x 5-7/16 inches).

Weight: 555g (19-9/16 oz.) without batteries.

Aperture Keys—On the left side of the lens mount are two blue keys, marked with arrows, used to set aperture. The up arrow selects larger aperture.

Shutter Keys—Just behind the Operating Button are two blue keys, marked with arrows, used to set shutter speed, and for other purposes. The up arrow selects faster speeds. Shutter-speed range is 1/2000 to 30 seconds.

CONTROL KEYS

At top left are four Control Keys labeled +/− (Exposure Adjustment), ISO (Film Speed), MODE (Exposure Mode) and DRIVE (Film Transport). To set values, such as Exposure Adjustment, press and hold the appropriate Control Key while pressing one of the Shutter Keys.

LOADING FILM

One of the displays is a Display Panel on top of the camera. In the panel is a frame counter with the word FILM and a frame number. If the number is 0, there is no film in the camera, or film has been incorrectly loaded, or it has been rewound.

Load film as shown in Chapter 4. The camera will automatically advance to frame 1 and the counter will show the number 1. If it shows 0, film is not loaded correctly. Open the back and do it again.

FILM WINDOW

A window in the camera back allows you to see data imprinted on film cartridges, such as film type, the number of exposures and the film speed.

FILM SPEED

With DX-coded film, the camera automatically sets film speed. The value is displayed in the Display Panel for 10 seconds when the back is closed during film loading. You can change the setting, if you wish.

With non-DX coded film, the setting will remain as it was for the preceding roll of film.

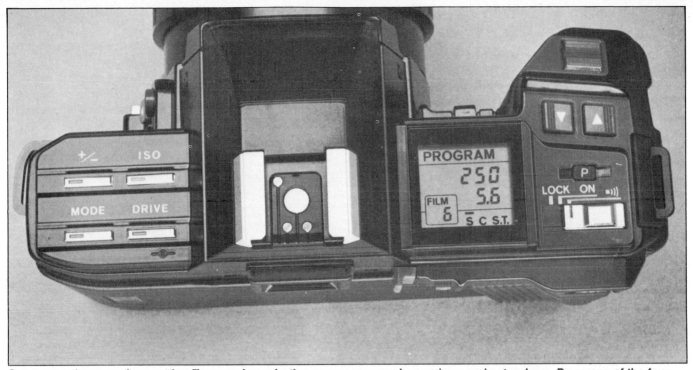

Setup procedures, such as setting film speed or selecting an exposure mode, require pressing two keys. Press one of the four Control Keys at left while also pressing one of the Shutter Keys at right, near the Operating Button.

Setting Film Speed—Depressing the Control Key labeled ISO causes the set film speed to appear in the Display Panel and in the viewfinder display. To change it, hold down the ISO key while pressing one of the Shutter Keys. The film-speed range is ISO 25 to 6400 in increments of 1/3 step.

DRIVE MODES

Drive modes are single-frame, continuous, and self-timer. In the continuous mode, frames are exposed continuously, by holding down the Operating Button, at rates up to two frames per second, depending on shutter speed.

Symbols—At lower right in the Display Panel are the symbols S C S.T. The symbol S stands for single-frame operation. The C indicates continuous operation and S.T. sets the self-timer.

Indicator—The drive-mode indicator is the bar that appears above the selected drive-mode symbol in the Dis-

play Panel.

Selection—To choose, press the Control Key labeled DRIVE while pressing a Shutter Key to place the indicator bar above the desired symbol.

FOCUS MODES—The camera can be set to focus the lens automatically or manually.

Focus-Mode Switch—The switch is below the Lens-Release Button. When set to AF, the camera is in the autofocus mode. When set to M, the camera is in the manual focus mode.

Caution—Do not attempt to focus the lens manually with the Focus-Mode Switch at AF. Doing so may damage the camera. In the AF mode, be sure your hand is not touching the focusing ring on the lens while the focusing motor is turning it.

Autofocus Limits—With suitable subjects, the MAXXUM 7000 autofocus system works with scene brightnesses from EV 2 to EV 19 at ISO 100.

FOCUS LOCK

With the Focus-Mode Switch at AF, depressing the Operating Button partway causes the camera to focus on the subject and then lock. Focus is locked at that distance until you make an exposure or release the Operating Button.

If you hold the Operating Button partially depressed, you can focus on a subject at the center of the frame and then recompose without losing focus on the subject. To focus on a different subject, release the Operating Button and then press it again to focus on the new subject.

With the camera set for continuous exposure on autofocus, the camera refocuses before each exposure.

FOCUS PRIORITY

On autofocus, the shutter cannot be released unless the subject is in focus. On manual focus, the shutter can be released whether or not the subject is in focus.

135

EXPOSURE METERING

The ambient-light system uses a silicon sensor in the viewfinder to measure brightness of the image on the focusing screen. The metering pattern is center weighted. Exposure is set before the mirror moves up.

MAXXUM flash is controlled during exposure by a silicon sensor at the bottom of the mirror box, measuring light on the film using a center-weighted pattern.

DISPLAYS

There are displays in the viewfinder and the Display Panel on top of the camera.

Viewfinder Focus Display—Below the image, at left, is the focus display. A green light glows when the image is in focus. The other indicators are red arrows, shown in the chart on page 138. This display operates on both autofocus and manual focus.

Viewfinder Exposure Display—Below the image, at right, is the LCD exposure display. Normally, it shows exposure mode, shutter speed, aperture, and an exposure-adjustment symbol if exposure adjustment is not zero. In dim light, this display is automatically illuminated.

Display Panel—An LCD Display Panel is on top of the camera. Normally, it shows the same information as the viewfinder exposure display, plus frame count and drive mode.

Display On-Off—In both displays, shutter speed and aperture appear when you touch or depress the Operating Button. To conserve battery power, those values are turned off after 10 seconds if you remove your finger from the Operating Button. Other items remain visible.

Focus Frame—In the center of the image, a rectangle shows the area used by the autofocus system to set focus.

EXPOSURE MODES

The mode being used is shown at left in the viewfinder exposure display by one of the symbols P (programmed auto), A (aperture-priority auto), S (shutter-priority auto), or M (metered manual). The mode is also shown at the top of the Display Panel except that PROGRAM is used instead of P.

Setting Exposure Mode—Press and hold the Control Key labeled MODE while pressing a Shutter Key until the desired mode symbol appears in either display.

PROGRAMMED AUTO

The camera sets both shutter speed and aperture automatically. The nearest half step is displayed.

Automatic Multi-Program Selection—Three programs are available, shown in the accompanying graph. Selection is made automatically by the camera, depending on the focal length of the lens in use. When a zoom lens is used, the program changes as the lens is zoomed.

Program Shift—In the Program mode, using Shutter or Aperture Keys, you can cause the camera to step through all possible *combinations* of aperture and shutter speed that produce the same exposure. Use the combination with the preferred shutter speed or aperture size. Shifting occurs in half steps of shutter speed and aperture. The exposure-mode symbols in both displays (P or PROGRAM) blink to show that the program has been shifted.

Shifted values can be held indefinitely if you keep your finger on the Operating Button, even during several exposures. Before the first exposure, values are held for 10 seconds if you lift your finger. After exposure, shifted values revert to unshifted values as soon as you lift your finger.

Exposure Warnings—If both shutter speed and aperture blink, there is no available combination that will produce correct exposure of an average scene. If overexposure is indicated, the *smallest* aperture and the *fastest* shutter speed blink. If underexposure is indicated, the *largest* aperture and *slowest* shutter speed blink.

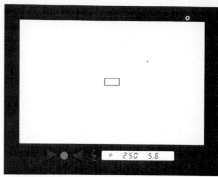

The standard focusing screen has a Focus Frame at the center of the image area. The focus display is at lower left, below the image. The exposure display is at lower right.

SHUTTER-PRIORITY AUTO

You set shutter speed, the camera sets aperture automatically. Aperture is displayed to the nearest half step. In the Display Panel, a triangle appears opposite shutter speed to show that you set it manually, using the Shutter Keys. Shutter speeds are in full steps, plus the X-sync speed of 1/100 second. In this mode, pressing Aperture Keys also changes shutter speed.

Exposure Warnings—Underexposure is indicated if the value for the *largest* lens aperture blinks in a display. Use a slower shutter speed. Overexposure is indicated if the value for the *smallest* lens aperture blinks. Use a faster shutter speed.

APERTURE-PRIORITY AUTO

You set aperture, the camera sets shutter speed automatically. Shutter speed is displayed to the nearest half step. In the Display Panel, a triangle appears opposite the aperture value to show that you set it manually, using the Aperture Keys. Aperture changes are in half steps. In this mode, the Shutter Keys also change aperture.

MAXXUM 7000 DISPLAY PANEL INDICATIONS DURING SETUP PROCEDURES

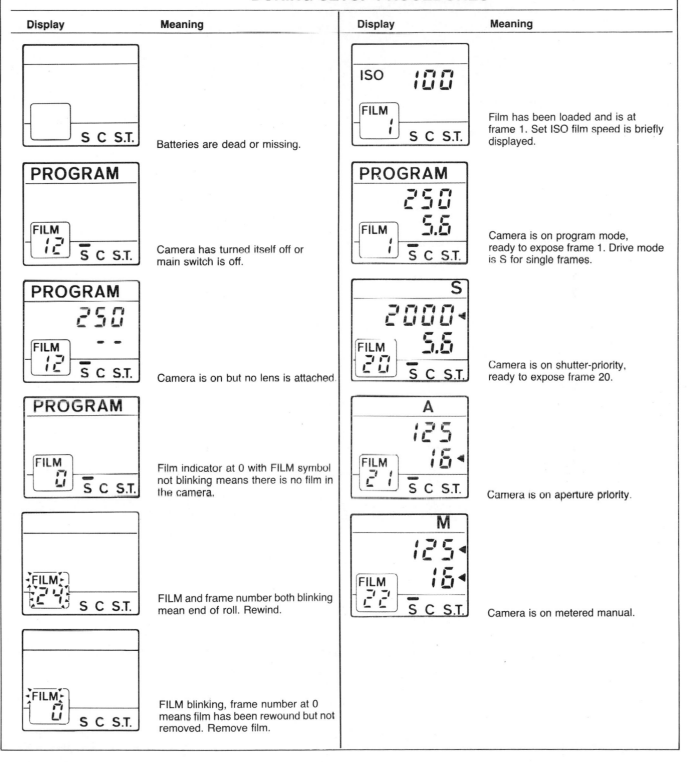

Display	Meaning	Display	Meaning

Batteries are dead or missing.

Camera has turned itself off or main switch is off.

Camera is on but no lens is attached.

Film indicator at 0 with FILM symbol not blinking means there is no film in the camera.

FILM and frame number both blinking mean end of roll. Rewind.

FILM blinking, frame number at 0 means film has been rewound but not removed. Remove film.

Film has been loaded and is at frame 1. Set ISO film speed is briefly displayed.

Camera is on program mode, ready to expose frame 1. Drive mode is S for single frames.

Camera is on shutter-priority, ready to expose frame 20.

Camera is on aperture priority.

Camera is on metered manual.

MAXXUM 7000 FOCUS DISPLAY

Symbol	On Manual Focus	On Autofocus
▶	Turn manual focusing ring to right.	Cannot focus because camera is too close to subject.
●	Subject is in focus.	Subject is in focus.
◀	Turn manual focusing ring to left.	Symbol not used.
▶ ◀	Focus by observing image on screen.	Autofocus not possible. Switch to manual focus.

Exposure Warnings—Underexposure is indicated if the *slowest* shutter speed (30 seconds) blinks. Use a larger aperture. Overexposure is indicated if the *fastest* shutter speed (1/2000 second) blinks. Use a smaller aperture.

EXPOSURE ADJUSTMENT

In any automatic mode, exposure adjustment can be made over a range of plus or minus 4 steps, in half steps.

In the metered manual mode, the metered exposure is changed by the exposure adjustment but you control exposure manually.

Setting Exposure Adjustment— Press the Control Key labeled +/−. The set value appears in the Display Panel and in the viewfinder. To change the value, hold down the +/− key while pressing a Shutter Key. The up arrow changes the setting in the plus direction.

Warning Symbol—When exposure adjustment is not zero, a + or − symbol inside a square border appears in the Display Panel and at the extreme right in the viewfinder display.

PROGRAM RESET

In front of the Main Switch is a button labeled P. When pressed and released, it sets the camera to Program mode, single-frame drive and zero exposure adjustment.

AE LOCK

The AEL (Automatic-Exposure Lock) button is on the back of the camera, near the position of your right thumb. In any automatic-exposure mode, pressing this button locks the exposure setting. The AE Lock can be used for substitute metering or to meter on a subject and then change the composition.

METERED MANUAL

You set both aperture and shutter speed, using the Aperture Keys and Shutter Keys. The values appear in both displays. In the Display Panel, a triangle to the right of each value indicates that each must be set manually. Only standard shutter speeds in full steps are available in this mode plus the X-sync speed of 1/100 second. Aperture can be set in half steps.

Metering Indicators—The camera-recommended exposure is indicated by two arrow symbols, called metering indicators, that appear between the shutter-speed and aperture values in the viewfinder.

If both arrows appear, exposure of an average scene will be correct within 1/4 step. The up arrow alone indicates overexposure; the down arrow alone indicates underexposure.

METERING RANGE WARNING

In all exposure modes, if the light is too dim or too bright for correct metering, both metering indicators blink.

BULB SETTING

Used only on manual, the shutter remains open as long as the Operating Button is depressed. Accessory Remote Cord RC-lOOOS or RC-1000L can be used to lock the shutter open.

Press the down-arrow Shutter Key until the bulb symbol appears in either display. The exposure meter does not operate. When you press the Operating Button, the frame-counter area in the Display Panel changes to an elapsed-time counter, counting to 99 seconds and repeating.

SELF-TIMER

Set the drive mode to S.T. and press the Operating Button. Exposure will be delayed for 10 seconds. A red LED on the front of the camera blinks slowly, then rapidly, then continuously during the last second. If the beeper is turned on, it beeps in synchronism with the LED. The frame counter in the Display Panel changes function and counts seconds downward from 10. To cancel during the countdown, press the DRIVE key. The Self-Timer does not function at the bulb setting.

On automatic exposure, stray light entering the eyepiece may cause incorrect exposure. When using the self-timer, if your eye is not at the eyepiece, cover the eyepiece with the Eyepiece Cap that is provided with the camera.

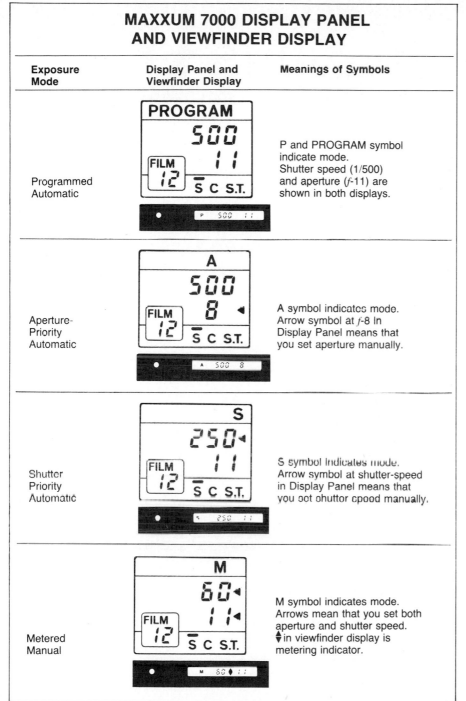

MAXXUM 7000 DISPLAY PANEL AND VIEWFINDER DISPLAY

Exposure Mode	Display Panel and Viewfinder Display	Meanings of Symbols
Programmed Automatic	**PROGRAM** 500 11 FILM 12 S C S.T.	P and PROGRAM symbol indicate mode. Shutter speed (1/500) and aperture (*f*-11) are shown in both displays.
Aperture-Priority Automatic	A 500 8 ◄ FILM 12 S C S.T.	A symbol indicates mode. Arrow symbol at *f*-8 In Display Panel means that you set aperture manually.
Shutter Priority Automatic	S 250◄ 11 FILM 12 S C S.T.	S symbol Indicates mode. Arrow symbol at shutter-speed in Display Panel means that you set shutter speed manually.
Metered Manual	M 60◄ 11◄ FILM 12 S C S.T.	M symbol indicates mode. Arrows mean that you set both aperture and shutter speed. ↕ in viewfinder display is metering indicator.

MEMORY BACKUP

The camera remembers some data and control settings even when turned off. Exposure mode, Exposure-Adjustment warning symbol, frame count and drive mode are displayed with the Main Switch on or off.

Film speed is always in memory but displayed only when the ISO key is pressed with the camera on. Values of shutter speed and aperture that you set manually are retained when the camera is turned off and restored when the camera is turned on again.

BATTERY WARNINGS

The main batteries should be replaced if the LCD displays blink, the shutter does not operate, film advance or rewind is slow, or if autofocus is slow.

The lithium battery should be replaced at a service center when the film-speed setting and the frame counter values blink.

When the main batteries are discharged, or the holder is removed to replace them, film speed and frame count are stored in a memory powered by the lithium battery. When the main batteries are replaced, film speed and frame count remain the same as before. The camera is reset, just as if the Program Reset Button had been pressed. If all batteries are discharged, all data is lost.

END OF ROLL

When the last frame has been exposed, the word FILM and the frame number blink in the Display Panel. If the beeper is turned on, it beeps. The shutter is locked.

Depress the Rewind-Release Button R and slide the adjacent Rewind Switch to the left. It locks while film is being rewound automatically. When the film is rewound, the motor stops. The word FILM continues to blink and the frame counter is reset to 0.

Caution—If the main batteries fail during rewind, the motor will stop but the frame counter will not show 0. Film

MAXXUM 7000 AUTOMATIC-EXPOSURE PROGRAMS

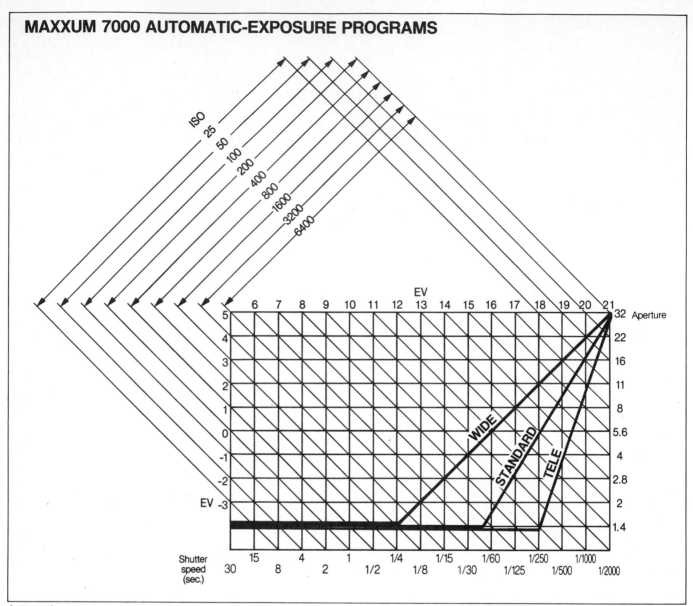

Automatic-exposure programs have limits determined by film speed and the metering range of the camera. The limits are shown here by the diagonal lines labeled with ISO film-speed values. For example, with a film speed of ISO 6400 the WIDE program can be used only from EV 21 to EV 5. Below EV 5 with the WIDE program, the camera viewfinder display will show that the low-light metering limit has been reached.

is not completely rewound. Do not open the camera. Move the Main Switch to LOCK. Replace the batteries. Move the switch to ON and wait for rewind to be completed.

BEEPER FUNCTIONS

When the beeper is turned on, it provides the following signals:

- Indicates good focus in autofocus mode.
- Beeps at end of roll.
- Beeps during self-timer operation.
- Warns of slow shutter speed in P or A mode. It beeps when shutter speed is below 1/30 second with lenses shorter than 35mm; below 1/60 second with lenses from 35mm to 105mm; and below 1/125 second with lenses longer than 105mm.

INTERCHANGEABLE FOCUSING SCREENS

Interchangeable focusing screens are shown in the accompanying chart. They are interchanged as shown in Chapter 3.

FILTERS

Color and special-effect filters can be used. Some filters may prevent autofocus operation. In that case, focus manually.

Autofocus will not work with a conventional polarizing filter. Minolta offers a special circular polarizing filter that will allow the autofocus system to work.

MAXXUM FLASH

With flash, the camera controls exposure, as discussed in Chapter 8. Operation is possible only with film speeds in the range of 25 to 1000. X-sync shutter speed is 1/100 second.

The Exposure Adjustment control affects flash exposure in all modes.

If the Operating Button is pressed before the flash is charged and ready to fire, the camera makes the exposure using ambient light, as though the flash were not attached.

INTERCHANGEABLE FOCUSING SCREENS FOR MAXXUM 7000 CAMERAS

Screen	Appearance	Description
Type G		Standard screen. Matte field with focus frame.
Type L		Matte field with grid and focus frame. For general and architectural photography.
Type S		Matte field with scales and focus frame. For macro- and astro-photography.
Type PM		Matte field with optical focusing aids. Horizontal line at center shows autofocus area. For general photography.

Screens for the MAXXUM 7000 are called Focusing Screen 70, plus a Type identification, such as Focusing Screen 70, Type S.

A continuous sequence of flash exposures is possible with the camera set to the C drive mode and the flash unit set to low power. Manual focusing is used to avoid the delay caused by automatic refocusing for each frame.

Viewfinder Indicators—The flash symbol blinks when the flash is charged and ready to fire. After flash exposure, the symbol blinks rapidly for about one second if exposure was sufficient. If the symbol does not blink, underexposure is indicated. There is no warning of overexposure.

AF ILLUMINATOR

MAXXUM flash units have an illuminator to assist autofocusing in dim light. If needed, the illuminator is triggered when you depress the Operating Button partway. If the camera finds focus, it then makes an exposure using light from the flash.

MAJOR ACCESSORIES

MAXXUM AF lenses, MAXXUM flash units, Control Grip CG-1000, Program Back 70, Program Back Super 70, interchangeable focusing screens, Eyepiece Correctors EC-1000, Wireless Controller IR-lN Set, Remote Cord RC-1000L (5 meters long) and RC-1000S (50cm long), Battery Holder BH-70L, External Battery Pack EP-70, filters, Angle Finder Vn, Magnifier Vn, Cable OC, Cable EX, Cable CD, Triple Connector TC-1000, Off-Camera Shoe.

When photographing in a location like this, it's advisable to use a fast film. Avoid excessive contrast by shooting in areas that are lit fairly uniformly. Using daylight-balanced film in tungsten illumination is fine for photographing a scene such as the one depicted here. The reddish glow of the light, as recorded on such film, adds warmth and atmosphere to the picture.

MAXXUM 9000

The MAXXUM 9000 is an auto-focus camera with manual film advance and rewind. The companion MD-90 motor drive provides automatic film advance and rewind. The camera has programmed automatic exposure with three programs that are selected automatically, depending on lens focal length. In addition, it has aperture-priority automatic, shutter-priority automatic and metered manual.

LENSES

MAXXUM AF (AutoFocus) lenses are used. The lens mount is a Minolta A-type, not compatible with earlier Minolta lenses.

BATTERIES

The battery holder holds two AA-size alkaline, carbon-zinc or NiCad batteries.

MAIN SWITCH

Moving the Main Switch to OFF turns the camera off. Setting the switch to ON turns the camera on. Moving the switch past ON to the "sound wave" symbol also turns on a beeper.

OPERATING BUTTON

The Operating Button has three stages. Touching it turns on the exposure meter, the autofocus system and the displays. The autofocus system changes focus if you point the camera at near or far objects.

The second stage is depressing the Operating Button partway. The auto-focus system will continue to search for focus. When focus is achieved, it locks focus at that distance.

Depress the Operating Button fully to make an exposure. In the autofocus mode, the shutter will operate whether or not the image is in focus.

If you are wearing gloves, or your fingertip is unusually dry, touching the Operating Button may not turn on the meter and autofocus systems. However, they will be turned on when the button is depressed partway.

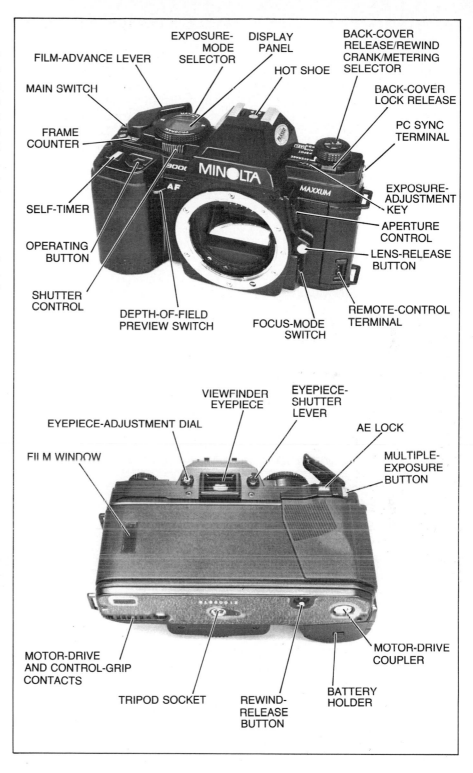

CONTROLS

Most controls are knobs or sliding switches. Pushbuttons are used only to set film speed and exposure adjustment. Frequently used controls are listed here.

Aperture Control—On the left side of the lens mount is a sliding switch. Push it up to select larger aperture, down for smaller. The switch is spring-loaded to return to center.

Shutter Control—Near the Operating Button is another spring-loaded sliding switch that sets shutter speed. Moving it to the left selects faster speeds. Shutter-speed range is 1/4000 to 30 seconds.

Exposure-Mode Selector—This is a ring surrounding a Display Panel on top of the camera. Rotate it to select the exposure mode.

Metering Selector—When flush against the top of the camera, the Rewind Crank also serves as the Metering Selector. Rotate it to select center-weighted or one of three spot-metering modes.

LOADING FILM

Load film as shown in Chapter 4. With the Main Switch ON, advance film to frame 1. The center part of the Rewind Crank should rotate to show that film is actually advancing. Shutter speed is automatically set to 1/4000 second and aperture to minimum size until frame 1 is reached.

FILM WINDOW

A window in the camera back allows you to see data imprinted on film cartridges, such as film type, the number of exposures and the film speed.

FILM SPEED

With DX-coded film, the camera automatically sets film speed. The value is displayed in the Display Panel when film is advanced to frame 1 and remains displayed until you touch the Operating Button. You can change the setting manually, if you wish. With non-DX coded film, the setting will

MAXXUM 9000 SPECIFICATIONS

Type: 35mm SLR with autofocus or manual focus, viewfinder focus display, multimode automatic exposure, automatic flash exposure.
Lens Mount: Minolta A-type; accepts only Maxxum AF lenses.
Autofocus System: TTL phase detection with digital control.
Autofocus Sensitivity: EV 2 to EV 19 at ISO 100.
Shutter: Electronic, vertical travel, stepless on automatic with nearest half-step displayed. Standard steps on manual. Range is 1/4000 to 30 seconds plus bulb setting. X-sync at 1/250 second.
Metering: For ambient light metering prior to exposure, TTL center-weighted or spot using compound silicon cell in mirror box. Also used for TTL center-weighted flash metering during exposure.
Metering Range: EV 1 to EV 20 with ISO 100 and f-1.4.
Film-Speed: ISO 6 to 6400. For TTL autoflash metering, ISO 12 to 1000. Set automatically with DX-coded film cartridges.
Exposure Modes: Programmed auto with automatic selection among three programs depending on focal length, and program-shift capability; aperture-priority auto; shutter-priority auto; metered manual.
Exposure Adjustment Control: Plus or minus 4 exposure steps in increments of 1/2 step.
AE Lock button: Functions in all automatic modes.
TTL Flash Modes: Programmed, A-mode with manually set aperture, S-mode with manually set shutter speed, M-mode with manually set shutter speed and aperture.
Film Advance: Manual.
Film Rewind: Manual.
Frame Counter: Mechanical. Automatic reset.
Viewfinder: Eyelevel, fixed pentaprism shows 94% of frame. Built-in eyepiece correction from -3 to +1 diopters. Magnification 0.81 with 50mm lens at infinity.
Viewfinder Displays: LED focus display. LCD display shows metering mode, exposure mode, program shift indication, shutter speed, aperture, exposure adjustment, metering-range limit, over- or underexposure, flash ready, sufficient flash exposure. LCD display automatically illuminated in dim light.
Data Panel Display: LCD displays shutter speed, aperture, exposure-adjustment warning, timer for bulb operation.
Multiple-Exposure Button: Allows multiple exposures without frame-counter advance.
Depth-of-Field Preview Switch: Operates in all modes. Stop-down warning in Data Panel display.
Batteries: Two AA-size alkaline, carbon-zinc or NiCad.
Beeper: Can be switched on or off.
Self-Timer: Electronic with 10-second delay. Operation indicated by flashing LED on camera front and beeper, if turned on. Cancellable.
Size: 53 x 92 x 139mm (2-7/8 x 3-5/8 x 5-1/2 inch).
Weight: 645g (22-3/4 oz.) without batteries.

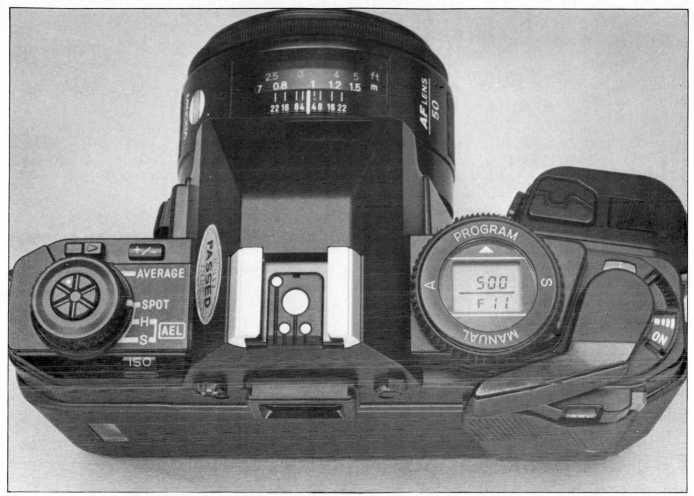

This top view of the MAXXUM 9000 shows clearly many of the major controls and features.

remain as it was for the preceding roll of film.

Setting Film Speed—Depressing the pushbutton labeled ISO causes the set film speed to appear in the Display Panel and in the viewfinder display. To change it, hold down the ISO button while moving the shutter control to the left or right. The film-speed range is ISO 6 to 6400 in increments of 1/3 step.

FOCUS MODES

The camera can be set to focus the lens automatically or manually.

Focus-Mode Switch—The switch is below the Lens-Release Button. When set to AF, the camera is in the autofocus mode. When set to M, the camera is in the manual focus mode.

Caution—Do not attempt to focus the lens manually with the Focus-Mode Switch at AF. Doing so may damage the camera. In the AF mode, be sure your hand is not touching the focusing ring on the lens while the focusing motor is turning it.

Autofocus Limits—With suitable subjects, the MAXXUM 9000 autofocus system works with scene brightnesses from EV 2 to EV 19 at ISO 100.

FOCUS LOCK

With the Focus-Mode Switch at AF, the autofocus system is active when you first touch the Operating Button. Depressing the button partway causes the system to lock focus. Focus is locked at that distance until you make an

exposure or release the Operating Button.

After focusing, you can press the Operating Button partway to lock focus and then recompose without losing focus on the subject. To focus on a different subject, lift your finger and then touch the button again to focus on the new subject.

Beeper—On manual focus, if the beeper is turned on, it beeps when the green focus light goes on to indicate good focus.

On autofocus, the beeper sounds only when you have pressed the Operating Button partway (to stage two) and the green focus light has turned on. In this mode, the beeper indicates both good focus and focus lock.

MAXXUM 9000 FOCUS DISPLAY

Symbol	On Manual Focus	On Autofocus
▶	Turn Manual Focusing ring to right.	Cannot focus because camera is too close to subject.
●	Subject is in focus.	Subject is in focus.
◀	Turn Manual Focusing ring to left.	Symbol not used.
▼ ▼	Focus by observing image on screen.	Autofocus not possible. Switch to manual focus.

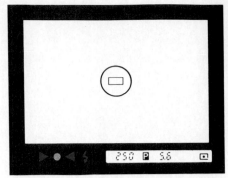

The MAXXUM 9000 viewfinder with the standard focusing screen has a Focus Frame at the center surrounded by a circle to show the spot-metering area. The focus display is at lower left and the exposure display is at lower right.

EXPOSURE METERING

The MAXXUM 9000 uses a compound silicon sensor in the bottom of the mirror box to perform all metering, as discussed in Chapter 5. Ambient light is measured with a center-weighted or spot pattern.

MAXXUM flash is controlled during exposure by the same sensor, measuring light on the film, using a center-weighted pattern.

AE LOCK

The AEL (Automatic-Exposure Lock) button is on the back of the camera, near the position of your right thumb. In any automatic-exposure mode, pressing this button locks the exposure setting. The Automatic-Exposure Lock can be used for substitute metering or to meter on a subject and then change the composition.

METERING SELECTOR

The Rewind Crank also serves as the Metering Selector. It has four positions:

The AVERAGE position selects center-weighted averaging.

The SPOT position selects spot metering. A circle in the center of the focusing screen designates the spot-metering area.

The H position selects highlight metering using the spot pattern. While

metering on white, press and hold the AEL button. Continue to hold the AEL button while making the exposure. That causes an exposure increase of 2.25 steps, which will cause the white surface being metered to record as white in the picture.

The S position selects shadow metering using the spot pattern. While metering on black, press and hold the AEL button. Continue to hold the AEL button while making the exposure. That causes an exposure decrease of 2.75 steps, which will cause the black surface being metered to record as black in the picture.

Metering Indicator—At extreme right in the viewfinder exposure display, a rectangle appears when center-weighted metering is used. With spot metering, a dot appears at the center of the rectangle.

DISPLAYS

There are displays in the viewfinder and the Display Panel on top of the camera.

Viewfinder Focus Display—Below the image, at left, is the focus display. A green light glows when the image is in focus. The other indicators are red arrows. This display operates on both autofocus and manual focus.

Viewfinder Exposure Display— Below the image, at right, is the LCD

exposure display. Normally, it shows shutter speed, exposure mode, aperture, an exposure-adjustment symbol if exposure adjustment is not zero, and a metering indicator to show if center-weighted or spot metering is being used. In dim light, this display is automatically illuminated.

Display Panel—An LCD Display Panel is on top of the camera. Normally, it shows shutter speed, aperture, and an exposure-adjustment reminder if adjustment is not zero.

Display On-Off—Both displays are turned on when you touch the Operating Button. To conserve battery power, they turn off after 10 seconds if you remove your finger from the Operating Button.

Focus Frame—In the center of the image, a rectangle shows the area used by the autofocus system to set focus.

146

To make good photos from an airplane, you must bear in mind a few important points. Sit in front of the engines, so the image isn't degraded by the heat trail from the jets. Hold the camera close to the window, to avoid unwanted reflections from inside the cabin. However, don't hold the camera in contact with the window. Doing so will transfer aircraft vibration to the camera, which may lead to blurry pictures. Because of atmospheric haze and windows of several thicknesses, exposure metering or evaluation may not be precise. To be sure of getting the image you want, bracket exposures liberally. This shot shows Honolulu, with Waikiki Beach and Diamond Head.

EXPOSURE MODES

The mode being used is shown on the Exposure-Mode Selector. The selected mode is shown in the viewfinder exposure display by one of the symbols P (programmed automatic), A (aperture-priority automatic), S (shutter-priority automatic), or M (metered manual operation).

Setting Exposure Mode—Rotate the Exposure-Mode Selector to place the desired mode opposite the triangular index mark. On the selector, the P and M modes are shown as PROGRAM and MANUAL.

PROGRAMMED AUTO

The camera sets both shutter speed and aperture automatically. The settings are shown in both displays. The nearest half step is displayed.

Automatic Multi-Program Selection—Three programs are available, shown in the graph, next page. Selection is made automatically by the camera, depending on the focal length of the lens in use. When a zoom lens is used, the program changes as the lens is zoomed.

Program Shift—In the Program mode, using the Shutter or Aperture control, you can cause the camera to step through all possible *combinations* of aperture and shutter speed that produce the same exposure. Use the combination with the preferred shutter speed or aperture size. Shifting occurs in half steps of shutter speed and aperture. The exposure-mode symbol P in the viewfinder blinks to show that the program has been shifted.

Shifted values can be held indefinitely if you keep your finger on the Operating Button, even during several exposures. Before the first exposure, values are held for 10 seconds if you lift your finger. After exposure, shifted values revert to unshifted values as soon as you lift your finger.

Exposure Warnings—If both shutter speed and aperture blink, there is no available combination that will produce correct exposure of an average scene. If overexposure is indicated, the *smallest* aperture and *fastest* shutter speed blink. If underexposure is indicated, the *largest* aperture and *slowest* shutter speed blink.

SHUTTER-PRIORITY AUTO

You set shutter speed, the camera sets aperture automatically. The settings are shown in both displays. Aperture is displayed to the nearest half step. In the Display Panel, a triangle appears opposite shutter speed to show that you set it manually. Shutter speeds are in full steps. In this mode, the Aperture control also changes shutter speed.

Exposure Warnings—Underexposure is indicated if the value for the *largest* lens aperture blinks in a display. Use a slower shutter speed. Overexposure is indicated if the *smallest* lens aperture value blinks. Use a faster shutter speed.

APERTURE-PRIORITY AUTO

You set aperture, the camera sets shutter speed automatically. The settings are shown in both displays. Shutter speed is displayed to the nearest half step. In the Display Panel, a triangle appears opposite the aperture value to show that you set it manually. Aperture changes are in half steps. In this mode, the Shutter control also changes aperture.

MAXXUM 9000 AUTOMATIC-EXPOSURE PROGRAMS

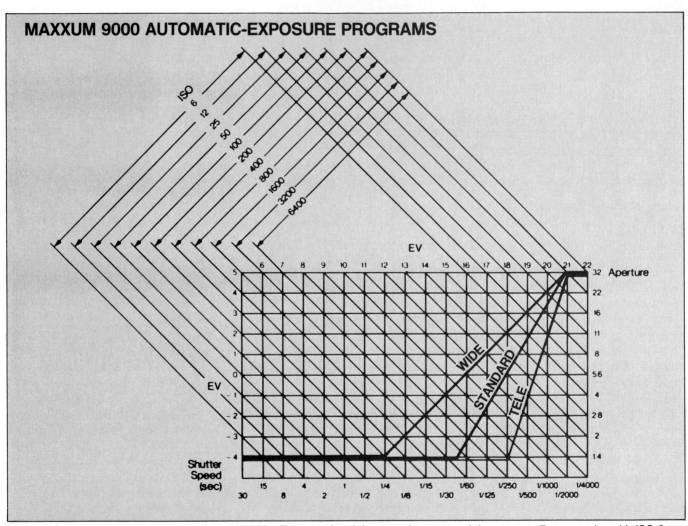

The usable range of each program is determined by film speed and the metering range of the camera. For example, with ISO 6, the upper parts of the programs cannot be used. At scene brightnesses above EV 16, the camera metering indicator will blink to show that the metering limit has been reached. An average scene in direct sunlight has a brightness of EV 15, so this limitation will not often be encountered, even at ISO 6.

Exposure Warnings—Underexposure is indicated if the *slowest* shutter speed (30 seconds) blinks. Use a larger aperture. Overexposure is indicated if the *fastest* shutter speed (1/4000 second) blinks.

EXPOSURE ADJUSTMENT

In any automatic mode, exposure adjustment can be made over a range of plus or minus 4 steps, in half steps. Exposure is increased or decreased by the amount of exposure adjustment set.

In any automatic mode, the amount of adjustment is shown in the viewfinder. A +/− appears in the Display Panel as a reminder that exposure adjustment is in use.

In the metered manual mode, the amount of adjustment is not shown in the viewfinder and the warning symbol does not appear in the Display Panel. The metered exposure is changed by the exposure adjustment, but not the manual exposure settings.

Setting Exposure Adjustment— Press the button labeled +/− . The set value appears in the Display Panel and in the viewfinder. To change the value, hold down the +/− key while moving the Shutter control to the left or right.

AE LOCK

The AEL (Automatic-Exposure Lock) button is on the back of the camera, near the position of your right thumb. In any automatic-exposure mode, pressing this button locks the exposure setting. The Automatic-Exposure Lock can be used for substitute metering or to meter on a subject and then change the composition.

METERED MANUAL

You set both aperture and shutter speed using the Aperture control and Shutter control. The values appear in both displays. In the Display Panel, a triangle to the right of each value indicates that each must be set manually. Only standard shutter speeds in full steps are available in this mode. Aperture can be set in half steps.

Exposure Deviation—The difference between the camera-recommended exposure and the manual exposure actually set is shown by a number in the viewfinder display, which Minolta refers to as *exposure deviation*. The range that is displayed is +6.5 to −6.5 steps, in half steps.

When passing from +1 to −1, the number will become +0 and then −0.

Either of the zeros means that the set exposure agrees with metered exposure within 1/4 step.

METERING RANGE

In all exposure modes, if the light is too dim or too bright for correct metering, the metering indicator blinks.

BULB SETTING

Used only in manual operation, the shutter remains open as long as the Operating Button is depressed. Accessory Remote Cord RC-1000S or RC-1000L can be used to lock the shutter open.

Change shutter speed downward until the bulb symbol appears in either display. The exposure meter does not operate. When you press the Operating Button, the shutter-speed area in the Display Panel changes to an elapsed-time counter, counting to 99 seconds and repeating.

DEPTH-OF-FIELD PREVIEW SWITCH

The preview switch folds up against the handgrip. To use, turn on the camera, *advance the film*, focus, and prepare to make the exposure. Any exposure mode can be used. The viewfinder display and the Display Panel show the aperture that the camera will use to make the next shot.

To See Depth of Field—Fold out the preview switch and press it down until there is resistance. The lens will close to the displayed shooting aperture so you can see depth of field. If the aperture is small, the image may be fairly dark.

Autofocus does not operate with the preview switch in use. Aperture size cannot be changed while the lens is stopped down.

To Change Aperture—If depth of field is not satisfactory, press the preview switch farther down, against noticeable mechanical resistance. The lens aperture gradually opens as you move the preview switch downward and is fully open when the switch

MAXXUM 9000
INTERCHANGEABLE FOCUSING SCREENS

Screen	Appearance	Description
Type G		Standard screen for MAXXUM 9000. Matte field with Focus Frame and spot-metering circle.
Type L		Matte field with grid, Focus Frame and spot circle. For general and architectural photography.
Type S		Matte field with vertical and horizontal scales, Focus Frame and spot circle. For macro- and astro-photography.
Type C		Focus Frame and spot-metering circle in clear field. For use at higher magnifications and when a brighter image is desired.
Type PM		Matte field with optical focusing aids. Horizontal line at center shows autofocus area. For general photography.

Screens for the MAXXUM 9000 are called Focusing Screen 90 plus a Type identification, such as Focusing Screen 90, Type S. The clear Type C screen can be used because exposure metering is in the camera body, not in the viewfinder above the focusing screen.

reaches its lower limit of travel. Release the preview switch. Now you can change aperture and view depth of field again if you wish.

To Shoot—When depth of field is OK, press the Operating Button. It is not necessary to return the lens to maximum aperture before shooting, but you can if you wish.

If Film is Not Advanced—If you are advancing film manually, instead of using a motor drive, be sure to operate the Film-Advance Lever before viewing depth of field. If film is not advanced, the Depth-of-Field Preview Switch will operate mechanically as just described but the lens will remain at maximum aperture.

SELF-TIMER

To set the timer, slide the Self-Timer Switch away from the Operating Button. When you press the button, exposure will be delayed for 10 seconds. A red LED on the front of the camera blinks slowly, then rapidly, then continuously during the last second. If the beeper is turned on, it beeps in synchronism with the LED. To cancel during the countdown, move the Self-Timer Switch back to its normal position. When you've finished using the timer, move the switch back to its normal position. The Self-Timer does not function at the bulb setting.

On automatic exposure, stray light entering the eyepiece may cause incorrect exposure. When using the self-timer, if your eye is not at the eyepiece, close the eyepiece shutter using the lever adjacent to the eyepiece.

MULTIPLE-EXPOSURE BUTTON

To make another exposure on the same frame, press the Multiple-Exposure Button while operating the Film-Advance Lever. Use your thumb on the button while rotating the Film-Advance Lever with your forefinger. Or, use your forefinger to press the button while your thumb rotates the lever. Make the second exposure. Repeat for additional exposures. After the last multiple exposure, operate the Film-Advance Lever normally, which will advance the film. The frame counter does not advance until the film actually advances.

Setting exposure for multiple exposures is discussed in Chapter 5.

MEMORY STORAGE

The camera "remembers" film speed, manual exposure settings and an exposure adjustment setting, even with the Main Switch off. This memory is powered by the two AA batteries in the battery holder. If the batteries fail, or if the battery holder is removed, memory is lost. When power is restored, film speed is displayed. It will be correct if DX-coded film is loaded. If the film is not DX-coded, a film speed of ISO 100 flashes continuously as a reminder that the camera has "forgotten" the manual film-speed setting. The shutter is locked until you set film speed manually.

Set the camera Main Switch to ON. Set film speed, if necessary. Otherwise, just touch the Operating Button. The camera will be set for manual operation with exposure settings of f-5.6 and 1/250 second. Change the exposure mode and settings, as desired. Exposure adjustment will be zero. Reset it if you wish.

BATTERY WARNINGS

The batteries should be replaced if the LCD displays blink, if shutter speed and aperture are not displayed when you touch the Operating Button, or if autofocus is slow.

END OF ROLL

When the last frame has been exposed, the Film-Advance lever will not move readily. Don't force it. Press the Rewind Button on the bottom of the camera. Pull the Rewind Crank upward and then to the side. Turn the crank clockwise to rewind the film. When it turns freely, film has been rewound into the cartridge. Open the back cover and remove the cartridge.

BEEPER FUNCTIONS

When the beeper is turned on, it provides the following signals:
- To indicate good focus when focusing manually.
- That you are using focus lock on autofocus.
- During self-timer operation.

INTERCHANGEABLE FOCUSING SCREENS

Interchangeable focusing screens are shown in the accompanying chart. They are interchanged as shown in Chapter 3.

FILTERS

Color and special-effect filters can be used. Some filters may prevent autofocus operation. In that case, focus manually.

Both exposure metering and autofocus will not work with a conventional polarizing filter. Minolta offers a special circular polarizing filter that will allow these systems to work.

MAXXUM FLASH

With flash, the camera controls exposure as discussed in Chapter 8. Operation is possible only with film speeds in the range of 25 to 1000. X-sync shutter speed is 1/250 second. The Exposure Adjustment control affects flash exposure in all modes.

If the Operating Button is pressed before the flash is charged and ready to fire, the camera makes the exposure using ambient light, as though the flash were not attached.

A continuous sequence of flash exposures is possible with the camera set to the C drive mode and the flash unit set to low power. Manual focusing is used, to avoid the delay caused by automatic refocusing for each frame.

Viewfinder Indicators—The flash symbol blinks when the flash is charged and ready to fire. After flash exposure, the symbol blinks rapidly for about one second if exposure was sufficient. If the symbol does not blink, underexposure is indicated. There is no warning of overexposure.

Dedicated Flash—X-sync and control signals for dedicated flash are available at the hot shoe and through electrical contacts on the bottom of the camera, used with Control Grip CG-90.

Other Flash—A PC socket on the left side of the camera supplies X-sync only.

AF ILLUMINATOR

MAXXUM flash units have an illuminator to assist autofocusing in dim light. If needed, the illuminator is triggered when you depress the Operating Button partway. If the camera finds focus, it then makes an exposure using light from the flash.

MAJOR ACCESSORIES

MAXXUM AF lenses, MAXXUM flash units, Control Grip CG-1000, Program Back 70, Program Back Super 70, interchangeable focusing screens, Eyepiece Correctors EC-1000, Wireless Controller IR-1N Set, Remote Cord RC-1000L (5 meters long) and RC-1000S (50cm long), filters, Angle Finder Vn, Magnifier Vn, Cable OC, Cable EX, Cable CD, Triple Connector TC-1000, Off-Camera Shoe.

MOTOR DRIVE MD-90

This is a powerful motor drive that provides automatic film advance and rewind and an additional autofocus mode for the MAXXUM 9000. It can expose and advance frames continuously at rates up to 5 per second. Additional film capacity can be provided by accessory 100-exposure Back EB-90, shown at the end of Chapter 9.

The motor drive is attached to the bottom of the camera, using the tripod screw. A power pack clips onto the bottom of the motor drive. Turn the motor drive off when installing or removing a power pack and when attaching the motor drive to a camera.

A tripod socket is on the bottom of the power pack. Electrical contacts on the bottom of the camera are relayed through the motor drive and power pack so a motor-driven camera can be used with Control Grip CG-1000, described in Chapter 8.

Selector Dial—There are two exposure settings above the OFF position and three continuous-exposure settings below. Autofocus operation is affected by the setting.

At OFF, the camera operates as though the motor drive were not attached.

At the S setting, the camera exposes a single frame each time the Operating Button is fully depressed. The camera operates with normal MAXXUM 9000 autofocus operation.

The F.P. symbol means Focus Priority. With the camera on autofocus and the Operating Button fully depressed, an exposure will not be made until the autofocus system finds focus and turns on the green focus light.

If you press and quickly release the Operating Button, only single frames are exposed. If you hold down the operating button, the camera will expose frames continuously, refocusing for each frame. Frame rate is about 4 frames per second or slower, depending on how much refocusing must be done and the shutter speed.

Without the MD-90, the MAXXUM 9000 does not have focus priority in any mode.

The H, M and L settings allow you to select maximum frame rates for continuous exposure with the Operating Button held down. At these settings,

Motor Drive MD-90, showing the major controls and features.

the autofocus system operates only before the first exposure and without focus priority. For the remaining frames in a sequence, focus is locked at the distance used for the first frame. Maximum frame rates are:

SETTING	FRAMES/SEC.
H	5
M	3
L	2

At slow shutter speeds, the maximum rate may not be possible because the motor drive always waits for the shutter to close before advancing the next frame. A rate of 5 frames per second requires a shutter speed of 1/250 second or faster and a Ni-Cad battery pack.

Frame Counter—The motor-drive counter starts at 36 and counts down to zero. It shows the number of frames remaining, rather than the number that have been exposed.

Frame count can be adjusted downward by pressing in the dial labeled SET and turning it clockwise. If you have loaded film with fewer exposures than 36, such as 24, change the counter to 24 before shooting.

The motor-drive counts downward to zero and turns off the motor. If the motor-drive frame counter is incorrectly set and the motor drive reaches the end of the film before the counter reaches zero, increased tension in the film path will operate a tension switch and turn off the motor.

Because of the increased tension before shut-off, the motor drive may tear the sprocket holes—more likely in cold weather, when the film is brittle, than in warm weather. You can avoid the potential problem by setting the counter to the correct number of frames before shooting.

When used with 100-Exposure Back EB-90, a frame counter on the EB-90 is used instead of the counter on the motor drive.

Reset—The MD-90 frame counter can be reset at any time by moving the COUNTER RESET button to the left. It resets to an S symbol, which is past 36. From there, it can be turned manually to 36 or a smaller count.

You can use this feature to count bursts of frames and turn off the motor. For example, if you reset and then set the motor-drive counter to 5, the motor drive will expose 5 frames and stop. To shoot bursts of frames without running out of film in the middle of a burst, set the motor-drive counter to a smaller number than the number of frames left on the film, as indicated by the camera frame counter.

Loading Film—Load film into the camera in the usual way. Manually advance one frame to be sure the film is caught in the take-up. Close the back cover. Set the MD-90 to H, M, or L and press the camera Operating Button. Film will automatically be advanced to frame 1.

The camera frame counter will show 1. The motor-drive frame counter will show 36. If the film cartridge doesn't have 36 frames, change the motor-drive counter.

Operation—Exposures can be made in three ways. You can use the camera Operating Button. Or, you can use the shutter button on the right end of the motor-drive battery pack. It's convenient for vertical-format shots. It does not turn on the camera autofocus system. It can be switched off to prevent accidental exposures. Thirdly, camera and motor drive can be controlled remotely with accessories shown later in this chapter.

Multiple Exposures—With the MAXXUM 9000, you can make multiple exposures using the normal procedure except that the motor drive resets the shutter and not the Film-Advance Lever. The camera frame counter does not advance during multiple exposure, but the motor-drive counter will advance. After the multiple exposure, reset the motor-drive counter and then set it to the correct count. At high speeds, it may be difficult to control the number of multiple exposures.

Rewinding—When the motor-drive frame counter reaches zero, a red light glows and the drive stops. With the Selector Dial at any setting except OFF, move the COUNTER RESET button to the left and hold it there while pressing the REWIND button. Film will be rewound by the motor in about seven seconds. While rewinding, a green light glows. Rewind stops with the film leader extending from the cartridge.

Manual rewinding cannot be done with the motor drive on the camera.

With Flash—MAXXUM flash units can be used for single or continuous frames. With a flash that has a low-power setting, such as the 2800 AF, or an MD setting, such as the 4000 AF, frame rates of 2 per second can be used.

Set the motor drive to L to prevent it from operating faster than the flash can recharge. The motor drive will not wait for the flash. Set the camera to manual focus to disable the AF Illuminator on the flash.

With the flash mounted on Control Grip CG-1000, and Ni-Cad batteries in both flash and grip, frame rates of 5 per second can be used for short bursts.

Batteries—Purchased separately, Battery Pack BP-90M uses 12 AA-size alkaline or carbon-zinc batteries. Battery Pack NP-90M has built-in Ni-Cad cells, rechargeable by the companion NC-90M charger which is supplied with the battery pack. The maximum frame rate of 5 frames per second requires a fully charged NP-90M pack.

WIRELESS CONTROLLER IR-1N

This is a transmitter and receiver that allow remote control of a camera at distances up to about 60 meters (200 feet). The transmitter sends a coded beam of infrared light to the camera location to trip the shutter. It does not turn on an autofocus system.

Receiver—The IR-1 Receiver has a mounting foot that fits a camera hot shoe but makes no electrical connections. A bracket is supplied to provide an alternate mounting arrangement. The receiver can be rotated on its foot to face the transmitter. Connection Cord IR-1C is used between a socket on the receiver and the Remote-Control socket on a MAXXUM camera.

A switch selects OFF, S (single-frame) or C (continuous). Continuous operation, C, can be used if the camera has a film-advance motor or an attached motor drive.

Transmitter—The transmitter is handheld and has a transmit button to trigger the camera. A clear line of sight must exist between transmitter and receiver.

With the receiver set for single-

Wireless Controller IR-1N Set consists of a transmitter unit that can be handheld and a receiver that mounts on or near the camera. The receiver must face the transmitter unit.

frames, pressing the transmit button exposes one frame. With the receiver set for continuous frames, pressing the transmit button starts the sequence. Pressing it again ends the sequence.

Channels—Both transmitter and receiver have three channels, identified on selector switches as 1, 2 and 3. One transmitter can control several receivers simultaneously or selectively, depending on channel settings.

Batteries—The IR-1 transmitter uses two AA-size alkaline, carbon-zinc or Ni-Cad batteries. The IR-1 receiver uses a single 9-volt "transistor" battery, Eveready 216 or equivalent.

For remote Control of MAXXUM cameras with autofocus, there are two Remote Cords. RC-1000S is 50cm (20 inches) long. RC-1000L is 5 meters (16.5 feet) long. One end plugs into the Remote Control Socket on the camera body. The handle on the other end has a Release Button. Pressing the Release Button partway turns on the autofocus system in the camera if the camera is set for autofocus operation. Pressing the Release Button farther makes the exposure. The Release Button can be depressed and locked, if desired.

For best cold-weather performance with MAXXUM 5000 or MAXXUM 7000 cameras, use four AA-size Ni-Cad batteries in External Battery Pack EP-70. Carry the battery pack in your pocket, to keep it warm. The standard battery holder on the camera is replaced with a "dummy" holder that has an electrical connector to receive the power cord of the EP-70. The dummy holder is packaged with the EP-70.

DEPTH OF FIELD TABLES FOR ZOOM LENSES

With a camera that doesn't have a depth-of-field preview switch, you can't check depth of field in the viewfinder. However, there's a depth-of-field scale on each fixed-focal-length lens. For each focused distance, it shows depth of field at various aperture settings. Zoom lenses don't have a depth-of-field scale because depth of field varies with focal length. The tables that follow represent some of the MAXXUM AF zoom lenses, at selected focal-length settings.

MAXXUM AF ZOOM 35—105mm f-3.5—4.5
DEPTH OF FIELD (Meters)
Focal Length = 35mm

FOCUSED DIST	f-3.5	f-4	f-5.6	f-8	f-11	f-16	f-22
inf	inf	inf	inf	Inf	inf	inf	inf
	11.0	9.87	7.00	4.97	3.54	2.53	1.81
20	inf	inf	inf	inf	inf	inf	inf
	7.16	6.69	5.26	4.04	3.06	2.28	1.69
7	18.1	22.1	229	inf	inf	inf	inf
	4.36	4.19	3.59	3.00	2.43	1.93	1.50
4	6.03	6.39	8.53	16.3	inf	inf	inf
	3.00	2.92	2.63	2.31	1.97	1.64	1.33
2.0	2.35	2.40	2.63	3.03	3.88	6.47	177
	1.74	1.71	1.62	1.50	1.36	1.21	1.04
1.5	1.67	1.70	1.80	1.96	2.26	2.89	4.81
	1.36	1.34	1.29	1.22	1.13	1.03	0.914

Focal Length = 50mm

FOCUSED DIST	f-3.8	f-4	f-5.6	f-8	f-11	f-16	f-22	f-24
inf	inf	inf	inf	inf	inf	inf	inf	inf
	19.7	19.0	13.4	9.53	6.76	4.80	3.42	3.21
20	inf	inf	inf	inf	inf	inf	inf	inf
	10.0	9.83	8.13	6.54	5.12	3.93	2.96	2.81
7	10.5	10.7	13.9	23.7	inf	inf	inf	inf
	5.24	5.19	4.69	4.13	3.53	2.94	2.38	2.29
4	4.91	4.95	5.49	6.51	8.84	18.0	inf	Inf
	3.38	3.36	3.15	2.90	2.60	2.28	1.94	1.88
2.0	2.18	2.19	2.28	2.42	2.65	3.07	3.98	4.25
	1.85	1.84	1.78	1.71	1.61	1.49	1.35	1.32
1.5	1.59	1.59	1.64	1.70	1.81	1.98	2.29	2.37
	1.42	1.42	1.38	1.34	1.28	1.21	1.12	1.11

Focal Length — 70mm

FOCUSED DIST	f-4.2	f-5.6	f-8	f-11	f-16	f-22	f-26
inf	inf	inf	inf	inf	inf	inf	inf
	35.7	26.1	18.5	13.1	9.28	6.58	5.77
20	44.6	81.3	inf	inf	inf	inf	inf
	12.9	11.4	9.71	8.01	6.43	5.03	4.56
7	8.59	9.38	10.9	14.2	25.2	inf	inf
	5.91	5.59	5.16	4.6	4.09	3.49	3.27
4	4.45	4.64	4.97	5.54	6.60	9.08	11.0
	3.63	3.51	3.35	3.14	2.88	2.58	2.46
2.0	2.09	2.13	2.19	2.28	2.43	2.66	2.80
	1.91	1.88	1.84	1.78	1.70	1.60	1.56
1.5	1.54	1.56	1.59	1.64	1.71	1.81	1.87
	1.45	1.44	1.41	1.38	1.34	1.28	1.26

Focal Length = 105mm

FOCUSED DIST	f-4.5	f-5.6	f-8	f-11	f-16	f-22	f-28
inf	inf	inf	inf	inf	inf	inf	inf
	71.4	56.4	39.9	28.2	20.0	14.2	11.5
20	27.5	30.6	39	66.0	inf	inf	inf
	15.7	14.8	13	11.8	10.1	8.39	7.39
7	7.71	7.92	8.38	9.14	10.4	13.2	16.7
	6.41	6.27	6.01	5.68	5.27	4.78	4.45
4	4.21	4.27	4.39	4.58	4.88	5.37	5.8
	3.81	3.76	3.67	3.55	3.39	3.19	3.05
2.0	2.04	2.05	2.08	2.12	2.17	2.25	2.32
	1.96	1.95	1.92	1.89	1.85	1.80	1.76
1.5	1.52	1.53	1.54	1.56	1.58	1.63	1.66
	1.48	1.47	1.46	1.44	1.42	1.39	1.37

MAXXUM AF ZOOM 28—135mm f-4—4.5
DEPTH OF FIELD (Meters)
Focal Length = 28mm

FOCUSED DIST	APERTURE f-4	f-5.6	f-8	f-11	f-16	f-22
inf	inf	inf	inf	inf	inf	inf
	6.38	4.54	3.24	2.32	1.67	1.21
20	inf	inf	inf	inf	inf	inf
	4.86	3.72	2.81	2.09	1.55	1.15
7	inf	inf	inf	inf	inf	inf
	3.37	2.79	2.24	1.7	1.37	1.05
3	5.59	8.84	53.1	inf	inf	inf
	2.07	1.84	1.5	1.34	1.10	0.889
2	2.86	3.51	5.20	16.9	inf	inf
	1.55	1.42	1.27	1.11	0.942	0.784
1.5	1.93	2.19	2.74	4.26	23.0	inf
	1.23	1.15	1.05	0.941	0.822	0.701

Focal Length = 50mm

FOCUSED DIST	APERTURE f-4.2	f-5.6	f-8	f-11	f-16	f-22	f-24
inf	inf	inf	inf	inf	inf	inf	inf
	18.1	13.4	9.52	6.75	4.80	3.41	3.22
20	inf	inf	inf	inf	inf	inf	inf
	9.51	8.05	6.47	5.0	3.88	2.93	2.78
7	11.4	14.6	26.8	inf	inf	inf	inf
	5.06	4.62	4.05	3.46	2.87	2.31	2.22
3	3.58	3.84	4.36	5.38	8.08	28.7	61.4
	2.58	2.46	2.30	2.09	1.86	1.62	1.57
2	2.24	2.33	2.51	2.82	3.41	4.87	5.35
	1.81	1.75	1.66	1.56	1.43	1.28	1.25
1.5	1.63	1.68	1.76	1.91	2.16	2.66	2.79
	1.39	1.36	1.30	1.24	1.16	1.06	1.04

Focal Length = 100mm

FOCUSED DIST	APERTURE f-4.4	f-5.6	f-8	f-11	f-16	f-22	f-26
inf	inf	inf	inf	inf	inf	inf	inf
	69.2	53.8	38.1	27.0	19.1	13.5	11.8
20	28.1	31.8	42.2	78.4	inf	inf	inf
	15.5	14.6	13.1	11.5	9.78	8.08	7.42
7	7.78	8.04	8.57	9.46	11.0	14.6	17.4
	6.36	6.20	5.92	5.56	5.13	4.62	4.40
3	3.13	3.17	3.25	3.37	3.55	3.85	4.02
	2.88	2.84	2.78	2.70	2.60	2.46	2.40
2	2.05	2.07	2.10	2.16	2.23	2.34	2.40
	1.95	1.93	1.90	1.86	1.81	1.75	1.71
1.5	1.53	1.54	1.56	1.59	1.62	1.68	1.71
	1.47	1.46	1.44	1.42	1.39	1.35	1.33

Focal Length = 135mm

FOCUSED DIST	APERTURE f-4.5	f-5.6	f-8	f-11	f-16	f-22	f-27
inf	inf	inf	inf	inf	inf	inf	inf
	113	92.8	65.7	46.5	32.9	23.3	19.6
20	24.2	25.4	28.7	35.1	51.2	147	inf
	17.0	16.5	15.3	14.0	12.5	10.8	9.91
7	7.45	7.56	7.82	8.23	8.88	10.0	10.9
	6.60	6.52	6.33	6.09	5.78	5.40	5.17
3	3.08	3.09	3.14	3.20	3.29	3.43	3.53
	2.92	2.91	2.87	2.82	2.76	2.67	2.61
2	2.03	2.04	2.06	2.08	2.12	2.18	2.22
	1.97	1.96	1.94	1.92	1.89	1.85	1.82
1.5	1.51	1.52	1.53	1.54	1.56	1.60	1.62
	1.48	1.48	1.47	1.46	1.44	1.41	1.40

MAXXUM ZOOM 70—210mm f-4
DEPTH OF FIELD (Meters)
Focal Length = 70mm

FOCUSED DIST	f-4	f-5.6	f-8	f-11	f-16	f-22	f-32
inf	inf	inf	inf	inf	inf	inf	inf
	38.3	27.9	19.8	14.0	9.95	7.07	5.04
15	24.1	31.3	57.5	inf	inf	inf	inf
	10.9	9.89	8.67	7.39	6.12	4.93	3.88
7	8.42	9.12	10.4	13.1	20.7	121	inf
	6.00	5.69	5.28	4.80	4.25	3.66	3.07
5	5.66	5.95	6.47	7.37	9.20	14.2	66.6
	4.48	4.31	4.08	3.80	3.46	3.07	2.66
3	3.20	3.29	3.42	3.64	4.00	4.66	6.10
	2.82	2.76	2.67	2.55	2.41	2.23	2.02
2	2.07	2.11	2.16	2.23	2.35	2.53	2.86
	1.93	1.90	1.86	1.81	1.74	1.66	1.55
1.5	1.53	1.55	1.57	1.61	1.66	1.74	1.87
	1.46	1.45	1.43	1.40	1.37	1.32	1.26
1.3	1.32	1.33	1.35	1.37	1.41	1.46	1.54
	1.27	1.27	1.25	1.23	1.21	1.17	1.13
1.1	1.11	1.12	1.13	1.14	1.16	1.20	1.24
	1.08	1.08	1.07	1.06	1.04	1.02	0.986

Focal Length = 150mm

FOCUSED DIST	f-4	f-5.6	f-8	f-11	f-16	f-22	f-32
inf	inf	inf	inf	inf	inf	inf	inf
	166	121	85.6	60.6	42.9	30.3	21.5
15	16.4	17.0	18.0	19.7	22.6	28.6	46.2
	13.8	13.4	12.8	12.1	11.2	10.2	9.00
7	7.27	7.38	7.56	7.82	8.22	8.86	9.9
	6.74	6.65	6.52	6.34	6.10	5.79	5.41
5	5.13	5.18	5.26	5.38	5.56	5.84	6.28
	4.87	4.83	4.76	4.67	4.54	4.38	4.16
3	3.04	3.06	3.08	3.12	3.17	3.25	3.37
	2.96	2.94	2.92	2.89	2.84	2.78	2.70
2	2.01	2.02	2.03	2.04	2.06	2.09	2.13
	1.98	1.98	1.97	1.96	1.94	1.91	1.88
1.5	1.50	1.51	1.51	1.52	1.53	1.54	1.56
	1.49	1.49	1.49	1.48	1.47	1.46	1.44
1.3	1.30	1.30	1.31	1.31	1.32	1.33	1.34
	1.30	1.29	1.29	1.29	1.28	1.27	1.26
1.1	1.10	1.10	1.10	1.10	1.11	1.11	1.12
	1.10	1.10	1.09	1.09	1.09	1.08	1.08

Focal Length = 210mm

FOCUSED DIST	f-4	f-5.6	f-8	f-11	f-16	f-22	f-32
inf	inf	inf	inf	inf	inf	inf	inf
	310	226	160	113	80	56.6	40.1
15	15.7	16.0	16.4	17.1	18.2	20.0	23.3
	14.3	14.1	13.8	13.3	12.7	12.0	11.1
7	7.14	7.19	7.28	7.40	7.59	7.86	8.29
	6.86	6.81	6.74	6.64	6.50	6.31	6.06
5	5.07	5.09	5.13	5.19	5.27	5.40	5.59
	4.93	4.91	4.87	4.82	4.75	4.65	4.53
3	3.02	3.03	3.04	3.06	3.08	3.12	3.17
	2.98	2.97	2.95	2.94	2.92	2.89	2.84
2	2.01	2.01	2.01	2.02	2.03	2.04	2.06
	1.99	1.99	1.98	1.98	1.97	1.96	1.94
1.5	1.50	1.50	1.50	1.51	1.51	1.52	1.53
	1.50	1.50	1.49	1.49	1.49	1.48	1.47
1.3	1.30	1.30	1.30	1.30	1.31	1.31	1.32
	1.30	1.30	1.30	1.29	1.29	1.29	1.28
1.1	1.10	1.10	1.10	1.10	1.10	1.10	1.11
	1.10	1.10	1.10	1.10	1.09	1.09	1.09

MAXXUM AF ZOOM 75—300mm f-4.5—5.6
DEPTH OF FIELD (Meters)
Focal Length = 75mm

FOCUSED DIST	f-4.5	f-5.6	f-8	f-11	f-16	f-22	f-32
inf	inf	inf	inf	inf	inf	inf	inf
	38.9	31.4	22.2	15.8	11.2	7.94	5.65
20	40.0	52.8	167	inf	inf	inf	inf
	13.4	12.4	10.7	8.98	7.32	5.82	4.52
7	8.37	8.79	9.84	11.8	16.6	39.9	inf
	6.02	5.82	5.44	4.99	4.46	3.89	3.29
5	5.63	5.81	6.23	6.94	8.30	11.4	25.5
	4.50	4.39	4.18	3.92	3.60	3.23	2.82
2.5	2.62	2.65	2.73	2.84	3.01	3.29	3.80
	2.39	2.36	2.31	2.24	2.14	2.02	1.88
1.5	1.53	1.54	1.56	1.59	1.63	1.69	1.78
	1.47	1.46	1.44	1.42	1.39	1.35	1.3

Focal Length = 135mm

FOCUSED DIST	f-5.2	f-5.6	f-8	f-11	f-16	f-22	f-32	f-37
inf	inf	inf	inf	inf	inf	inf	inf	inf
	107	98.9	69.9	49.5	35.0	24.8	17.6	15.3
20	24.4	24.8	27.6	32.8	44.8	93.0	inf	inf
	16.9	16.7	15.7	14.4	12.9	11.3	9.55	8.87
7	7.43	7.47	7.69	8.02	8.54	9.40	10.9	11.9
	6.61	6.58	6.42	6.21	5.94	5.59	5.16	4.97
5	5.20	5.22	5.32	5.47	5.70	6.05	6.63	6.97
	4.81	4.79	4.71	4.60	4.46	4.27	4.02	3.9
2.5	2.54	2.54	2.56	2.59	2.63	2.69	2.78	2.83
	2.46	2.46	2.44	2.41	2.38	2.33	2.27	2.24
1.5	1.51	1.51	1.51	1.52	1.53	1.55	1.57	1.58
	1.49	1.49	1.48	1.48	1.47	1.45	1.43	1.43

Focal Length = 200mm

FOCUSED DIST	f-5.4	f-8	f-11	f-16	f-22	f-32	f-38
inf	inf	inf	inf	inf	inf	inf	inf
	220	154	109	77.3	54.7	38.8	31.5
20	21.9	22.8	24.2	26.6	30.8	39.9	52.0
	18.4	17.8	17.0	16.0	14.8	13.4	12.4
7	7.20	7.29	7.41	7.60	7.89	8.33	8.72
	6.81	6.73	6.63	6.48	6.29	6.04	5.86
5	5.09	5.13	5.19	5.28	5.41	5.60	5.77
	4.91	4.87	4.82	4.75	4.65	4.52	4.42
2.5	2.51	2.52	2.53	2.55	2.58	2.61	2.64
	2.48	2.47	2.46	2.45	2.43	2.40	2.37
1.5	1.50	1.50	1.51	1.51	1.52	1.52	1.53
	1.50	1.49	1.49	1.49	1.48	1.47	1.47

Focal Length = 300mm

FOCUSED DIST	f-5.6	f-8	f-11	f-16	f-22	f-32	f-40
inf	inf	inf	inf	inf	inf	inf	inf
	449	326	230	163	115	81.7	64.3
20	20.8	21.2	21.7	22.6	23.9	26.0	28.4
	19.2	18.9	18.5	17.9	17.2	16.2	15.5
7	7.09	7.13	7.18	7.26	7.38	7.55	7.72
	6.91	6.88	6.83	6.76	6.66	6.53	6.41
5	5.04	5.06	5.08	5.12	5.17	5.25	5.33
	4.95	4.94	4.92	4.88	4.84	4.77	4.71
2.5	2.51	2.51	2.51	2.52	2.53	2.54	2.56
	2.49	2.49	2.48	2.48	2.47	2.46	2.44
1.5	1.50	1.50	1.50	1.50	1.50	1.51	1.51
	1.50	1.50	1.50	1.50	1.49	1.49	1.49

INDEX